ANDY WARHOL: THE FACTORY YEARS 1964-1967

PHOTOGRAPHS BY NAT FINKELSTEIN

POWERHOUSE BOOKS, NEW YORK

CONTENTS

GOD DAMN *THESE FLIES! I'M NOT DEAD YET!* BY DAVID DALTON

EVERYTHING THE BURNING BUSH! ONLY AN IMMEDIATE AND TERRIFYING FOREGROUND. OUTSIDE OF THIS CHARMED CIRCLE — NOTHING! WHEN ANDY AND BETSEY JOHNSON POINT OFFSTAGE, WE KNOW IT'S A JOKE. THIS IS HISTORY, FOR CHRISSAKES! AND HISTORY HAS EDGES. AND NOW THIS...

YOU ARE RUNNING FACE TO FACE WITH THE WILDEST BUNCH OF ARTIFICIAL ANIMALS YOU'VE EVER SEEN. LIKE THE OVERWEIGHT WAITRESS FROM THE DINER ON THE OUTSKIRTS OF TOLEDO WHO PRESSES HER FACE AGAINST THE WINDOW OF THE BUS, YOU PEER INTO THESE SHALLOW BIBLICAL SPACES, DIORAMAS OF THE LATE TWENTIETH CENTURY (COMPLETE WITH ETIOLATED, SELF-DEVOURING SAINTS, POSTURING STABLE BOYS, MUSEUM CURATORS, AGING ACTRESSES WITH THEIR BITCHY ENTOURAGE) AND REALIZE THE APOCALYPSE IS GOING TO LOOK SOMETHING LIKE THIS:

UNEXPECTED, BRILLIANTLY LIT, THE PRINCIPAL CHARACTERS HAVING REHEARSED THEIR PARTS PERHAPS A BIT TOO OFTEN. SO-AND-SO'S MOTHER WILL BE THERE, A BOULEVARDIER, A DRUNK WHO'S WANDERED IN FROM ANOTHER SET, THE ROCK 'N' ROLL STAR WHO WILL DROWN IN HIS POOL, ALL THOSE PEOPLE ON THE GUEST LIST, STRAY DOGS, WOMEN OF A CERTAIN AGE, THE PRESS (THEY WITHOUT WHOM, NOTHING) AND, AS ALWAYS, THE RUBBERNECKING CROWD STRAINING AT THE VELVET ROPE...

YOU ENTER A NINEVEH OF SILVER NITRATE SHADOWS WHERE IMAGES, LIKE ASH FROM A VOLCANO, FALL ENDLESSLY, OVERLAYING ONE ANOTHER, EACH TRANSPARENT THROUGH THE NEXT. AN ALMOST TRANSLUCENT ANDY GREETS YOU AT THE FREIGHT ELEVATOR. AGAINST THE WALL, A PAINTING OF TENNESSEE WILLIAMS SQUEEZED BETWEEN A PREHENSILE LESTER PERSKY AND A TONGUE-BITING ANDY (AN EMBEZZLER IN THE CUSTODY OF TWO BIZARRE FBI AGENTS).

WHO'S TO SAY WHAT'S MORE REAL HERE? THE SILKSCREEN OF TENNESSEE WILLIAMS OR A PHOTOGRAPH OF ANDY STANDING IN FRONT OF IT, A FINGER IN HIS MOUTH, LIKE A STATUE PRESIDING OVER A RAILWAY STATION?

IMAGES SLITHER FROM ONE DIMENSION TO THE NEXT. NO ONE HERE TALKS MUCH ABOUT ART, TECHNIQUE, OR TALENT — THAT WOULD SMACK TOO MUCH OF CHOICE. ELSEWHERE ABSTRACT MONSTERS MAY CROUCH, BUT HERE THE DIVUS KNOWS THAT TRUE GENIUS IS REPLICATION, AND THE ULTIMATE WORK OF ART A PHOTOGRAPH OF A PHOTOGRAPH.

A DARK CHAPEL OF FLUORESCENT SAINTS, A SPEED FREAK'S TINFOIL VERSAILLES WHERE A UNIVERSE OF TACKY ICONS, LOOSE ENDS, KITSCH AND QUATSCH BECOME TOTEMS OF A TARNISHED MYTHOLOGY. AN AFTERLIFE JUST OFF 46TH STREET WHERE SPECTERS PROWL IN WRAPAROUND SHADES WHILE THE MASTER, IN A WHISPER, TELLS A JOKE ABOUT OLD MOVIES ON THE LATE LATE SHOW: I SAW A MOVIE LAST NIGHT WITH A CROWD SCENE AND EVERYBODY WAS...DEAD.

THIS IS THE HAUNT OF TRANSITIVE GHOSTS WHERE ELVIS MULTIPLIES, AND A DIVINE OTTER SIPS FROM HIS HIP FLASK WATCHING A 16MM MOVIE OF A MAN SLEEPING ON A COUCH. THE FACTORY: A WAITING ROOM DESIGNED BY JEAN-PAUL SARTRE, WHERE THE OCCUPANTS DISCUSS THE SEX LIVES OF THE GODS. JUDY, MARILYN, GARBO, KIM. THEY KNOW OBSCURE AND TERRIBLE THINGS ABOUT THEM. ABOUT THE GAS STATION ATTENDANT WHO FUCKED THEM ALL, AND WHERE MISS THING HID HER PILLS. ACOLYTES OF THE 2-D RELIGION — MOVIES! THEY ALL BELIEVE WITH SUCH A PASSION IN DEAD HEROINES, THIN AS AIR. THEY HAVE A HARD TIME KEEPING TRACK OF WHERE THEIR PERSONALITIES END AND MARIA MONTEZ BEGINS.

ANDY WAS ALWAYS ATTRACTED TO DARK SATANIC MILLS; SWEATSHOPS HAVE POWER AND OPPRESSION AND A DECREPIT GLAMOUR. ENGRAMS OF IMMIGRANT MEMORY — THE WICKED IRONY OF THE COAL MINER'S SON JUMPING ON THE BONES OF JEREMY BENTHAM.

A MOLE-LIKE ALBINO, NOSFERATU, SILENTLY CHANTING MEDIUMISTIC DICTATION AS HE SCRAPES AT A BURIED DOOR. THE SCENARIO HE HAS JUST CONCOCTED INVOLVES AS ACTORS THE PROLEPTIC DEAD (NO MATTER!): EDIE, JACKIE, HOLLY, CANDY DARLING, MISS AMANDA JONES — SACRIFICIAL VIRGINS FLIRTING WITH THE INSTRUMENT OF THEIR OWN UNDOING. THE SPOOL OF FILM UNWINDS ON THE FLOOR, THE UNLOOPED FRAMES SPINNING BACKWARDS TOWARD THEIR POINT OF ORIGIN.

ACCORDING TO THE THEORY OF THE MAGIC SELF, A STAR ENTERING ANOTHER'S ORBIT MUST YIELD ITS MANA AT THE DOOR. BUT DYLAN COULD BEND SPACE AROUND HIM LIKE A HAT. HE BROUGHT HIS OWN SCENERY, HIS OWN ALPHABET. PORTABLE DARKNESS! TUNGSTEN BULBS BLOOMING LIKE NOVAS IN THE EXISTENTIAL BLACK OF A TIJUANA NIGHT. A PROCREATING VOID PUNCTUATED BY BIBLICAL SHAFTS OF LIGHT.

IT WAS THE MERCURIAL JACKIE CURTIS WHO SAW THROUGH THE PASTY, NECROTIC SKIN AND GUESSED THAT UNDER THAT DYNEL WIG AND PHANTOM OF THE OPERA MASK WAS JAMES DEAN...AFTER RECONSTRUCTIVE SURGERY! THE TERROR OF THE CRASH AND HIS HIDEOUS DISFIGUREMENT HAD MADE HIM SOMETHING OF A DRACULA. THE HORROR, HE KNEW AS ONE ONCE DEAD, ALWAYS BEGINS BY STEPPING OVER THE LINE. "AND WHEN HE HAD CROSSED THE BRIDGE THE PHANTOMS CAME TO MEET HIM...."

A JADED VAMPIRE PREYING ON NARCISSISTIC YOUTH. INNOCENCE, LIKE HIS OWN LOST SELF, COMPELLED TO BECOME AWARE OF ITS OWN CAPACITY FOR GROTESQUE BEHAVIOR.

ALL THOSE CRYPTIC COTERIES, LIKE TRANSYLVANIAN CHILDREN OF DARKNESS SCURRYING OUT INTO THE DAYLIGHT, FRESH FROM THEIR SEASONS IN HELL. PACKS OF FREAKISH, DISTURBED SOULS HANGING OUT IN DINGY GAY BARS. SPEED QUEENS PLAYING POOL DOWN AT SLUGGER ANN'S (THE PLASTIC IVY AND CHRISTMAS LIGHTS STILL UP). OUT OF THE DARK CORNERS THEY CAME: ATTICS, SPARE ROOMS, BASEMENT HOVELS, THEIR MOTHERS' HOUSE IN QUEENS. THINGS WERE LOOSENING UP AND THE ODDITIES CONVERGED — MUTANTS WITH THE DESPERATE STARE OF CIRCUS DWARFS.

THE FACTORY WAS THE NODAL POINT FOR THESE WILLING VICTIMS, THE MAGNETIC OTHER TOWARDS WHICH, HALF IN TRANCE, THEY WERE DRAWN LIKE WHITE ZOMBIES TO LUGOSI'S SATANIC SUGAR MILL. AGITATED SPIRITS FOR WHOM ORDINARY LIFE WAS DRAB, UNENDURABLE, AND UNTOUCHED BY THE POETRY OF DESECRATION — POINTLESS. SOME LEFT IN LIMOUSINES, SOME IN AMBULANCES, SOME COULDN'T FIND THE DOOR.

MAD, MAD CREATURES LIKE MARGOT MARGOT WHO THOUGHT SHE WAS MARY QUEEN OF SCOTS. NUREYEV DANCING WITH A RUSSIAN SAILOR. EDIE IN HER TIGHTS, HER EYEBALLS SCREWED INTO HER BETTY BOOP FACE. THE TERROR CREW: THE OVERWEIGHT TRANSVESTITE AND SKINNY GAY BOYS WITH METHEDRINE BODIES. ALWAYS IN A PACK. LED BY A GHOST! A FEROCIOUSLY DRESSED MENAGERIE OF FREAKS. IN DAYLIGHT PEOPLE ON THE STREET GASP AND CROSS THE AVENUE, UNABLE TO CONCEAL THE DREAD THESE APPARITIONS EFFORTLESSLY INSPIRE.

REJECTS, DAMAGED GOODS, DISPLACED PERSONS-LIKE CREATURES FROM A HORROR FLICK...THEY GLITTERED IN THE REFLECTED LIGHT OF FOILSTARS. NO COURT EVER HAD SUCH CATAPULTING ROMAN CANDLES, SUCH STACCATO ELOQUENCE, SUCH FLORID FANTASIES. ANDY'S ARMY OF MANGY MONSTERS! SPEED FREAKS, DRAG QUEENS, DOMINATRICES, HUSTLERS AND JUNKIES. HE WAS READY TO LEAD THEM INTO MAINSTREAM AMERICA. A REVOLUTION OF PERVERSION, TOYS AND TITILLATION AS COMPELLING AS AMERICA'S LOVE/HATE RELATIONSHIP WITH ITSELF. TURN THE OUTSIDE IN AND THE INSIDE OUT! AND WHY NOT? OUTSIDE, THE GLASS WAS SHATTERING: WATTS, HANOI, BIRMINGHAM, DALLAS. INSIDE WAS THE AMNIOTIC CAVE OF THE FACTORY.

AND ALL THOSE YEARS LIVING WITH HIS MOTHER. MRS. WARHOLA, DRINKING A QUART OF VODKA A DAY, RAILING ON ABOUT MARTYRED SAINTS AS UR-ANDY INCUBATED INTO MEGA-ANDY. GOTHAM'S CYCLOTRON BREEDS MONSTERS, AND IT WAS FROM THAT SUBLUNAR TRIBE OF PECULIARS THAT ANDY CAME. SUBLIME FREAKS:

THE LAST EMPEROR OF CONSTANTINOPLE, THE BRONX GIANT, THE LIEDER-SINGING LESBIAN, ALIENS FROM HYPHENATED GALAXIES, INDUSTRIOUS BRICOLEURS. THEY LIVE TO DRESS UP, COLLECT STRANGE OBJECTS, DWELL IN PHANTASMAGORICALLY DECORATED APARTMENTS. RARIFIED, FRAGILE CREATURES AROUND WHOM EVOLVES A UNIVERSE OF ODDNESS AND MAGIC. WHEN CELEBRITY'S GLARE FALLS ON THEM THEY TEND TO SHRIVEL UNDER ITS RAKING LIGHT. ANDY ESCAPED THIS FATE BY GIVING BIRTH TO SERIAL SELVES, THE COPIES, WITH SUBSEQUENT GENERATIONS, GRADUALLY FADING.

SOMEDAY A CATALOGUE OF SINISTER SAINTS WILL BE COMPILED THAT EXPLAINS ALL THIS. WOULD THE FACTORY HAVE EVER BECOME A PLACE OF PILGRIMAGE IF IT HAD NOT FLIRTED WITH THREATS (OR PROMISES) OF DEFILEMENT? TABOOS TRANSGRESSING THE MOST RECENTLY DEMARCATED EDGE? BEHIND IT ALL THE EMINENCE ARGENT, THE UNDYING FAIRGROUND HUCKSTER WHO SELLS TICKETS TO A WORLD BEFORE THE CREATION, PURVEYOR OF A SIDE SHOW FROM WHICH AT ANY MOMENT THE FREAKS MIGHT BREAK OUT. AMAZONIAN CANNIBALS SUBJECTING TOURISTS TO METICULOUSLY SIMULATED MUTILATIONS. A MERCURIAL SELF-MADE MASTER OF TRANSFORMATION. THE TRAVELLING HYPNOTIST WHO SAWS HIS VICTIMS IN HALF, THE SCULPTOR WHO EMBALMS HIS MODELS, THE SURGEON IN QUEST OF BODY PARTS TO RESTORE A LOST SELF.

THE VELVET UNDERGROUND ("THE PSYCHOPATH'S ROLLING STONES") EXECUTE THEIR RITUAL OF POLLUTION: LEATHERBOY LOU BLOWING HIS HORN ("I'LL MAKE ALL YOU FUCKERS WISH YOU'D NEVER BEEN BORN!"); MARY WORONOV'S WHIP DANCE; NICO, CHANTING TENEBROUS HYMNS TO BARON VON SACHER-MASOCH AND WAILING DRUIDIC BOYO. JOHN CALE: THE BLACK SAIL OF THE MEDUSA'S RAFT ON THE HORIZON, A FATAL PACKAGE ARRIVING AT THE LOVER'S DOOR. SOMEWHERE A PIANO FALLS DOWN A MINDSHAFT.

AND THEN ONE AFTERNOON, AS THE PARTY DRAGGED MORBIDLY ON, CAME VALERIE SOLANIS, LIKE SOME EXTERMINATING ANGEL. SHE DIDN'T REALIZE THAT WHAT SHE WAS AIMING AT WAS NO THICKER THAN A SNAPSHOT. AFTER THAT THE FREAKS FLED, THE TINFOIL WAS STRIPPED OFF, THE FACTORY CLOSED, THE LEATHER AND THE SHADES PACKED AWAY IN ARCHIVAL BOXES. THE GATES OF XANADU SHUT FOREVER.

THEN HE MOVED DOWNTOWN. NO LONGER A FACTORY, IT WAS NOW A CORPORATION WITH, AS CEO, A HOLY GHOST WHOM PEOPLE CAME TO VISIT AS ONE GOES TO A WAX MUSEUM: TO STARE AT AN EFFIGY FOR WHAT HE WAS IN LIFE.

AFTER VALERIE SOLANIS COMES THE NEW ANDY, A PREPPIE REVENANT IN TIE AND LOAFERS, DINING UPON HIS FORMER SELF. HE NO LONGER CONSORTED WITH CHIMERICAL EDGY BOYS AND DOOMED ELFIN GIRLS WHIRLING FANTASIES IN THE SPIN CYCLE OF AMPHETAMINE. THE COCKATRICE NOW HAD TROUBLE FINDING HIS REFLECTION IN THE MIRROR. HE TOOK UP WITH JET SET GIGOLOS AND BUBBLE-HEADED HEIRESSES WHO DID NOT KNOW HIS DUMB ACT WAS JUST THAT: AN ACT. THE FINAL IRONY FOR HE WHO HAD ONCE RADIATED PUT-ON, PARODY, AND MENACE WAS TO BE TAKEN LITERALLY. APRES MOI, COMMES DES GARÇONS!

DEAR READER, YOU HAVE HEARD, NO DOUBT, THOSE STORIES ABOUT THE KINDLY OLD ANDY, THE NOBODADDY IN THE WIG WHO, LIKE A DALIESQUE APPARITION AT EMMAUS, BROKE BREADSTICKS WITH THE LADIES WHO LUNCH (FOR WHOM, BETWEEN COURSES, BORED AS A DONKEY, LIFE HOVERS LIKE A MAITRE D'). HE LONGED IN THOSE TERRIBLE PAUSES TO HEAR THE SOUND OF THE LID OF HELL BEING OPENED. BUT IT NEVER CAME. ONLY THE CLATTERING OF SILVERWARE ON LIMOGES CHINA, THE RAPIDLY EXPUNGED "I" OF THE ARBITRAGER'S WIFE, WHO, IN UNRELATED BITS OF GOSSIP ABOUT BIANCA AND THE BEHEADED MANICURIST, CAN'T REMEMBER WHAT HAS LED HER FROM ONE THOUGHT TO THE OTHER.

HE WAS A SWEETHEART. ALL THE BOYS SAY IT. VICTOR, RAYMOND, RICHARD, PETER...THEY FATUOUSLY REPEAT THE PHRASE "LEGENDARY SWEETNESS" LIKE TAIWAN CHIP TRADERS SPEAKING ABOUT A BOX OF BELGIAN CHOCOLATES. BUT, DARLING BOYS, DON'T YOU REALIZE YOU KNEW ONLY THE POSTHUMOUS ANDY, ANDYPOSTHUMATA, THE YUPPIE ANDY, THE POST-VALERIAN PUPPET, THE CHINESE JEW, THE DEATH DOLL?

THIS MELLOW FELLOW OF WHICH YOU SPEAK WAS NOT THE ANDY WHO MADE THOSE *PAINTINGS* — TUNA DISASTER, HANDLE WITH CARE, TRIPLE ELVIS, BLUE ELECTRIC CHAIR, TWO HUNDRED CAMPBELL SOUP CANS, GOLD MARILYN, 129 DIE IN JET, FLOWERS, WHITE BURNING CAR III, SIXTEEN JACKIES, THIRTEEN MOST WANTED MEN, BRILLO BOX, FALLEN BODY, THIRTY ARE BETTER THAN ONE, MAO WALLPAPER, SKULL, MUSTARD RACE RIOT, LARGE SLEEP, DOUBLE TORSO, JULIA WARHOLA...THIS WAS NOT THE ANDY WHO LOVED TO WATCH CAT FIGHTS IN THE BACK ROOM AT MAX'S, THE NEURASTHENIC SAINT WHOSE VISIONS INVOLVED LEATHER-CAPPED SAILORS FROM TOM OF FINLAND, WHO COULD TURN HIMSELF INSIDE OUT AT WILL, WHO CLIMBED ROPE LADDERS TO CONCEAL HIS STIGMATA, WHO BEGGED TO BE ELECTROCUTED BY THE TERRIBLE BLACK GOD OF ELECTRICITY. BUT SURELY YOU KNEW THIS?

I AM ANDY WARHOL. REALLY. I BOUGHT YOUR WIG AT SOTHEBY'S, I CUT OFF YOUR THUMB WITH A SHARP KNIFE AS YOU LAY IN STATE AT ST. PATRICK'S CATHEDRAL. OR ARE YOU — I AM CONFUSED! — MY DADDY? DADDY ANDY, BRING HOME THE BACON! PAPA POP; PAPA LEGBA GOING TO A GO-GO, A SKELETON IN DRAG WITH A WIG HAT ON ITS HEAD.

WE ALWAYS SEEM TO END UP WHERE WE STARTED: THE OPEN COFFIN AND THE DEATH SHIP SWARMING WITH RATS, THE OMINOUS FLASHES (STROBE LIGHTS IN THIS CASE), THE GRANITE SHOELACES, THE WIG UNDER THE BELL JAR AND THE PLAQUE ON THE WALL.

PICK UP THE SILVER TELEPHONE, DEAR LISTENER. THERE'S A 900 NUMBER YOU CAN DIAL AND HEAR THE STORY OF HIS LIFE, THE MYSTERY OF HIS TWO DEATHS, HIS PRETERNATURAL ART. "NOTE HOW CLEVERLY THE FLEEING FIGURE'S ELEVATED RIGHT LEG IS ECHOED BY THE STATE TROOPER'S FIRE HOSE...NOTE, TOO, THE ALLUSIONS TO THE WINGED VICTORY OF SAMOTHRACE IN THE PORTRAIT OF ETHEL SCULL, AND TO THAT OTHER NOBLY WINDBLOWN FIGURE, HERR DOPPELKOHLENSAUR (HEAD OF THE TODFARBEN PETROCHEMISCHES A.G.), WITH HIS SCHNAUZER, FRITZY."

AN INTERACTIVE WEBSITE IS NEXT. WHO NEEDS THE REAL THING? TOO COMPLICATED, TOO PERVERSE AND PATHETIC — AND YOU'LL NEED A HOUSE TO KEEP HIM IN AS WELL. ALL THOSE SHOPPING BAGS! THE DEAD ARE JUST PHOTOGRAPHS, ANYWAY.

IF YOU WISH TO VIEW HIS CAMEO APPEARANCE ON THE LOVE BOAT, <CLICK HERE>.

FOR PHILOSOPHY FROM A TO B AND BACK AGAIN, <CLICK HERE>.

IT WOULD BE GLAMOROUS TO BE REINCARNATED AS A BIG RING ON PAULINE DE ROTHSCHILD'S FINGER.

"AURA" MUST BE UNTIL YOU OPEN YOUR MOUTH.

"ON" IS DIFFERENT THINGS TO DIFFERENT PEOPLE.

PRESS <ESC> TO EXIT.

SO, ANDY, NOW THAT YOU EAT ICE CREAM WITH THE GODS, WILL YOU GRANT US ONE MORE WISH? JUST ONE LAST TIME LET US HEAR YOU UTTER WITH SIBYLLINE SURPRISE THAT ONOMATOPOEIA OF YOUR SILVERY SOUL, YOUR INIMITABLE "OOOOOOOOH!"?

BUT BEWARE, MY INNOCENT EXEGETE, VOYEUR OF THIS ROSY APOCALYPSE AS YOU PASS BY, AS YOU TURN THE PAGES WHICH FOLLOW: ALL THE SHORT GHOSTS FROM THE THIRTEENTH TOWN ARE HERE, THEIR LEADER A SPECTER IN LIFE (WITH HIS ECTOPLASMIC SKIN AND HIS MUMBLING). "FUCK ETERNITY,' HE TELLS THEM. "JUST GET THE PICTURE!"

MAKING ART

Andy Warhol

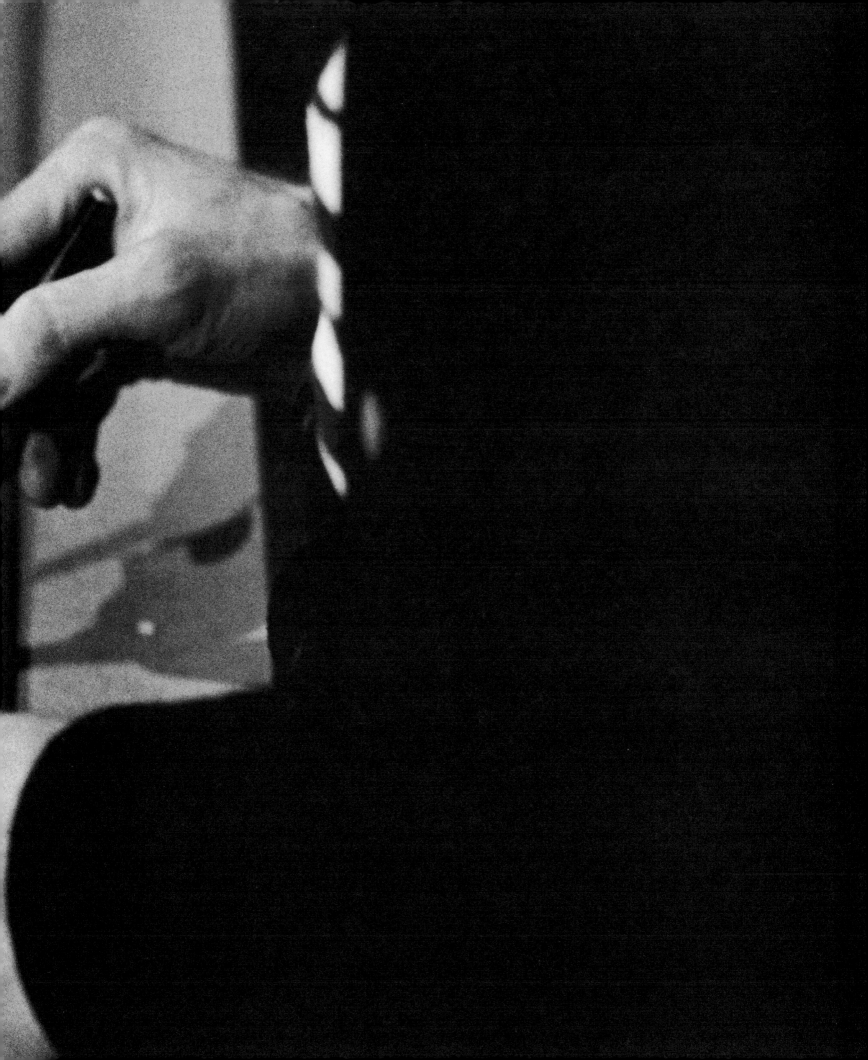

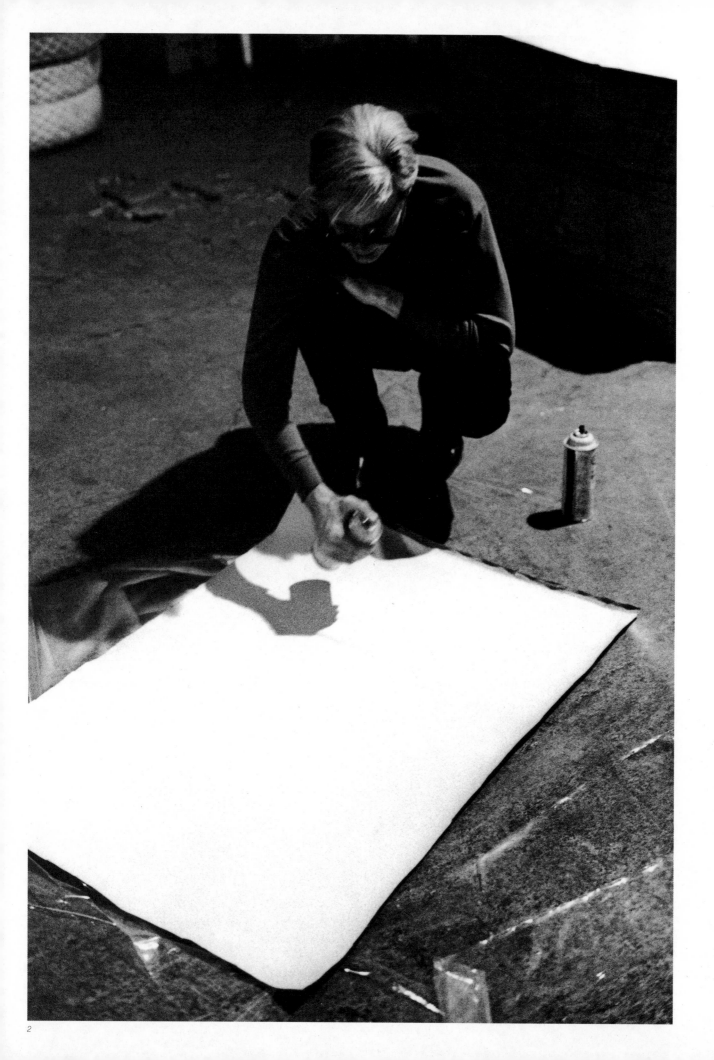

ANDY WARHOL'S GREATEST WORK OF ART WAS ANDY WARHOL. OTHER ARTISTS FIRST MAKE THEIR ART AND THEN CELEBRITY COMES FROM IT. ANDY REVERSED THIS.

FOR ME THE FACTORY WAS A PLACE OF SEX AND DRUGS AND ROCK 'N' ROLL, FOR SOME OF THE OTHERS IT WAS: FROM FERMENT COMES ART. I WAS THINKING, 'ART WHO?' THEY TOOK THIS GUY NAMED ART, PUT HIM ON A PEDESTAL AND EVERYBODY WOULD GET DOWN ON THEIR HANDS AND KNEES AND RAISE THEIR ASS LIKE IT WAS ALLAH. 'ANDEE, ANN...DEE, ANDY WARHOL, HERE HE COMES!' WAS THE DRUM THAT ANDY DANCED TO IN THOSE DAYS.

ANDY'S STRATEGY WAS ORGANIZED LIKE AN AIR-RAID THROUGH RADAR-PROTECTED TERRITORY. HE WOULD DROP THESE SHOWERS OF SILVER FOIL OUT OF THE PLANE TO DEFLECT THE RADAR. BEHIND THIS SCREEN OF SMOKE AND MIRRORS, THERE WAS ANDY AT WORK. THAT WAS THE REAL FUNCTION OF THE ENTOURAGE. IT WAS A WAY TO GET THE ATTENTION AWAY FROM ANDY, WHILE HE HID BEHIND THEM, DOING HIS NUMBER. THE ENTOURAGE WAS THERE TO DISTRACT THE ATTENTION, TO TITILLATE AND AMUSE THE PUBLIC, WHILE ANDY WAS DOING HIS VERY SERIOUS WORK.

ANDY WAS A VERY HARD-WORKING ARTIST, A WORKING MAN. HE HID THIS VERY CAREFULLY, CREATING THE MYTH THAT HIS PRODUCTS JUST KINDA APPEARED. I'M PROBABLY ONE OF THE VERY FEW PHOTOGRAPHERS WHO ACTUALLY HAS PICTURES OF ANDY WITH HIS HANDS ON A PAINTBRUSH AND THE PAINTBRUSH TOUCHING THE PAINTING. HE DIDN'T WANT TO GET PAINT ON HIS HANDS. SO LIKE ANY GREAT ARTIST, HE HAD AN ATELIER. HE MANIPULATED PEOPLE TO DO THINGS FOR HIM. IT WAS A VERY STUDIED CASUAL ACT, 'HEY, YOU DO IT'. WHILE HE WAS WORKING, HE ALSO HAD THE OTHERS WORK FOR HIM... WELL, WHAT ELSE IS A FACTORY? IT WAS A BRILLIANT SCAM. ANDY ACTED THE SAME WITH THE INTERVIEW SESSIONS. PEOPLE WOULD CALL UP AND ANDY WOULD SAY, 'OH NO, NAT, YOU TALK TO THEM.' HE WAS VERY PARTICULAR ABOUT WHO HE WOULD TALK TO. I REMEMBER WHEN JOHN HEILPERN CAME UP TO THE FACTORY ON ONE OF HIS FIRST MAJOR ASSIGNMENTS FOR THE OBSERVER. JOHN IS A FINE PERSON, BUT NOT A PRETTY BOY... AND HE DIDN'T COME ACROSS AS STRONG AS HE BECAME IN LATER DAYS, BUT FOUND HIMSELF IN AN ENVIRONMENT WHERE HE WASN'T VERY SURE OF HIMSELF. THEY GAVE HIM A HARD TIME, THEY PLAYED UPTIGHT — FAGGOT GAMES — THEY GOT IN HIS FACE — DANCED ON HIS HEAD. NOBODY, AND CERTAINLY NOT ANDY, WOULD TALK TO HIM. I THOUGHT, 'ENOUGH OF THIS BULLSHIT. I'M GONNA TALK TO ANDY'. ANDY TOLD ME TO BE HIS VOICE, SO I WAS ANSWERING FOR HIM. WHEN ANDY GOT THE IDEA THAT THIS WAS GOING TO BE A PUBLISHED ARTICLE, HE FINALLY GAVE JOHN HIS INTERVIEWS.

ANDY WAS SO GOOD IN HIDING THE FACT THAT HE WAS DIRECTING AND MANIPULATING THAT IT CAUSED A LOT OF FRICTION, AS WITH DANNY WILLIAMS OF THE VELVET UNDERGROUND. IT'S NOT THAT PEOPLE WERE ANDY'S PUPPETS, OR THAT HE SPOKE THROUGH THEIR BODIES, BUT HE WAS ALWAYS ABLE TO INSINUATE HIMSELF AS THE DRIVING FORCE, DONOVAN'S BRAIN. IT WAS LIKE TWO HAPLOID CELLS COMING TOGETHER AND FORMING A UNIFIED CELL — THOUGH IT LOOKED LIKE A MASS SNAKE FORNICATION. ANDY'S GREAT TALENT WAS TO UNCOVER MINOR TALENTS, PUT THEM TOGETHER AND COME OUT WITH A GREAT WHOLE MADE OUT OF MINOR PARTS. GERARD WAS ANDY'S GREAT DISCOVERY. GERARD WAS THE FACTORY. HE WAS THE CURRY THAT HID THE TASTE OF SLIGHTLY SPOILED MEAT. THE FACTORY WAS A STEW MADE OUT OF SOCIETY'S LEFT-OVERS, REJECTS AND DAMAGED MERCHANDISE. THE SATELLITES WERE PEACHES, WAITING TO BE BRUISED. ANDY MERCHANDISED ART IN EACH AND EVERY WAY. HE MADE ART INTO POP CULTURE. THE PROOF OF THE PUDDING IS THAT THE BRILLO COMPANY STARTED IN 1968 TO GIVE AWAY THESE PLASTIC BALLOONS WITH A BRILLO PRINT ON IT. WALK INTO ANY SUPERMARKET NOW, WALK INTO ANY PARK, AND YOU CAN BUY THESE VINYL BALLOONS: HEART-SHAPED OR SAUSAGE-SHAPED. ANDY WAS THE PERSON WHO INVENTED THE VINYL BALLOONS AND THEN THEY BECAME PART OF POP CULTURE — AND DRIFTED AWAY. IT WAS A TWO-WAY PROCESS. ANDY DIDN'T NEED THE STORY OF JESUS AND MARY TO MAKE A PIETA, JUST CAMPBELL'S SOUP CANS AND AN IDEA. HE TOOK THE ARTEFACTS OF ORDINARY LIFE AND USED THEM TO CREATE A MIRROR OF SOCIETY. HE PUT INTO AN ASSIMILABLE GESTALT THE SIGNS AND SYMBOLS OF REALITY. NOT A CREATOR... AN INNOVATOR. ANDY WAS THE SONY OF MODERN ART.

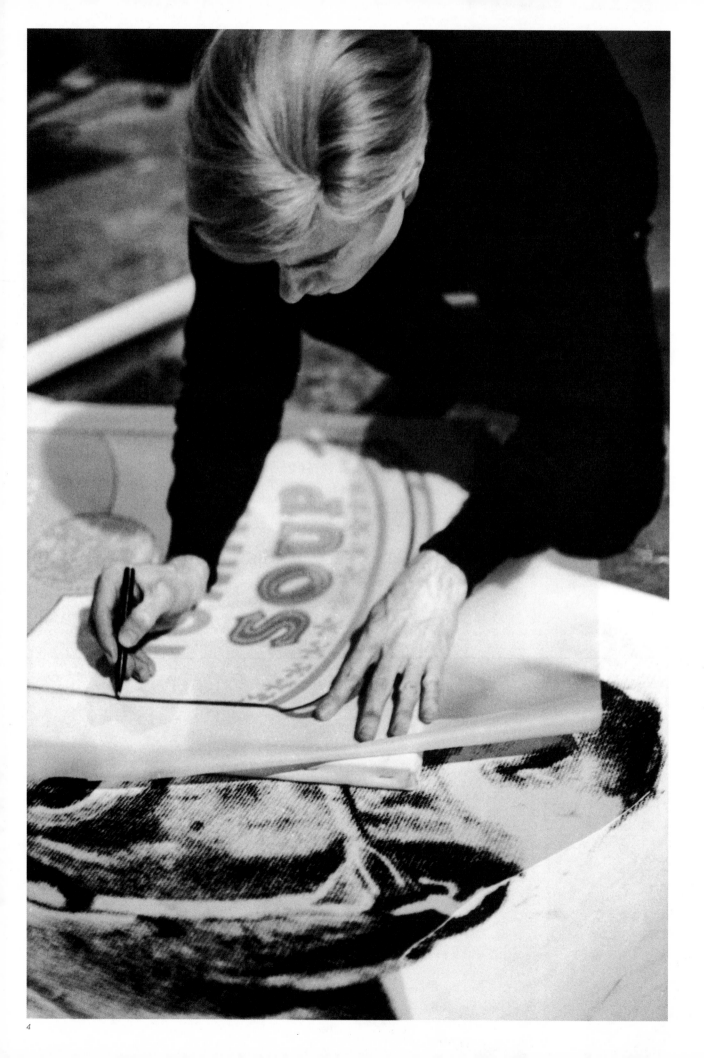

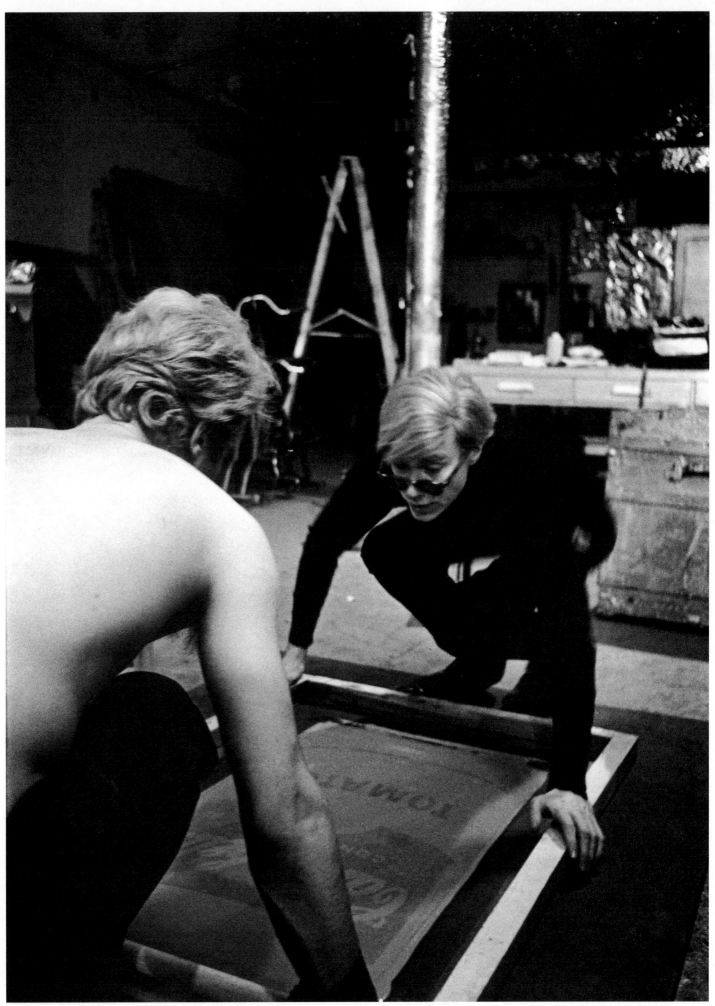

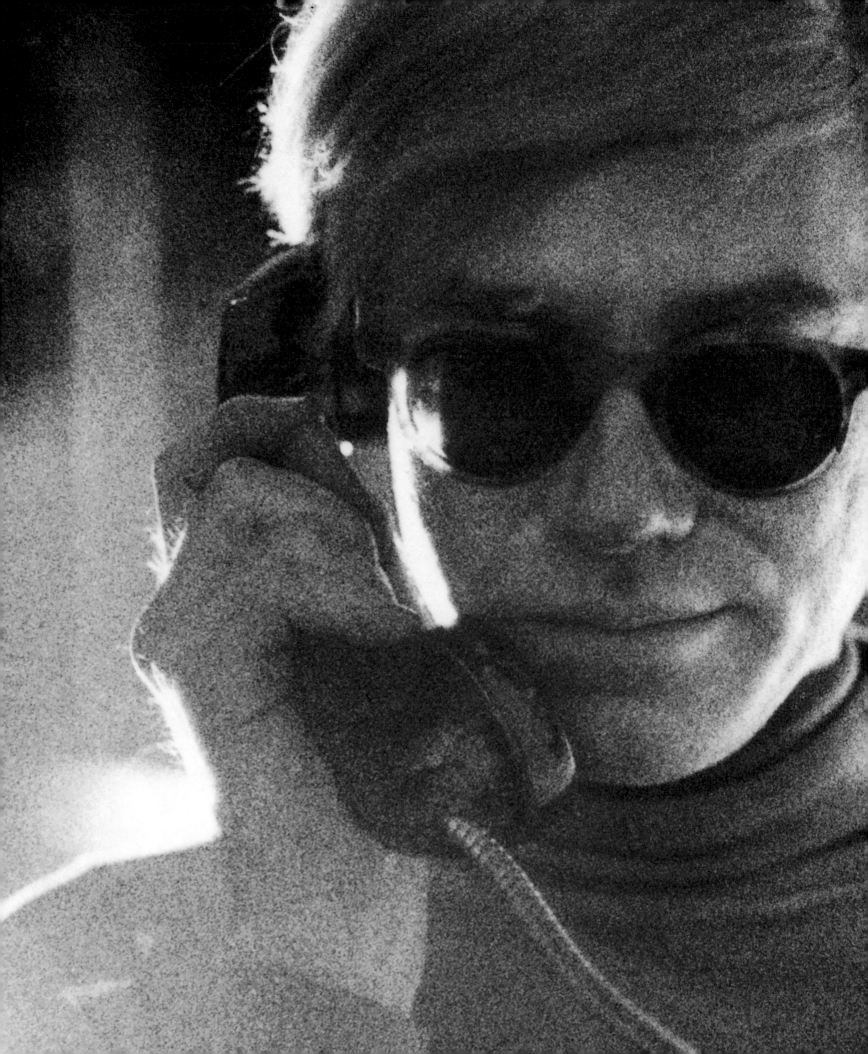

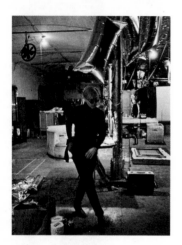

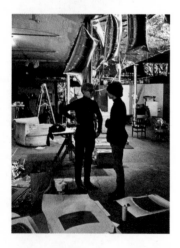

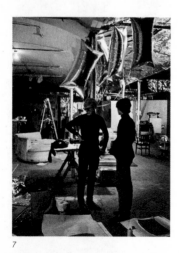

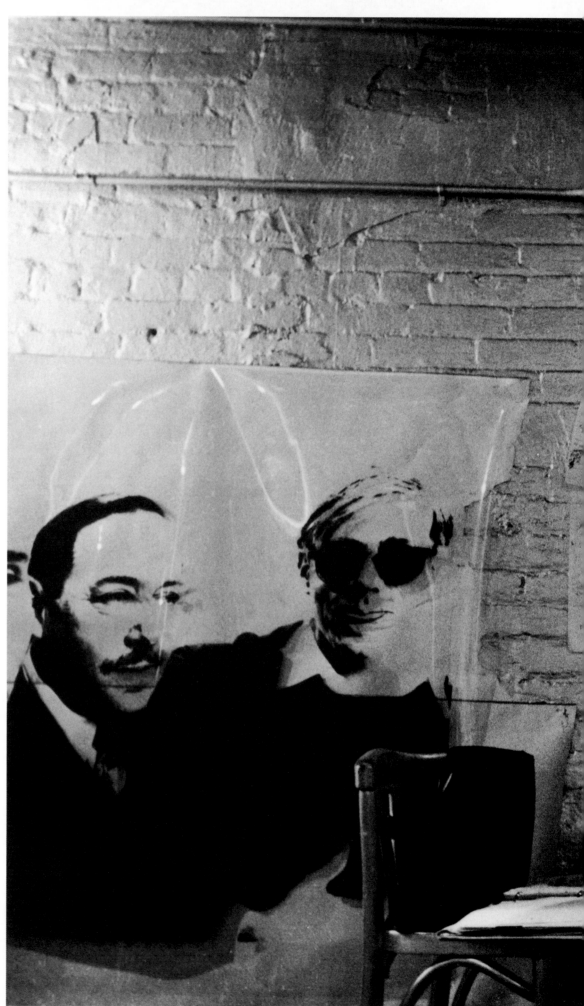

7

8

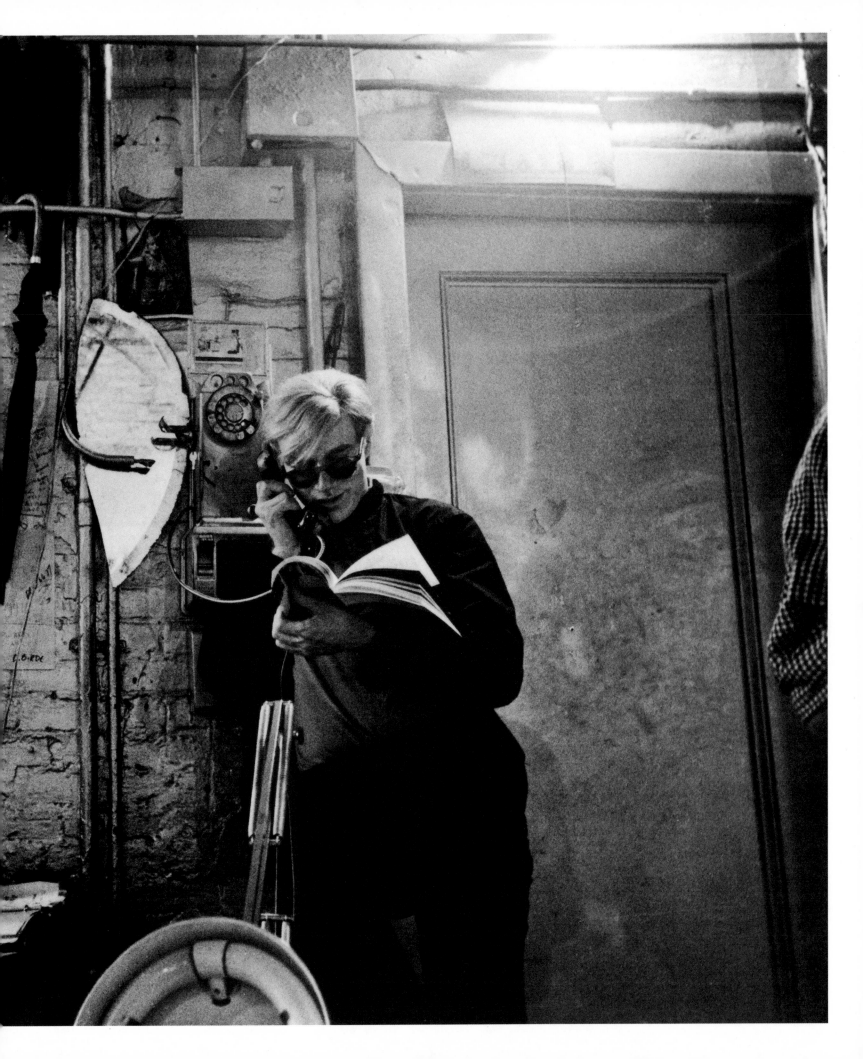

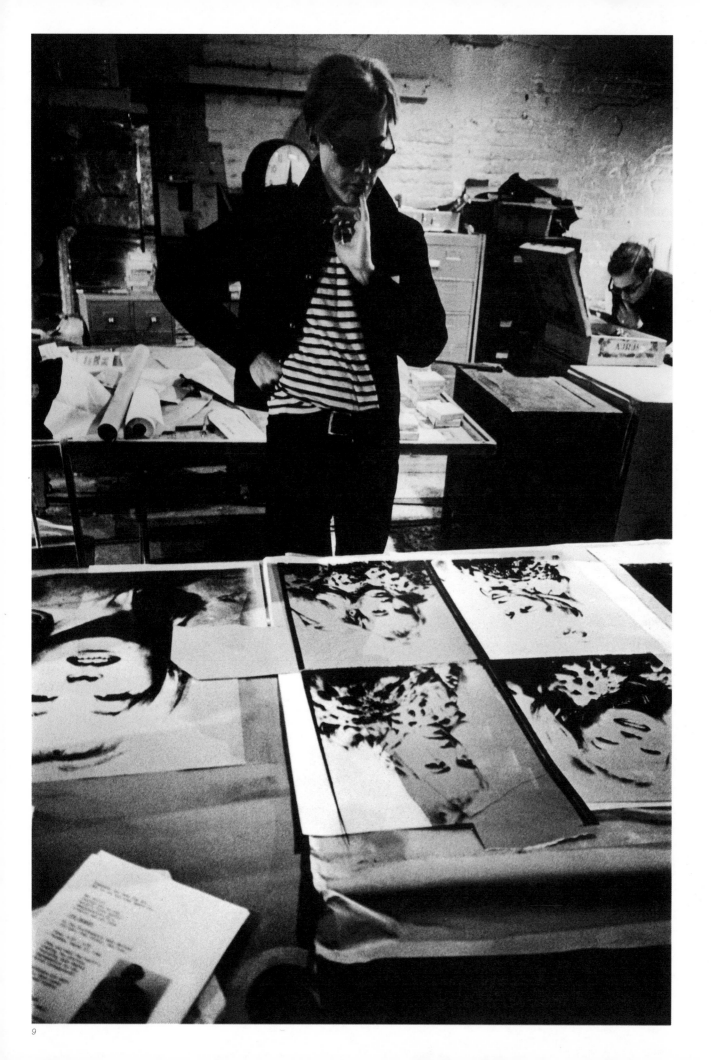

10

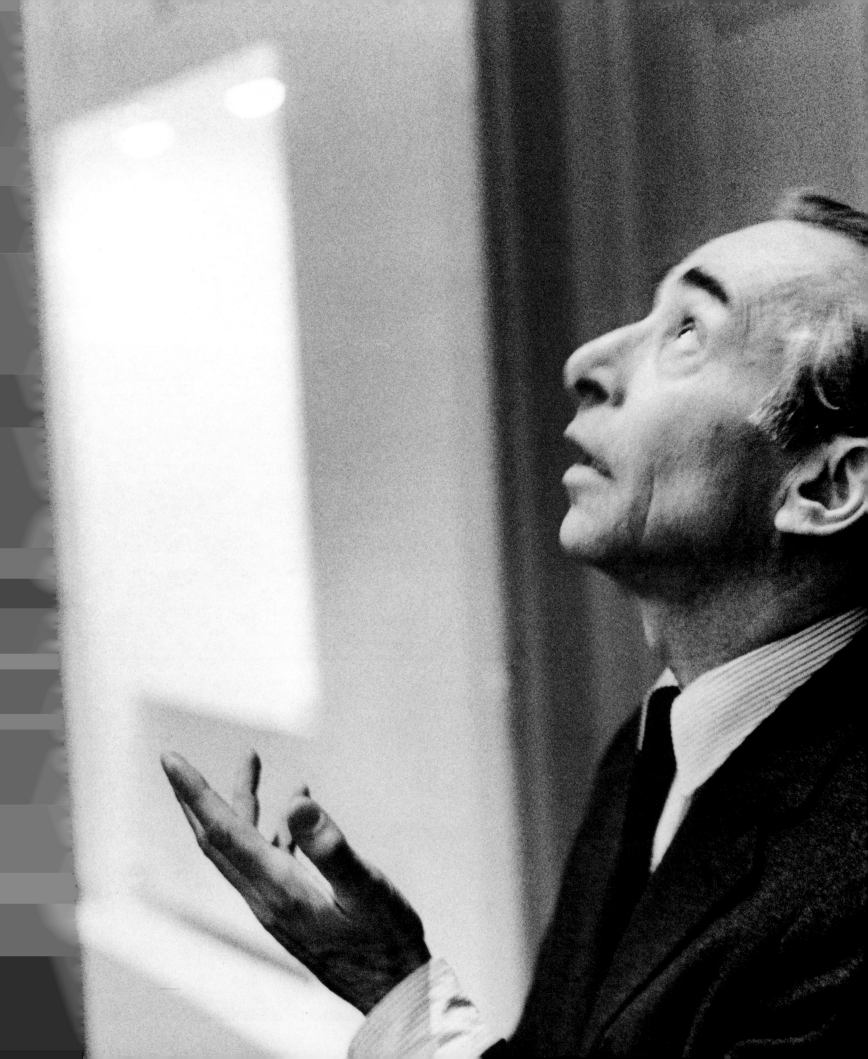

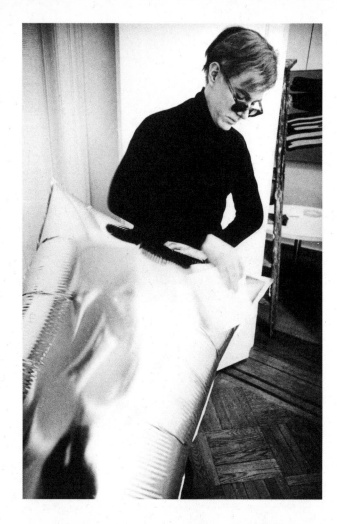 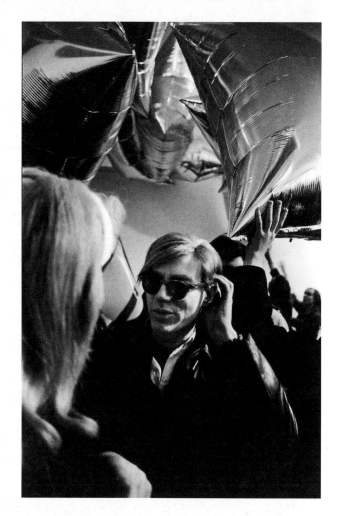

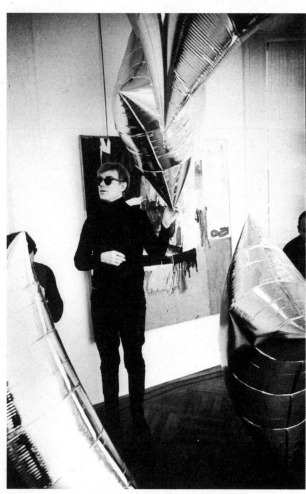 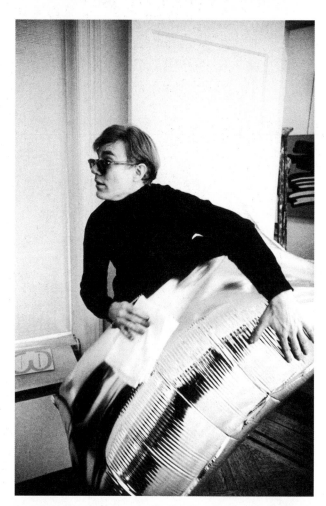

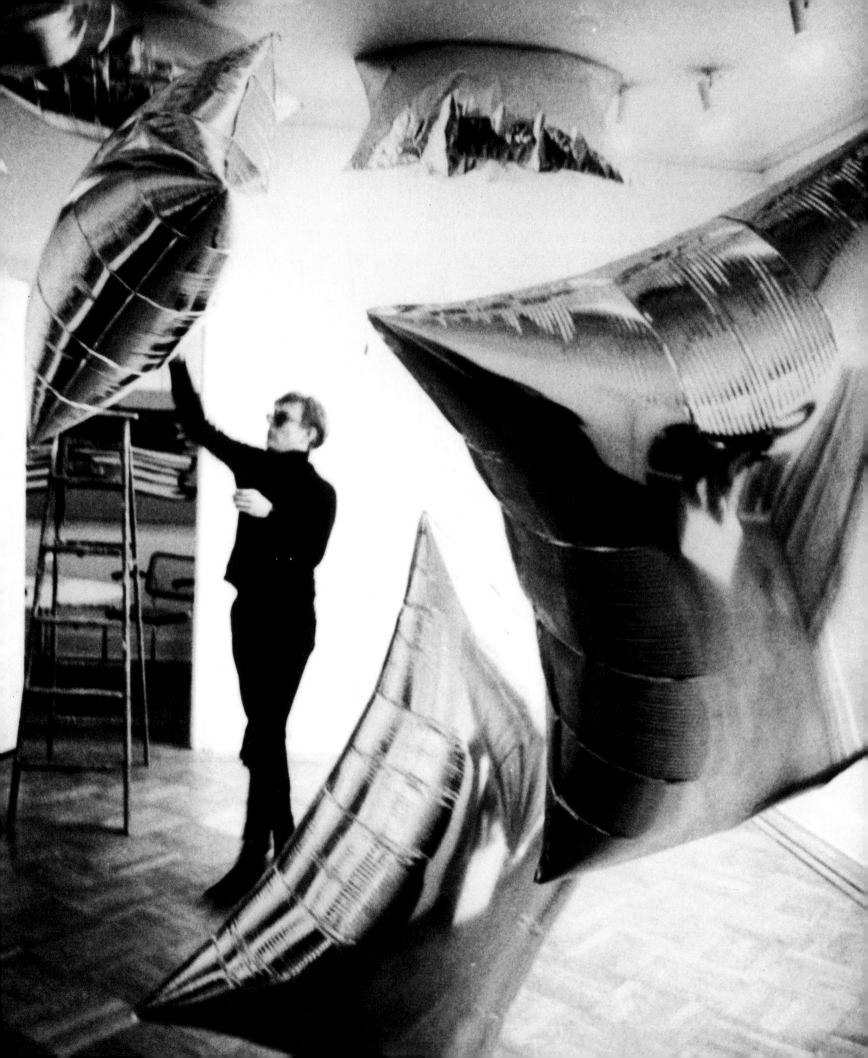

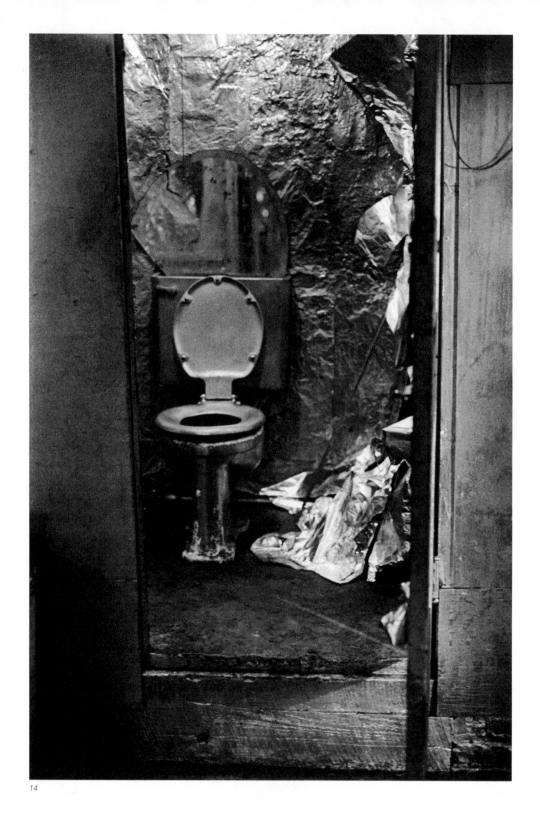

14

15

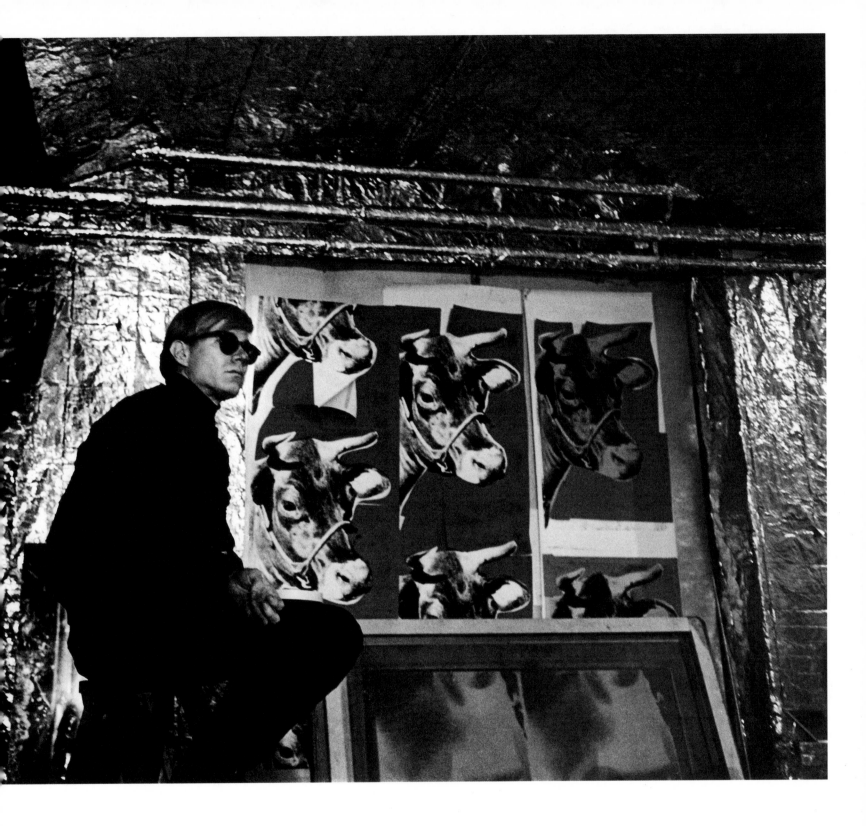

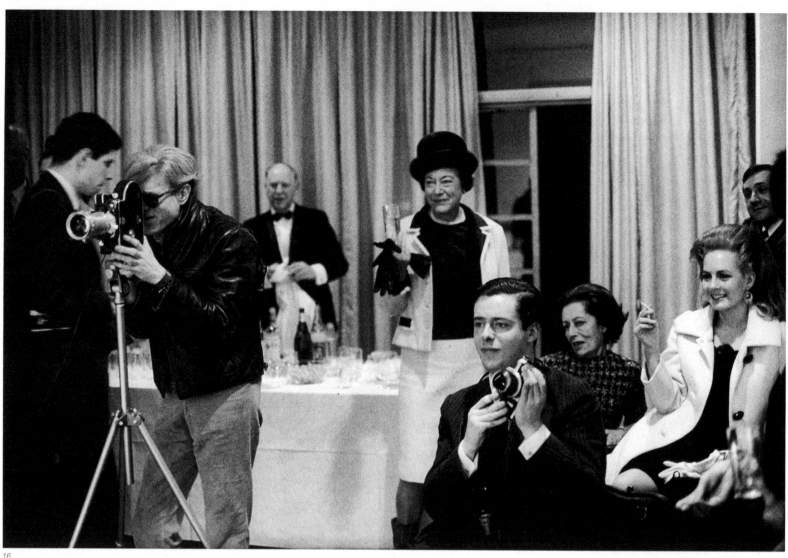

16

FILM MAKING. FROM TIME TO TIME, WHEN OTHER PEOPLE WEREN'T AROUND, ANDY AND I WOULD HAVE THEORETICAL ARTSY-DISCUSSIONS. THE FRAME: WHAT DOES ONE DO WITH THE FRAME, DOESN'T THE FRAME TYRANNIZE YOU, HOW DO YOU GET RID OF THE FRAME? EVEN THOUGH HE ALWAYS SAID HE DIDN'T, OF COURSE HE DID THINK THINGS LIKE THAT, AND GOT OTHER PEOPLE TO HELP CRYSTALLIZE THESE IDEAS. BUT HE ALSO 'JUST DID'. THAT'S EVIDENT WHEN YOU LOOK AT THE EARLY EXPERIMENTAL MOVIES. IF YOUR AMBITIONS ARE TO BE A FILM MAKER — YOU KNOW THAT YOU KNOW NOTHING AT ALL ABOUT IT — AND YOU WANT TO LEARN ABOUT WHAT HAPPENS WHEN LIGHT STRIKES A SURFACE, THERE IS NO BETTER WAY THAN SIMPLY PUTTING A CAMERA ON A SURFACE AND RECORDING IT. MOST OF THESE FILMS ARE GRUESOMELY BORING. IN WESTERN CIVILIZATION, WITH THE PROPER PACKAGING, IT IS QUITE POSSIBLE TO SELL SPECKLED HORSE-SHIT. THE DIFFERENCE BETWEEN ANDY'S MOVIES AND THE OTHER RESULTS OF THE EXPLOSION OF MOVIE-MAKING THAT WAS TAKING PLACE ON THE LOWER EAST SIDE, WAS THAT ANDY WARHOL HAD HIS PUBLIC RELATIONS TEAM. EVERYTHING BEFORE CHELSEA GIRLS WAS ANDY HUSTLING THE GENERAL PUBLIC, HIS GENERAL PUBLIC, INTO FINANCING HIM WHILE HE LEARNED HOW TO MAKE FILMS. THERE IS NO BETTER WAY OF FINANCING YOURSELF THAN BY CALLING YOUR PRODUCTS 'ART', AND GETTING SUBSIDIES FROM PEOPLE TO PAY FOR YOUR FILM AND YOUR CAMERAS... IN THE CAUSE OF ART.

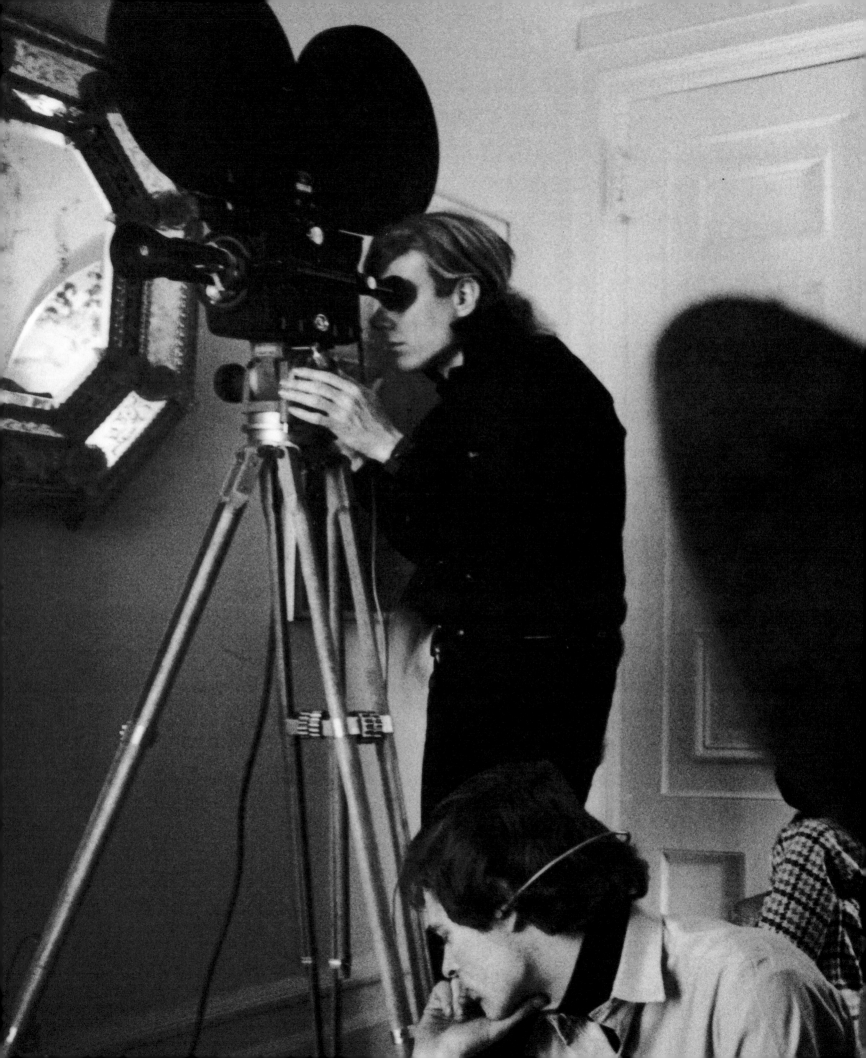

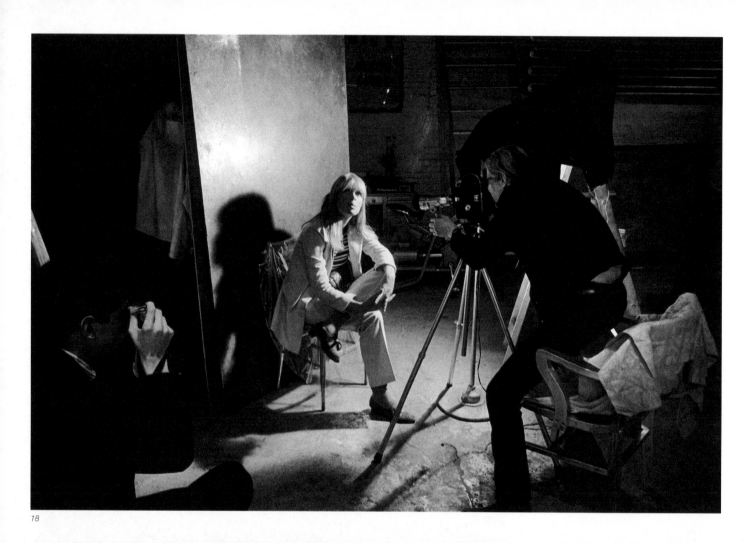

18

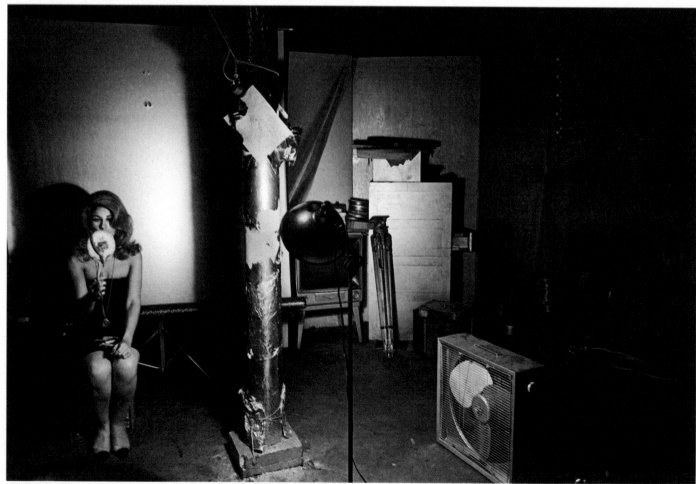

19

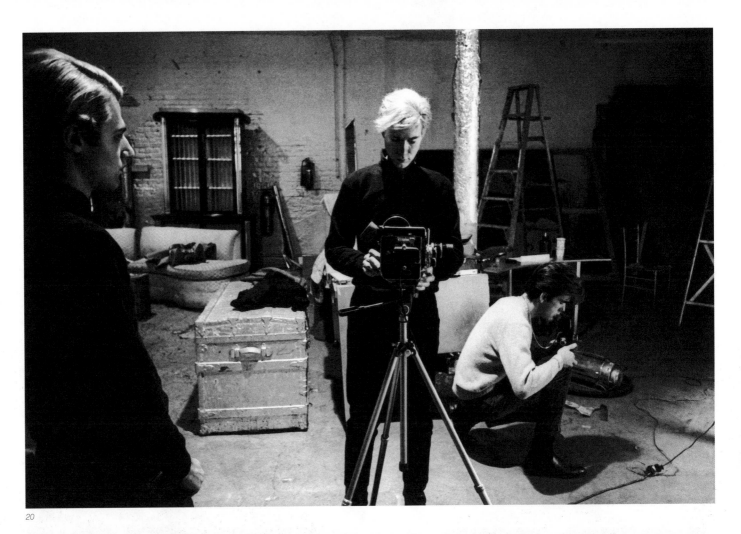

20

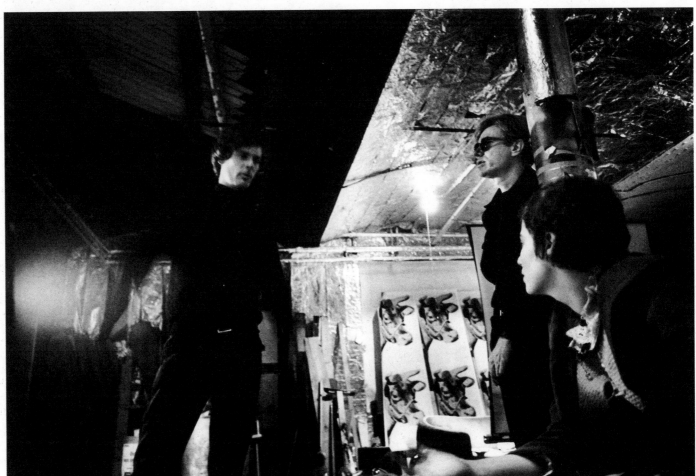

21

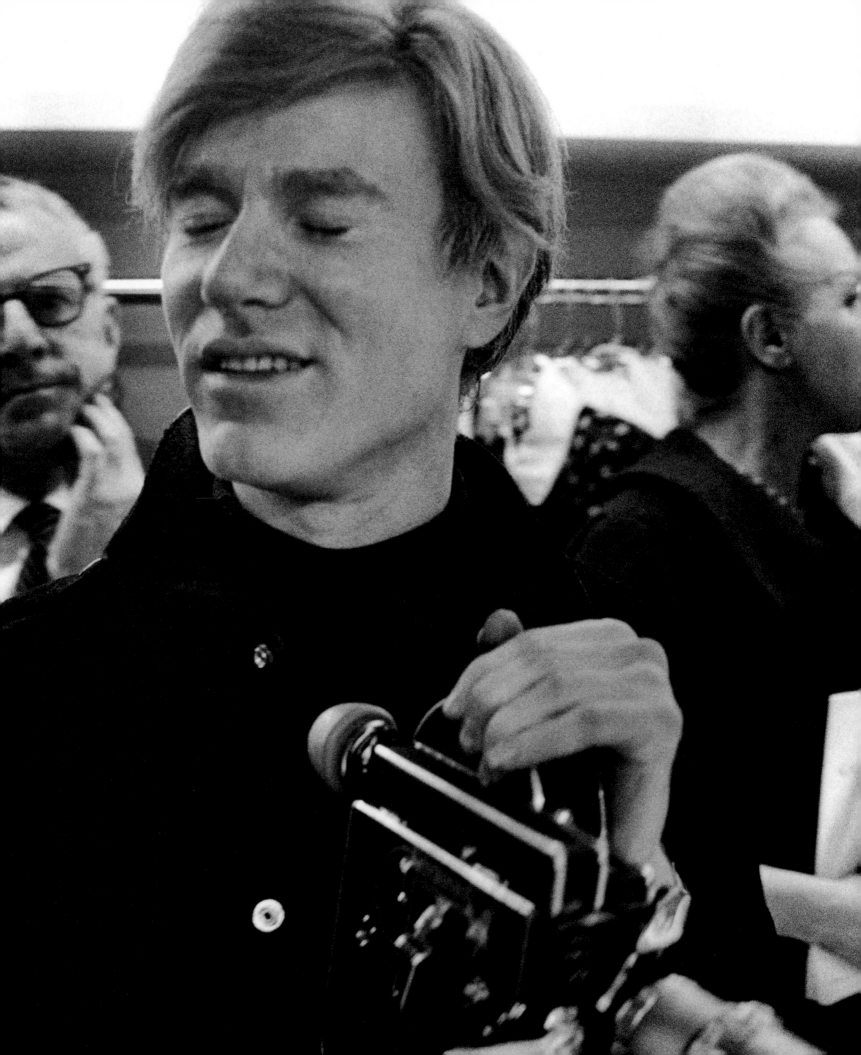

MAKING ART

THE

PSYCHOP

ROLLING

I HAD WRITTEN A PROPOSAL FOR THE ANDY WARHOL INDEX. A PROPOSAL IS WHAT A WRITER USES TO TITILLATE THE PUBLISHER, NOT THE PUBLIC. I DIDN'T EXPECT ANYBODY AT THE FACTORY TO READ IT. ONE DAY I WAS DOING SOMETHING OR OTHER AT THE FACTORY AND EVERYBODY WAS VERY ALOOF. THEN LOU REED WALKED OVER TO ME AND HE SAID, 'THE PSYCHOPATH'S ROLLING STONES, HUH?', WHICH WAS THE WAY I HAD DESCRIBED THEM, BEING CUTE. I THOUGHT HE WOULD LIKE IT. HE WAS VERY SENSITIVE, HAD A DEEP SENSE OF PRIDE, WANTED TO BE REGARDED AS THE BEST. I THINK THOSE WERE THE LAST WORDS THAT LOU REED EVER SPOKE TO ME. LATER THE REPORT CAME BACK TO ME THAT LOU HAD SAID THAT THE THREE WORST PEOPLE IN THE WORLD WERE NAT FINKELSTEIN AND TWO SPEED DEALERS. ABOUT THE UP-TIGHT BOOK HOWEVER, HE TOLD BERT VAN DE KAAP, 'LOUSY TEXT, GREAT PHOTOGRAPHS' – MY PHOTOGRAPHS. JOHN CALE MARRIED BETSEY JOHNSON SHORTLY AFTER I LEFT THE SCENE. I WASN'T INVITED, EVEN THOUGH I DIDN'T VOMIT ON HIS FLOOR AND HE DID ON MINE... SHORTLY AFTER THE MARRIAGE BETSEY DESIGNED GAUNTLET GLOVES WITHOUT FINGERS, SO THAT A JUNKIE COULD PERFORM UNENCUMBERED WITHOUT EXPOSING THE TRACKS ON HIS ARMS.

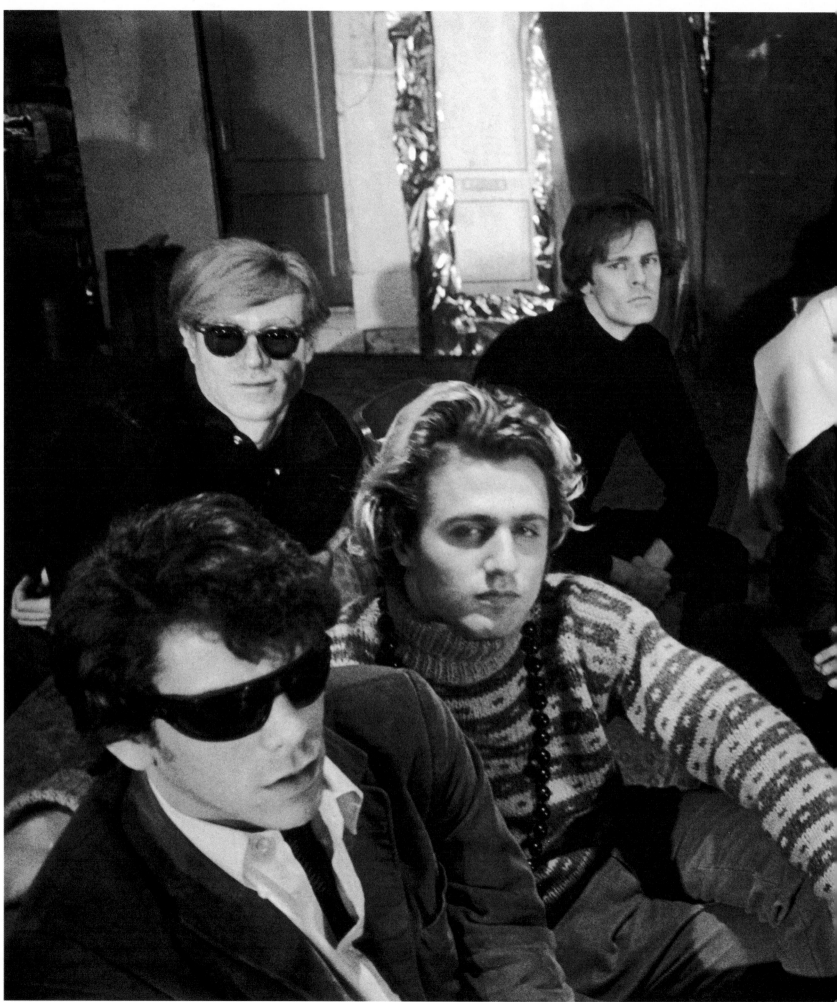

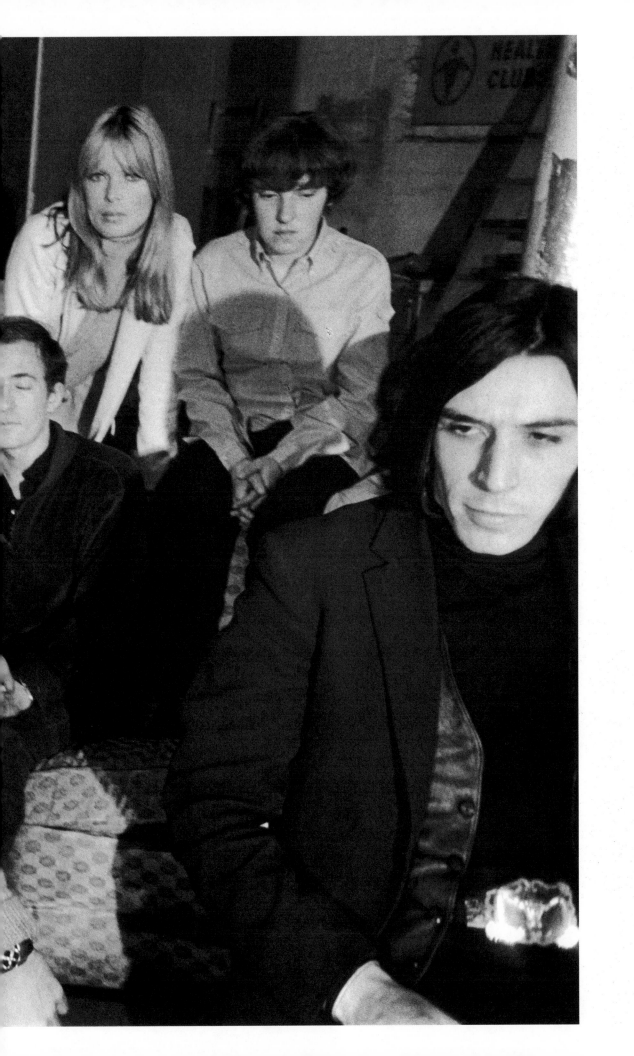

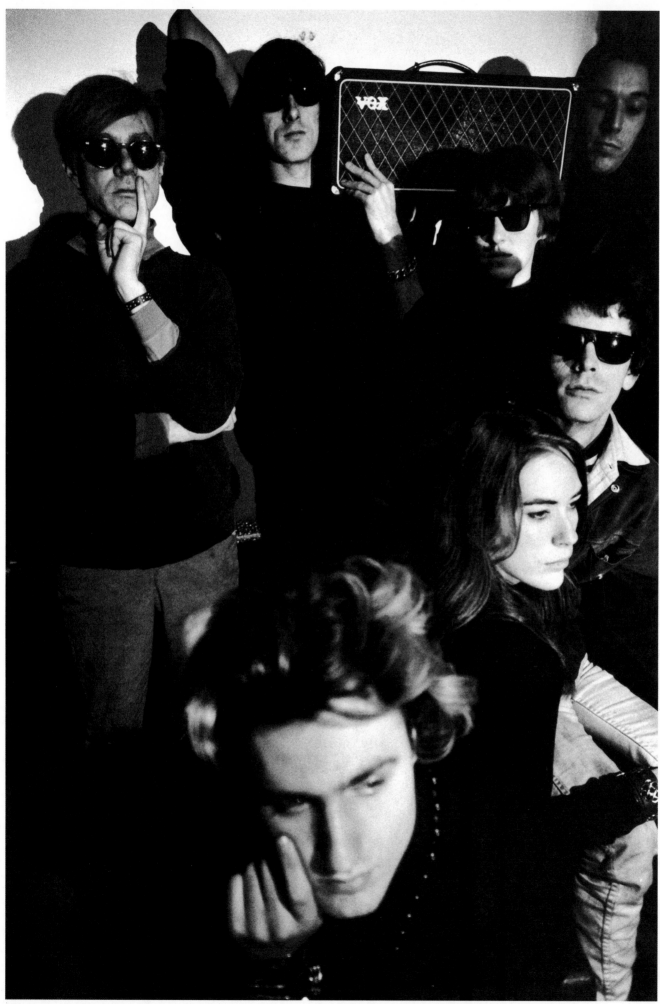

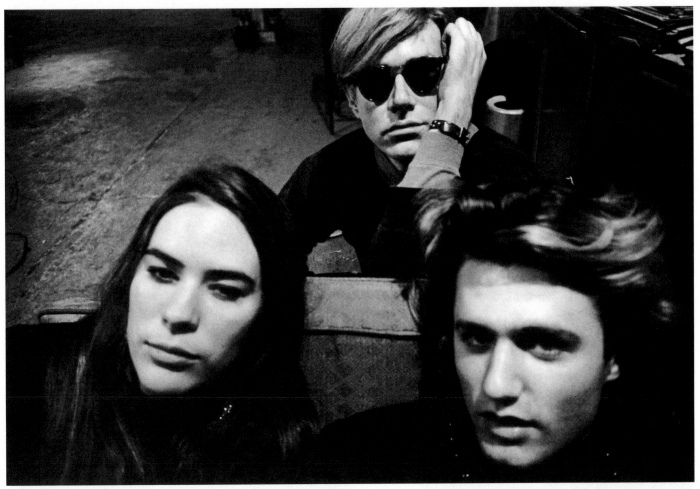

27

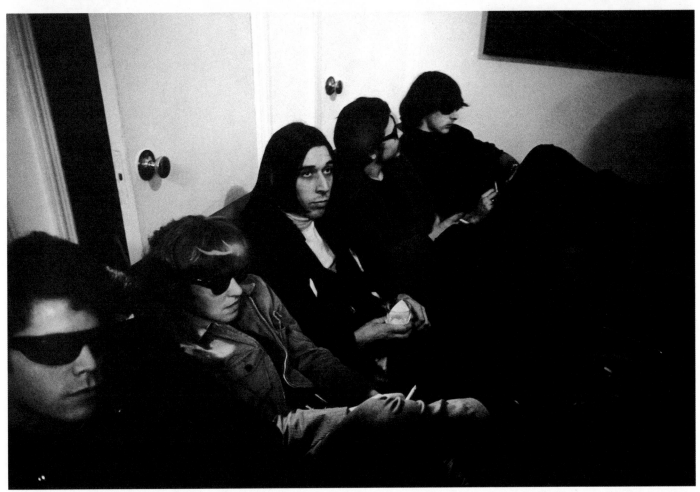

28

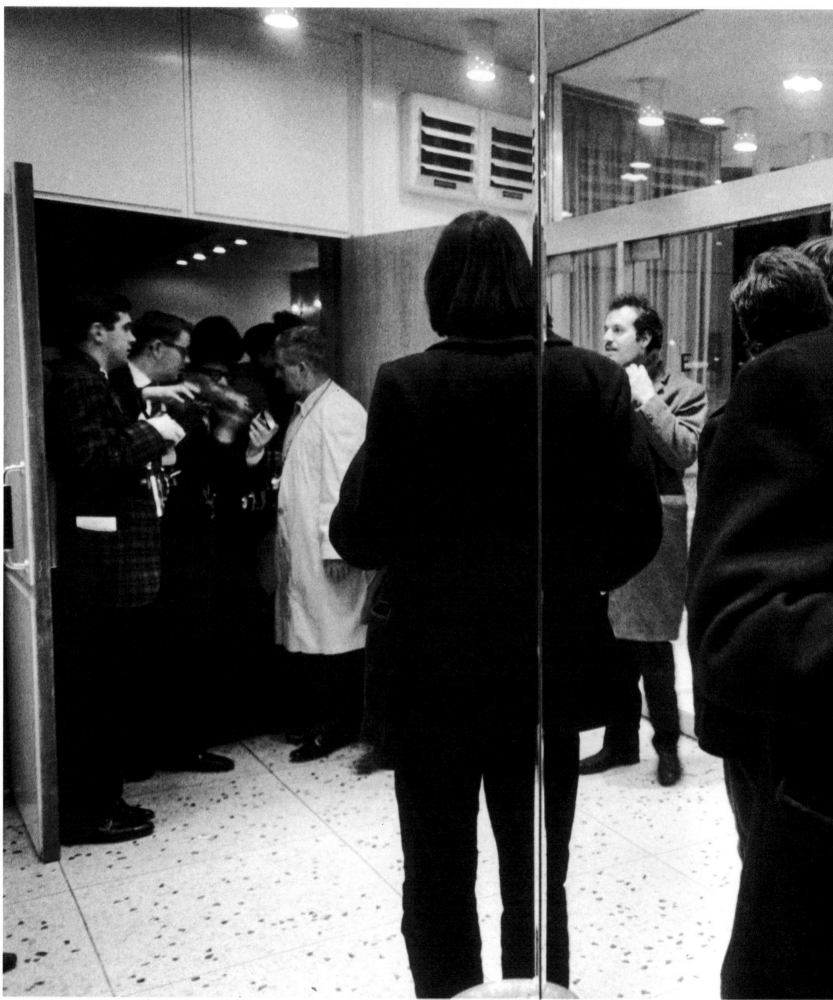

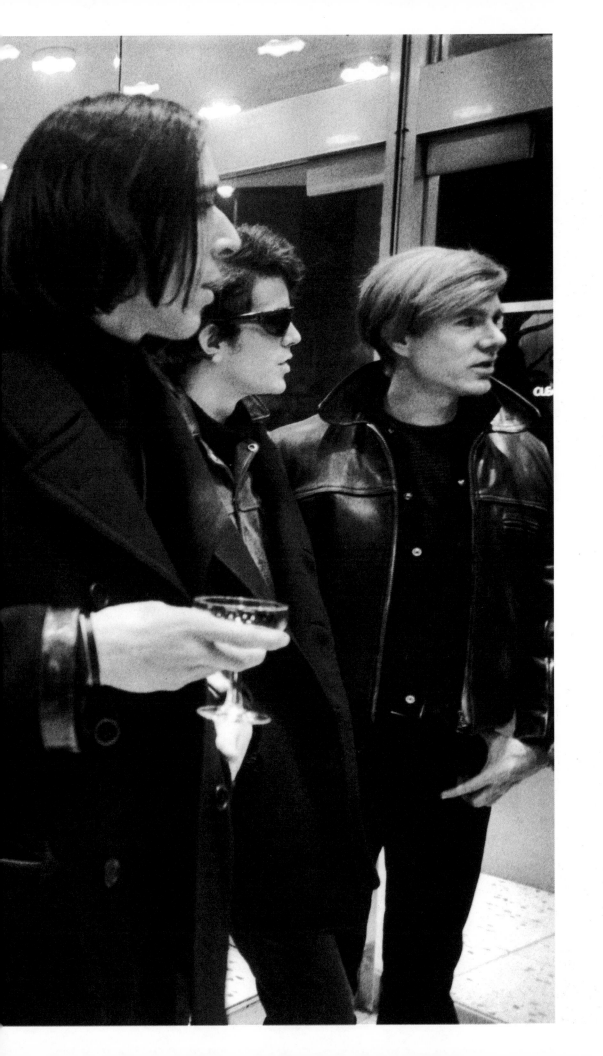

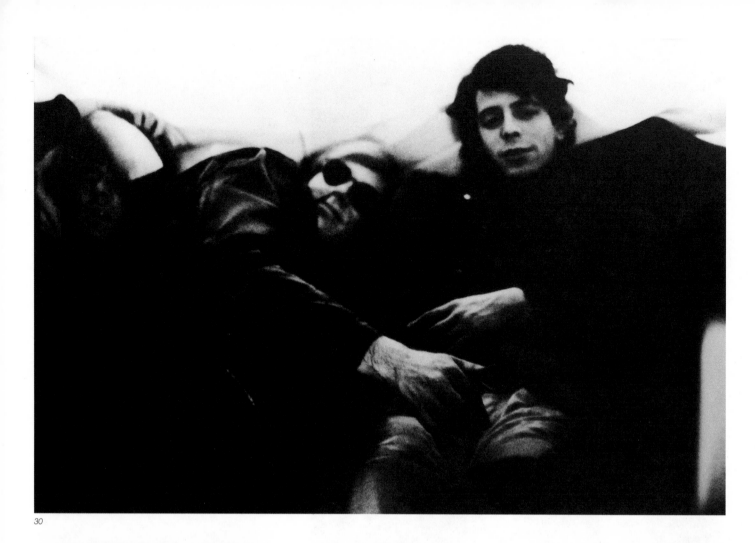

30

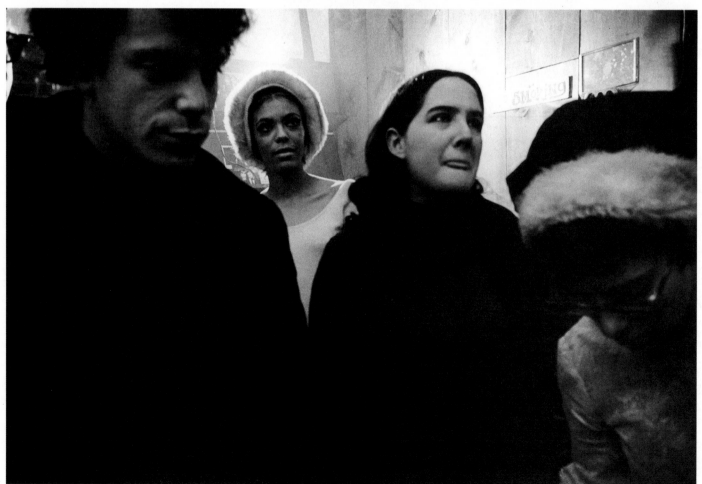

31

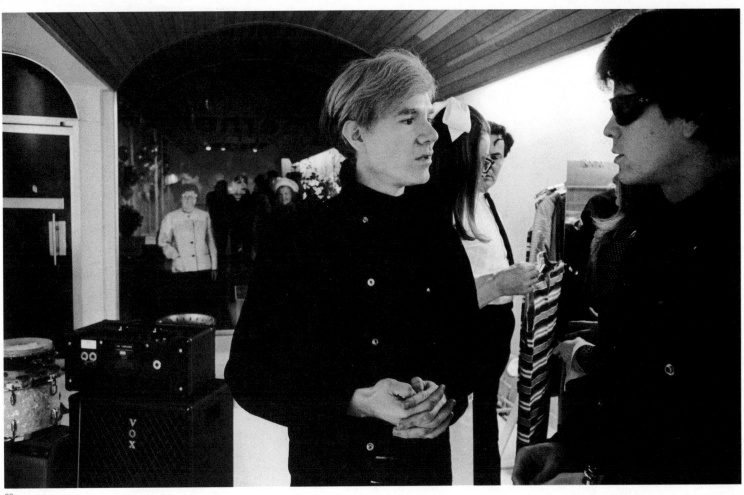

32

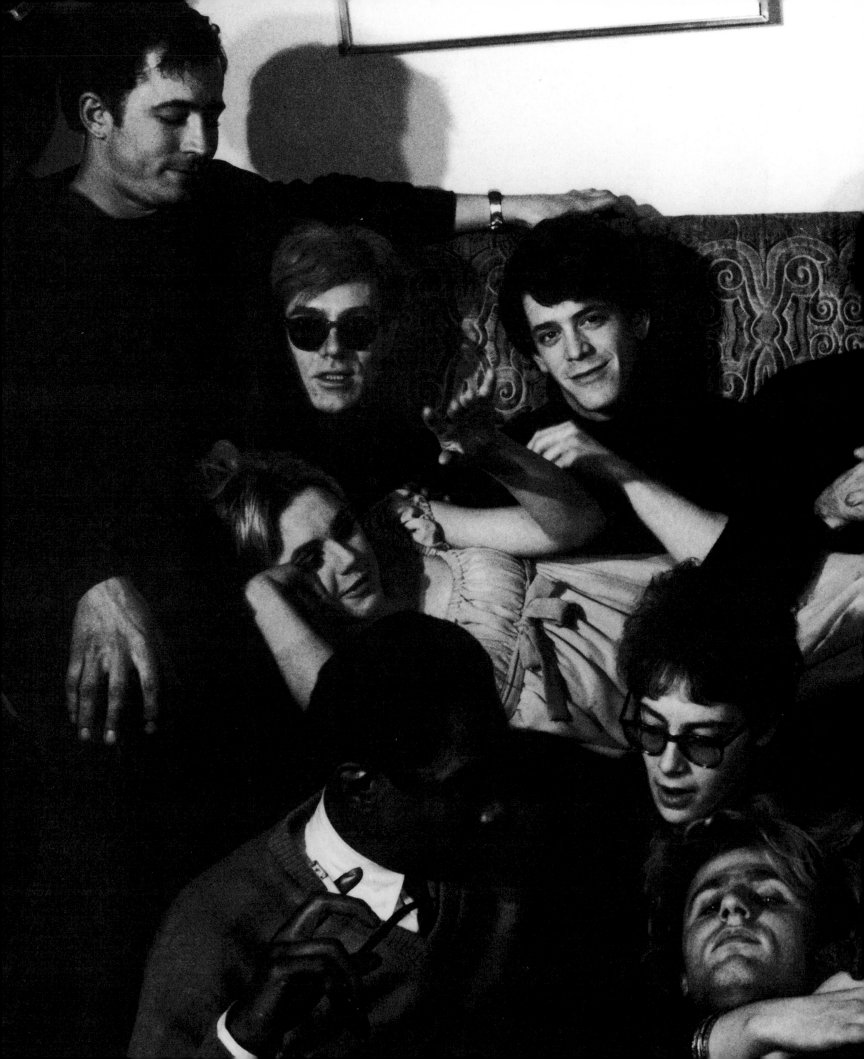

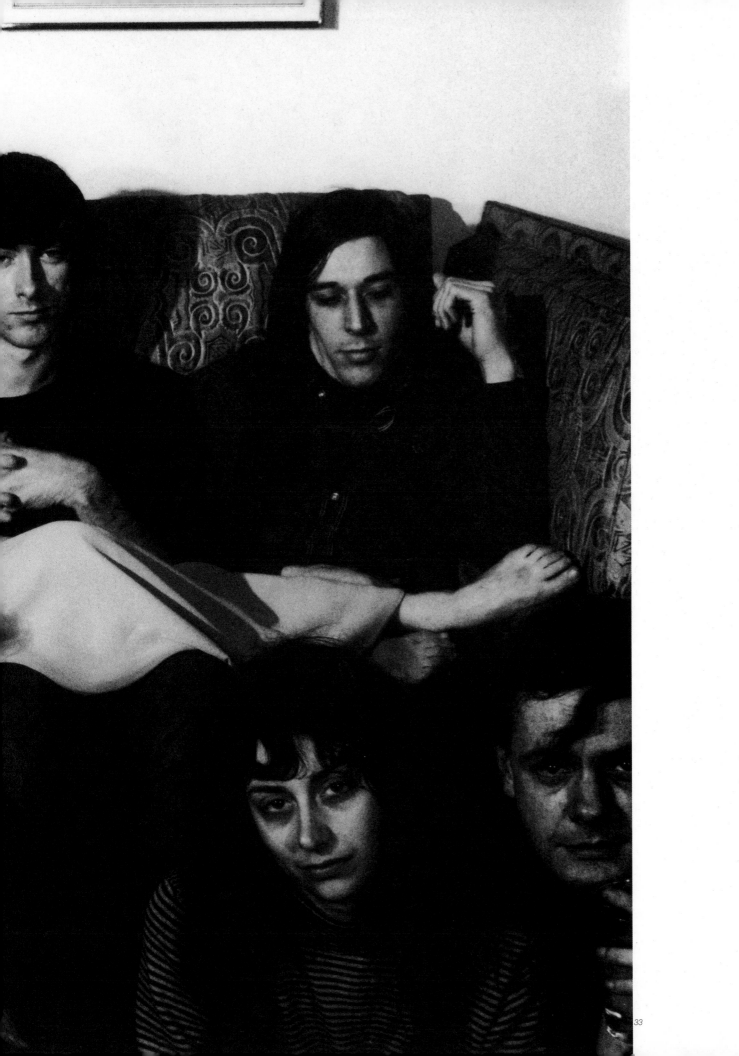

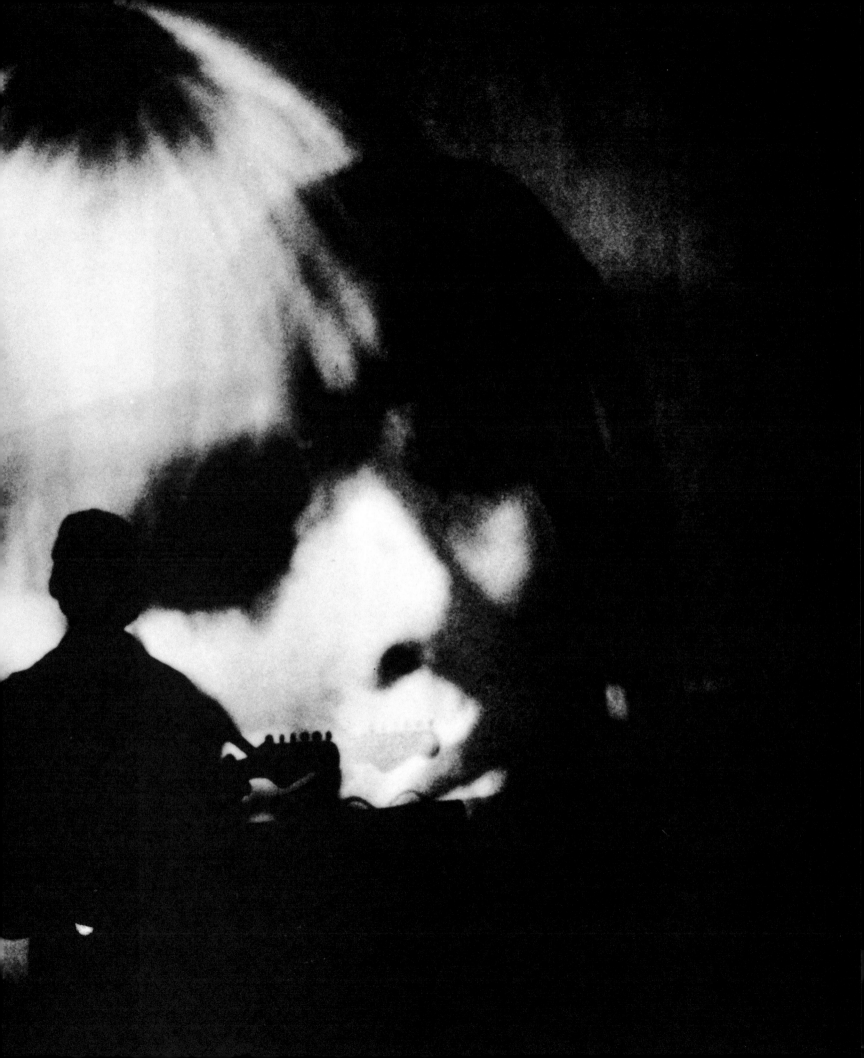

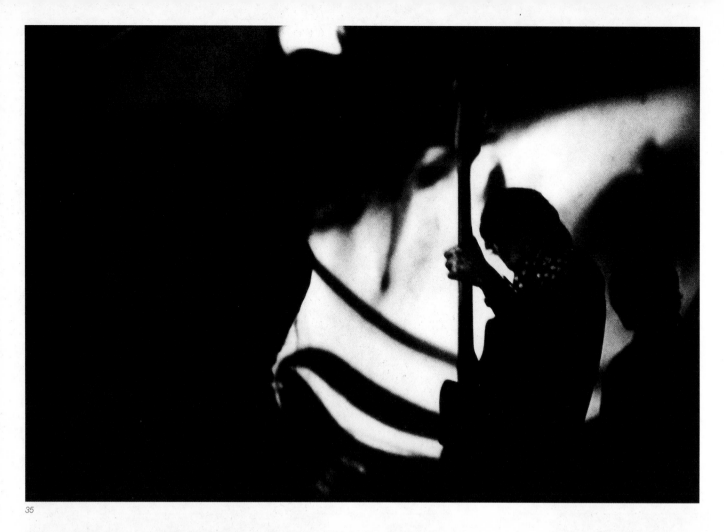

35

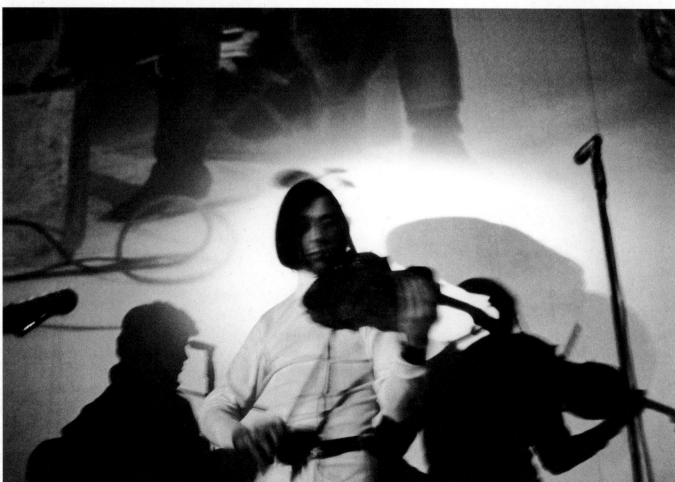

36

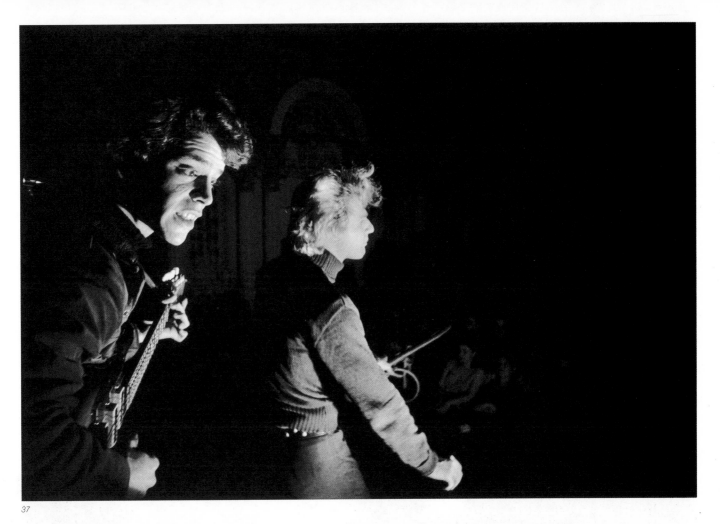

37

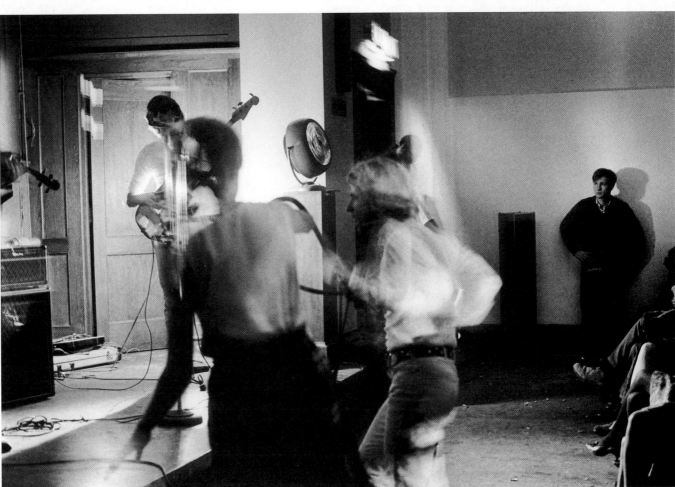

38

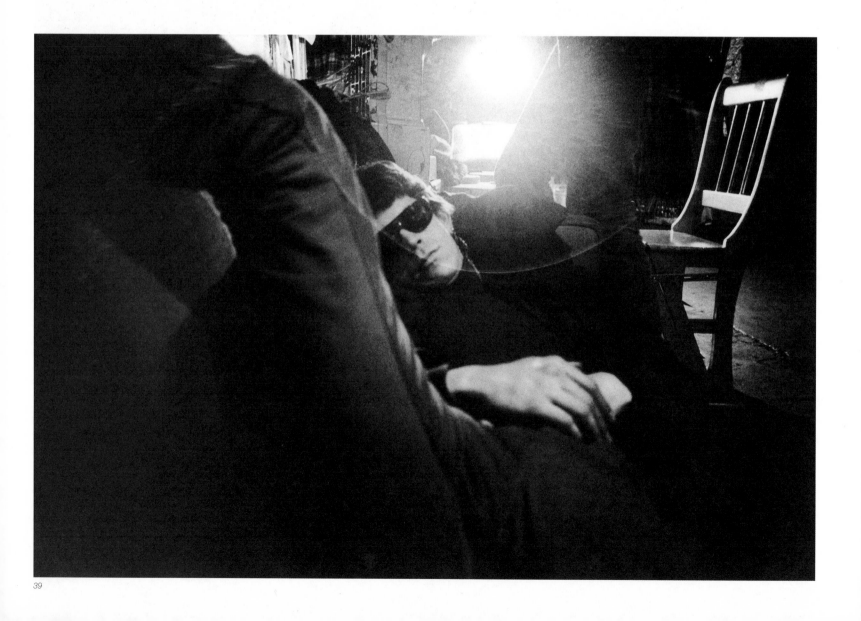

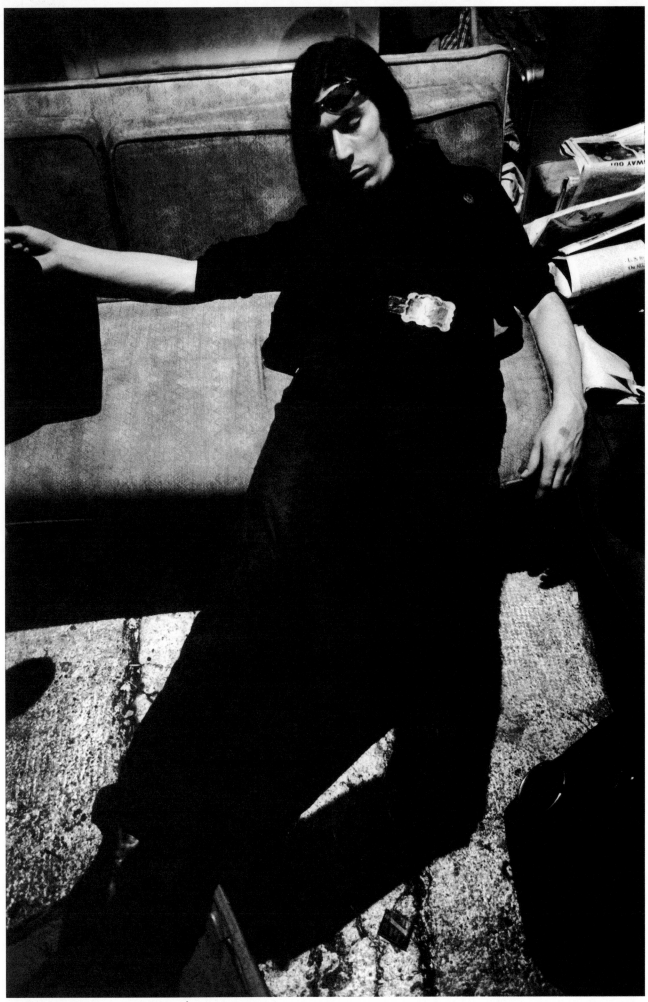

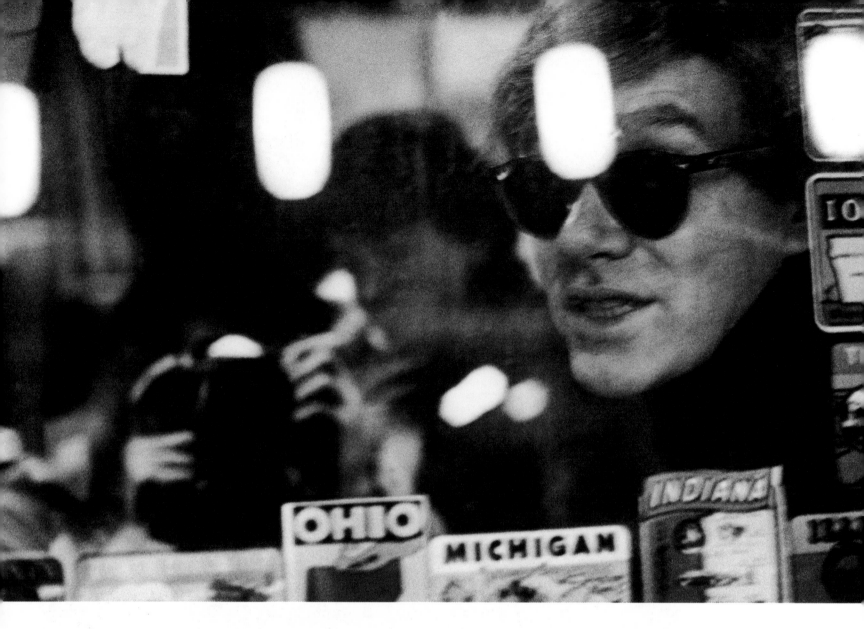

THE
COLOR
PRINTS

IN APRIL OF 1995 A FRIEND CALLED ME, TO TELL ME THAT THEY HAD SEEN SOME OF MY FACTORY PHOTOGRAPHS PUBLISHED IN A JAPANESE MAGAZINE AND WONDERED IF I HAD BEEN PAID FOR THE USAGE. OF COURSE, I HADN'T BEEN AND ACCORDINGLY I SEARCHED OUT THE AGENCY WHICH HAD DISTRIBUTED THE PHOTOGRAPHS — THE TOPHAM PICTURE LIBRARY IN LONDON. I CALLED TOPHAM AND THEY SAID, 'OH, MISTER FINKELSTEIN, WE SEARCHED THE WHOLE WIDE WORLD LOOKING FOR YOU...' (EVERYWHERE EXCEPT YOUR AGENT, PUBLISHERS OR ANY MUSEUM OR GALLERY WHERE YOU EXHIBIT, THAT IS). SO WE MADE ARRANGEMENTS FOR PAYMENT AND THEN THE LADY FROM TOPHAM SAID, 'OH, BY THE WAY, WE ALSO FOUND 170 COLOUR TRANSPARENCIES WHICH YOU SHOT AT THE FACTORY AND WERE MISFILED UNDER THE WRONG NAME — DO YOU WANT THEM?'

ONE YEAR LATER FOUND ME AT THE ANDY WARHOL MUSEUM IN PITTSBURG, SHOWING THE LOST AND FOUND TRANSPARENCIES TO THE MUSEUM ARCHIVIST, JOHN SMITH. 'AHA,' HE SAID, 'SO IT IS YOU.' JOHN WENT TO A DRAWER AND PULLED OUT A SMALL PACKET OF SEVEN TRANSPARENCIES FROM THE SAME SHOOTINGS. 'WE FOUND THESE AMONGST ANDY'S PERSONAL COLLECTION. DO YOU WANT THEM?' AND HERE THEY ARE.

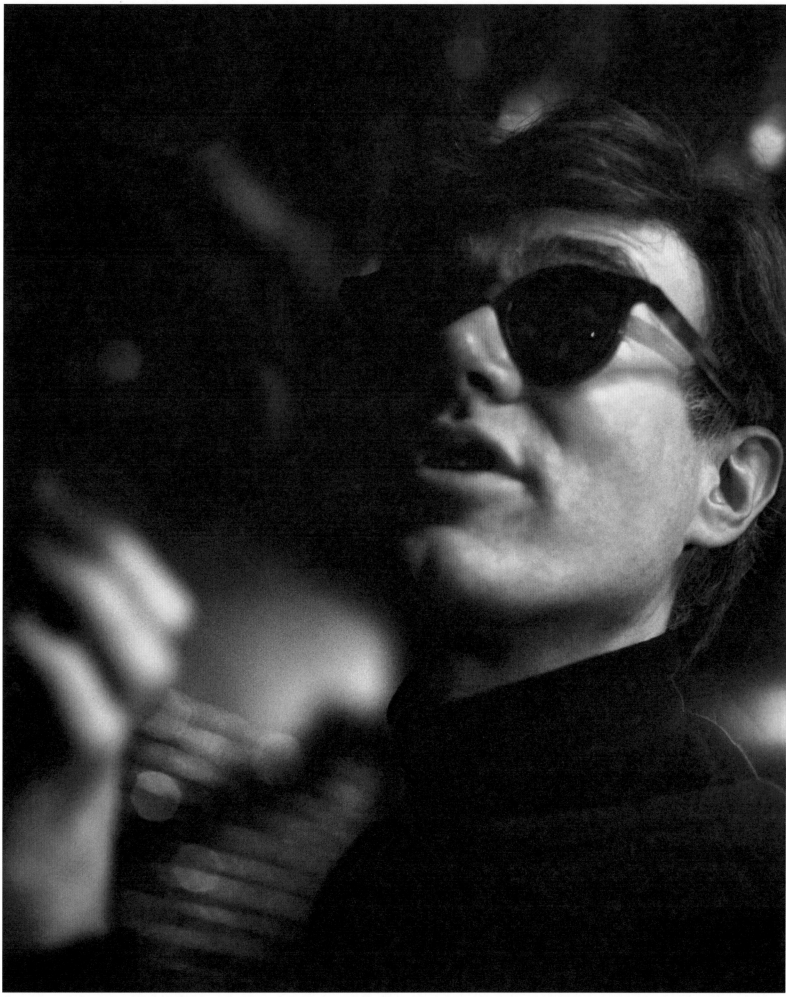

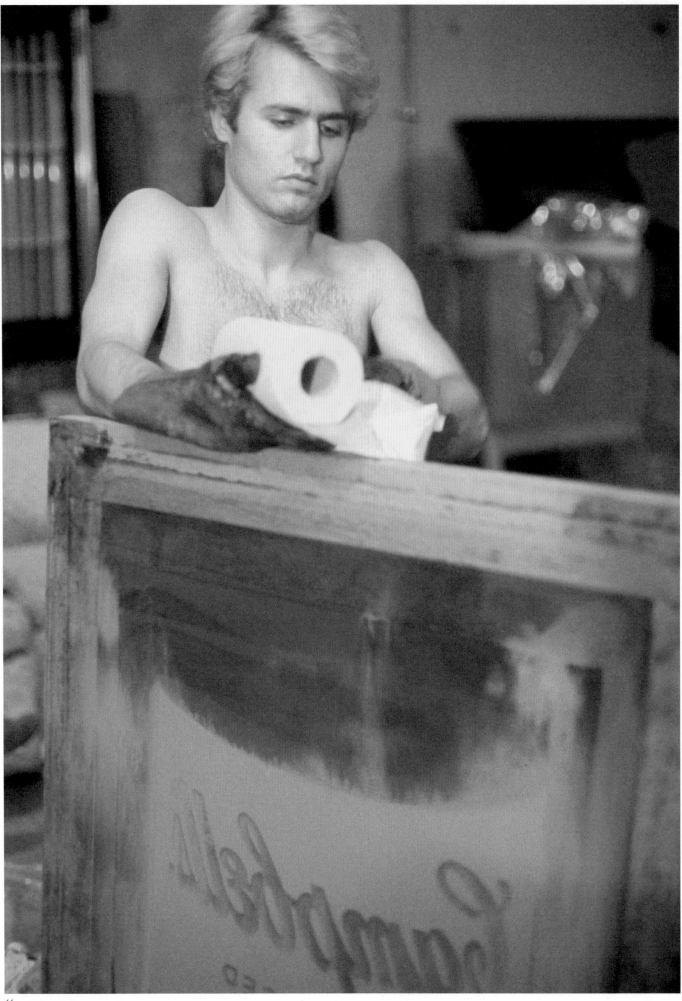

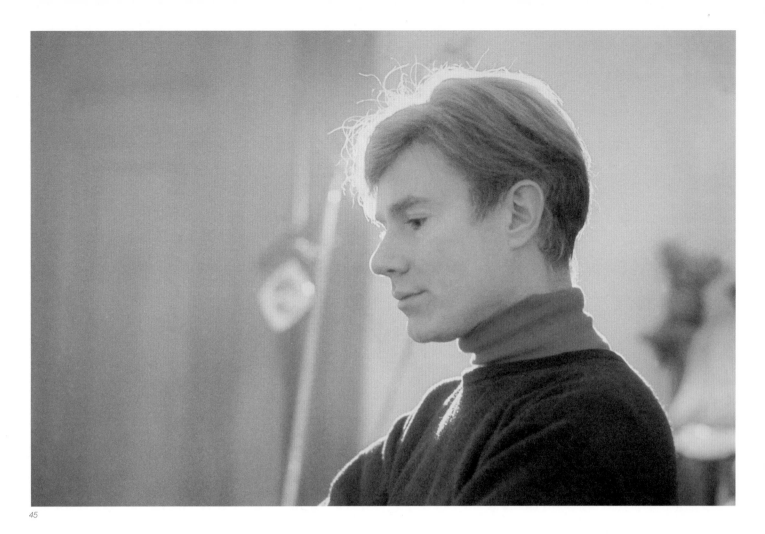

45

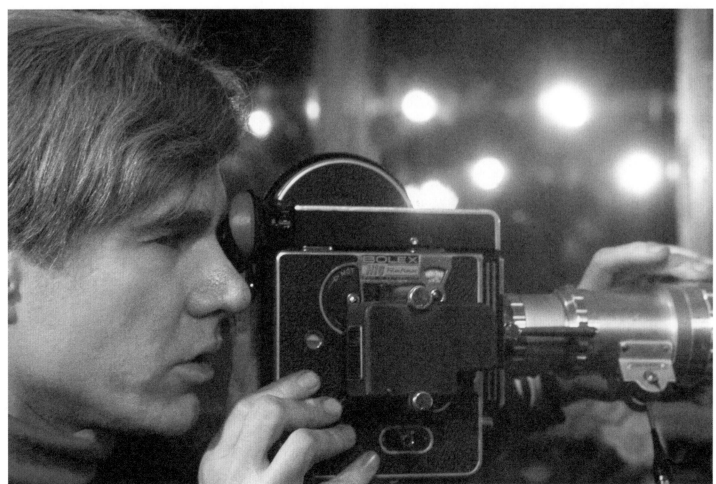

46

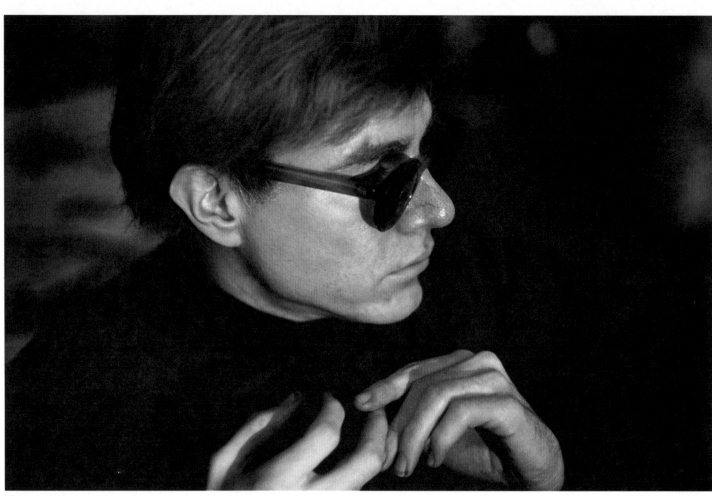

47

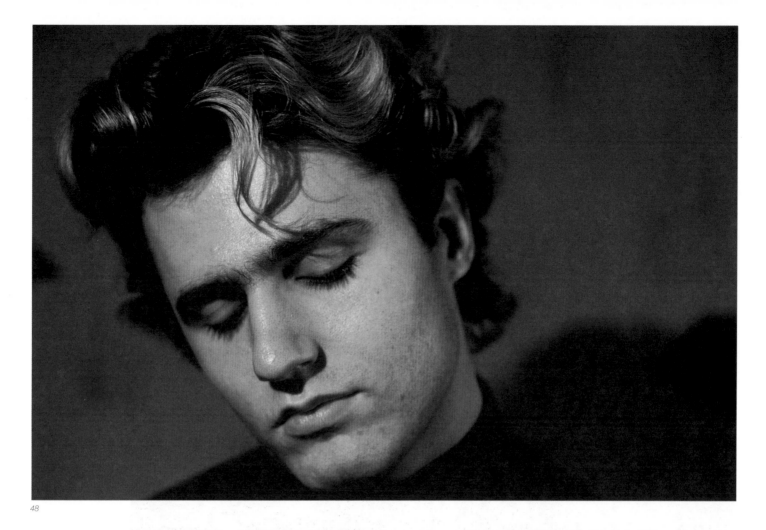

48

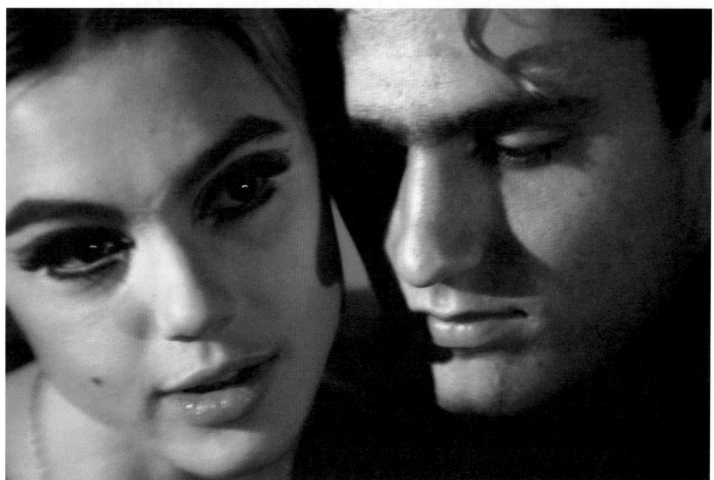

49

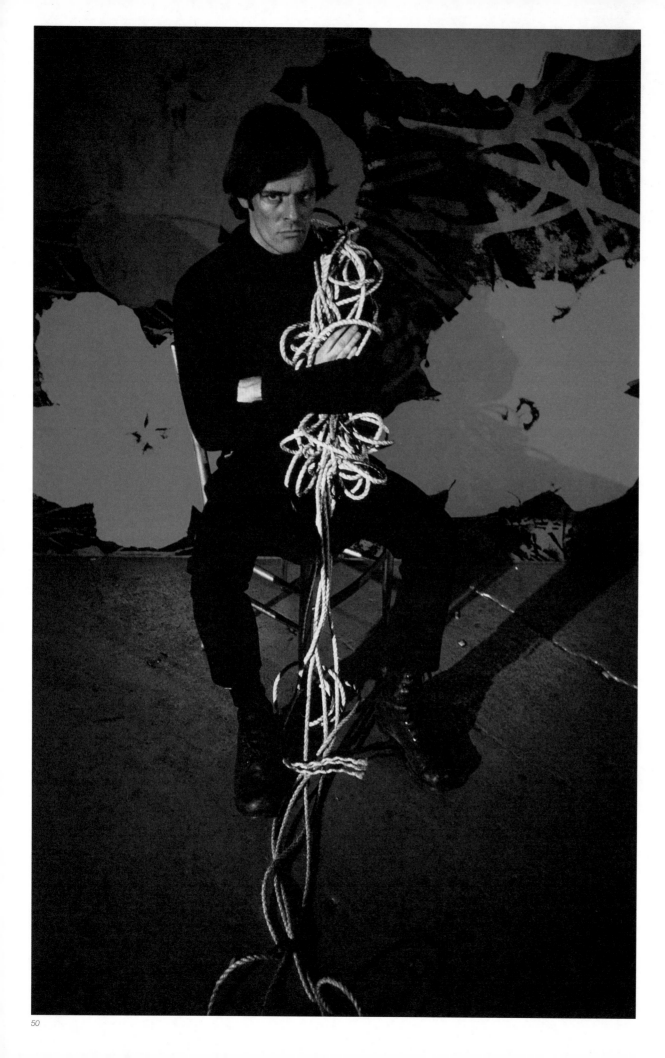

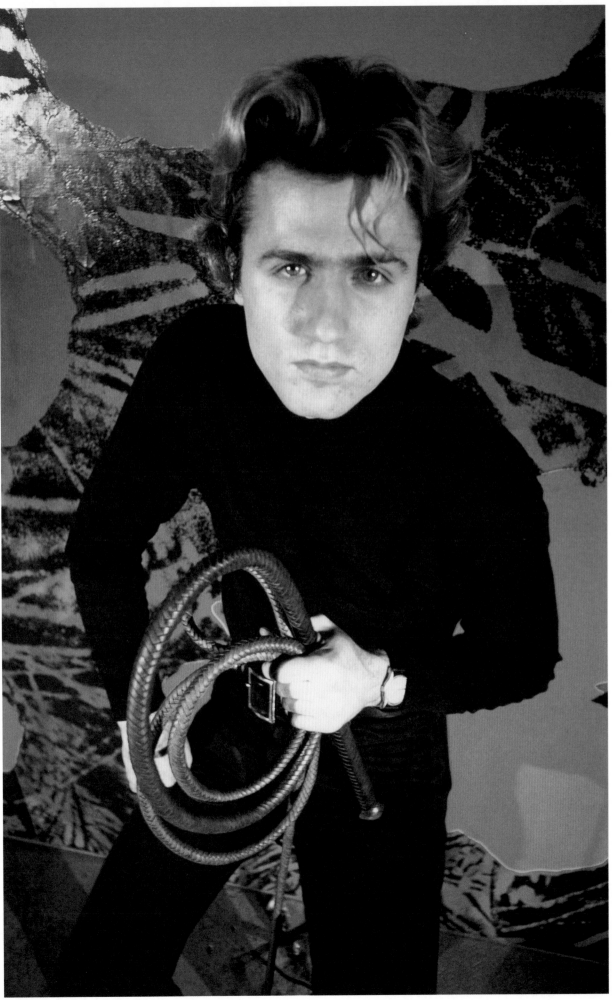

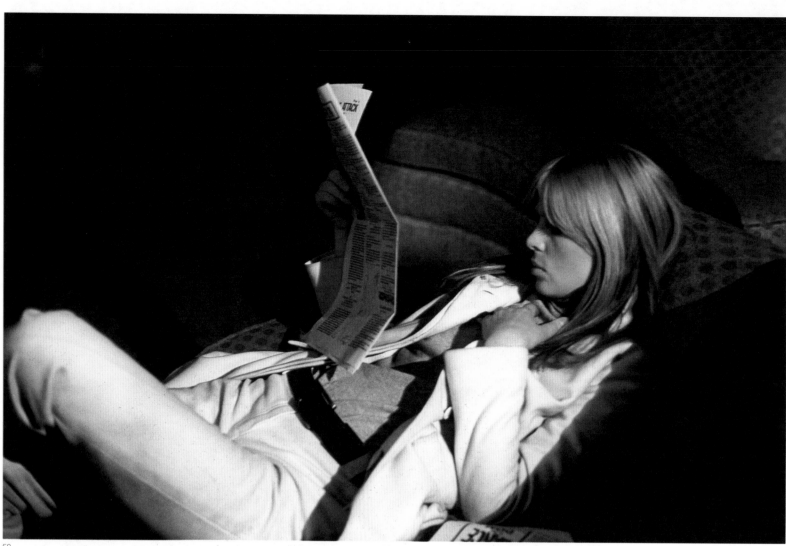

52

53

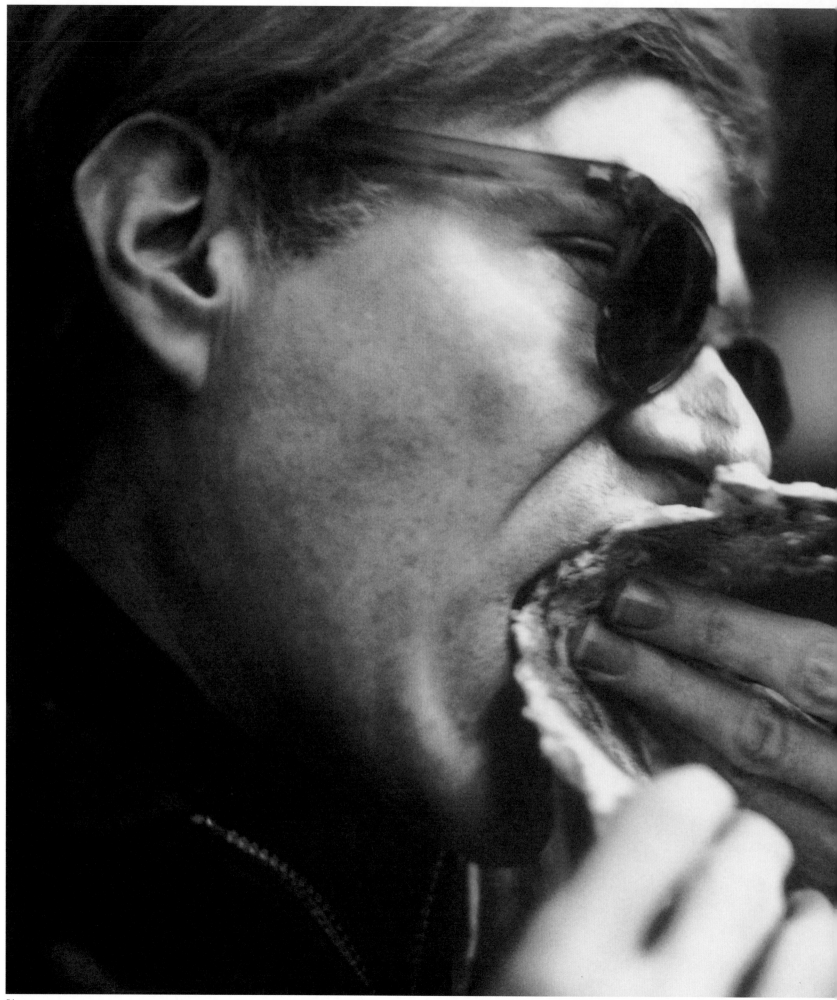

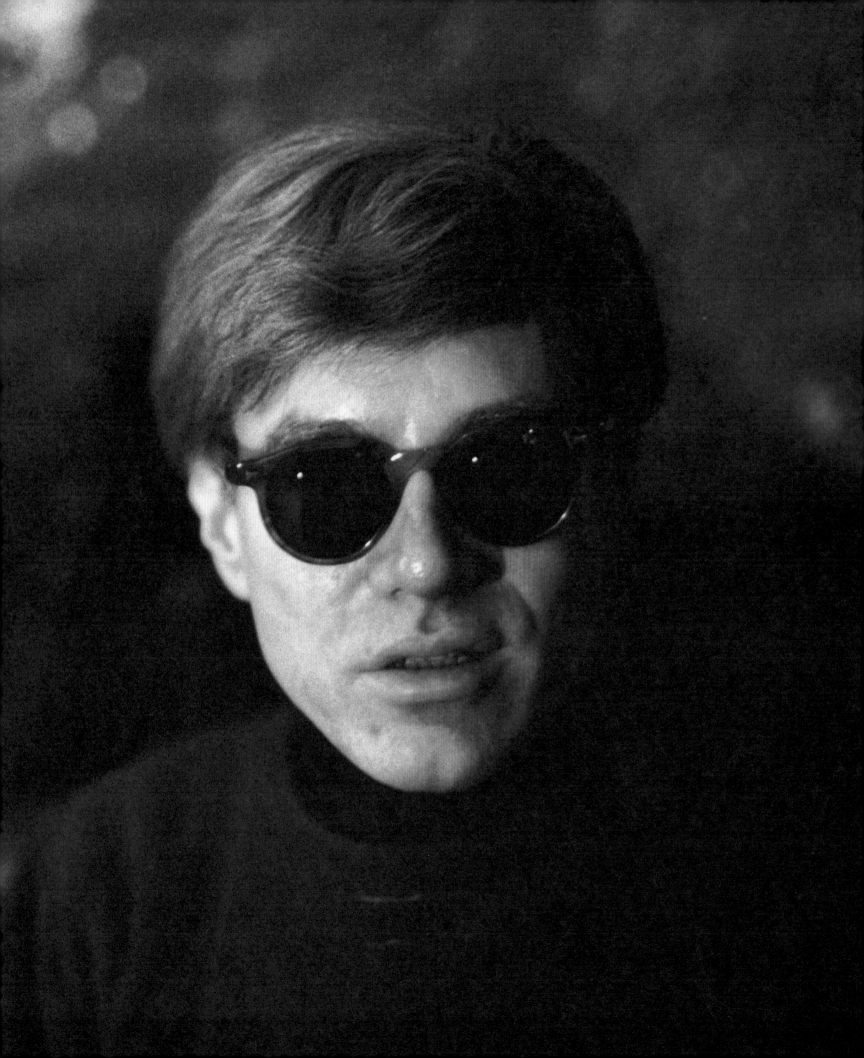

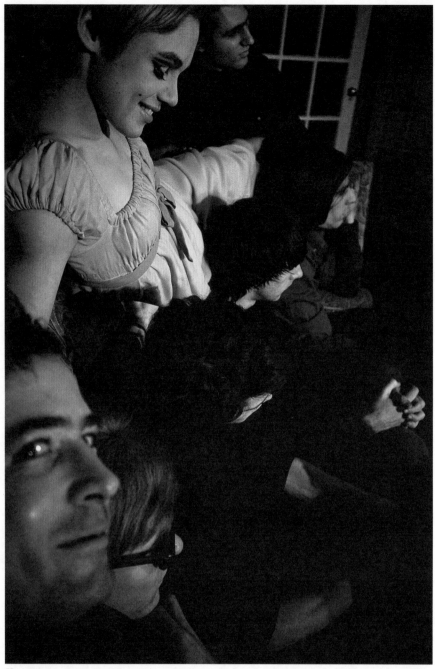

56

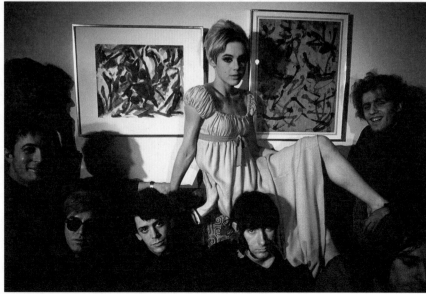

57

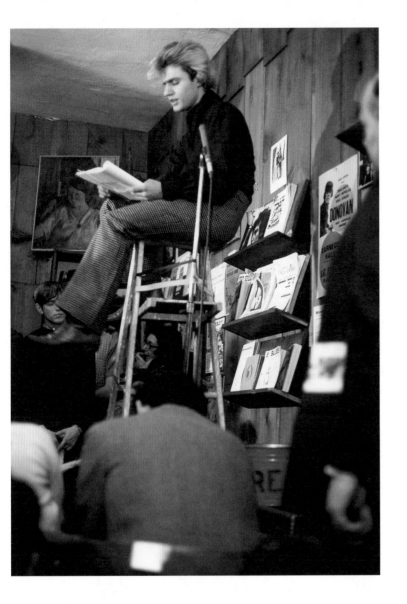

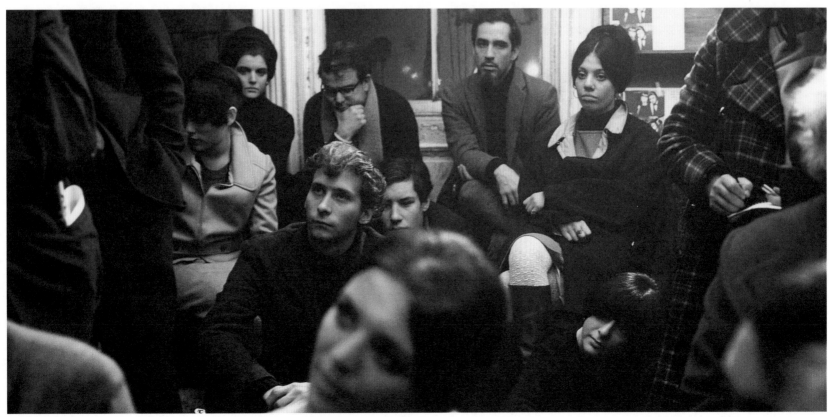

EDIE. SHE WAS THERE, I WAS LIKE A MIRROR PASSING THROUGH HER HOUSE. I ARRIVED, AND THERE WAS HIS FAMILY AND THERE WAS THIS GIRL NAMED EDIE SEDGWICK, A MEMBER OF THE FAMILY. AND SHE WAS PRETTY, AND SHE WAS FUN, AND SHE WAS SICK — SO MAYBE, MAYBE… BUT MAYBE NEVER CAME. I REMEMBER ONE NIGHT I SPENT WITH HER AT HENRY GELDZAHLER'S PLACE. THIS WAS IMMEDIATELY BEFORE SHE WENT OUT AND HAD HER BATTLE WITH ANDY. AS A MATTER OF FACT IT WAS THE SAME NIGHT. I SPENT THE WHOLE NIGHT WITH EDIE… OF COURSE I WAS THINKING OF SEX, SHE WASN'T. SHE TAUGHT ME A LOT OF THINGS: SHE TAUGHT ME WHERE TO BUY EXPENSIVE WINE LATE AT NIGHT, SHE POINTED OUT THE BEST SOULFOOD PLACE IN MIDTOWN MANHATTAN. WE TALKED ABOUT CLOTHING AND ABOUT ALL HER PARTICULAR PERSONAL PROBLEMS. SHE COMPLAINED ABOUT MONEY, SAID SHE WASN'T LIVING TOO WELL. MEANWHILE WE WERE DRINKING CHÂTEAU MARGAUX. SHE CAME FROM A RICH FAMILY, BUT LIKE ALL OTHER RICH PEOPLE SHE WOULDN'T LET YOU KNOW ABOUT HER FINANCES. RICH PEOPLE ARE ALWAYS BROKE, THE CAPITAL ITSELF IS THE OBJECT. SHE COMPLAINED THAT WITH ALL THIS SHIT OF 'ART FOR ART'S SAKE', SHE WASN'T GETTING ANY MONEY OUT OF HER PART IN THE ART. GOD! EDIE WAS BORING. SHE HAD A BEAUTIFUL BODY, WHOOP TI DOO, BUT THAT WAS ALL. LIKE MOST OF THE GIRLS AT THE FACTORY, THERE WASN'T ANYTHING REAL ABOUT EDIE. SHE WAS SIMPLY SIGNS AND SYMBOLS. SHE WAS SPOILED IN EVERY SENSE, A CHILD OF THE HAUTE BOURGEOISIE, WITH NO THOUGHT IN HER HEAD AT ALL EXCEPT EDIE. EDIE WAS SLUMMING: RICH DOWNTOWN PEOPLE GETTING IN THEIR CAR AND DRIVING UP TO HARLEM TO SCORE, PRETENDING THEY WERE IN THAT SCENE. THEN THE SCENE JUMPED UP AND BIT HER IN THE ASS. EDIE WAS ANOTHER ONE OF THESE LITTLE RICH KIDS WHO CAME DOWN TO WHERE IT WAS TOO ROUGH FOR HER TO PLAY… SO SHE LOST THE GAME. SHE WOUND UP DESTROYED, DYING A JUNKIE-DEATH. SHE WAS A REPRESENTATIVE OF SOMETHING SO SELFISH AND SO SUPERFICIAL THAT THE ONLY THING SHE WAS ABLE TO DESTROY OR CHANGE WAS HERSELF. HER LIFE IS A POP TRAGEDY, A MANUFACTURED, SUPERFICIAL TRAGEDY.

AMERICAN SOCIETY PRODUCES DISPOSABLES. EDIE WAS NOT BIONIC WOMAN, BUT DISPOSABLE WOMAN. THE FACTORY WAS A GAY MALE-DOMINATED SOCIETY, WOMEN WERE THERE TO BE USED. NO GIRLS EVER HUNG AROUND VERY LONG. THE BOYS WERE REAL, TOUCHABLE… ANDY NEVER TOUCHED THE GIRLS. EDIE WAS A BUILDING BLOCK, A MODEL ON THE COVER OF VOGUE. SHE WAS IN THE NEWSPAPERS AND GOT ANDY PUBLICITY. THAT WAS PROBABLY THE MAIN ATTRACTION FOR HIM. SHE CUT HER HAIR AND SPRAYED IT SILVER, JUST LIKE ANDY'S. IT WAS, 'LOOK AT ME, LOOK AT ME,' AND PEOPLE LOOKED AT THEM. THEY BECAME THEIR OWN PUBLICITY. EDIE

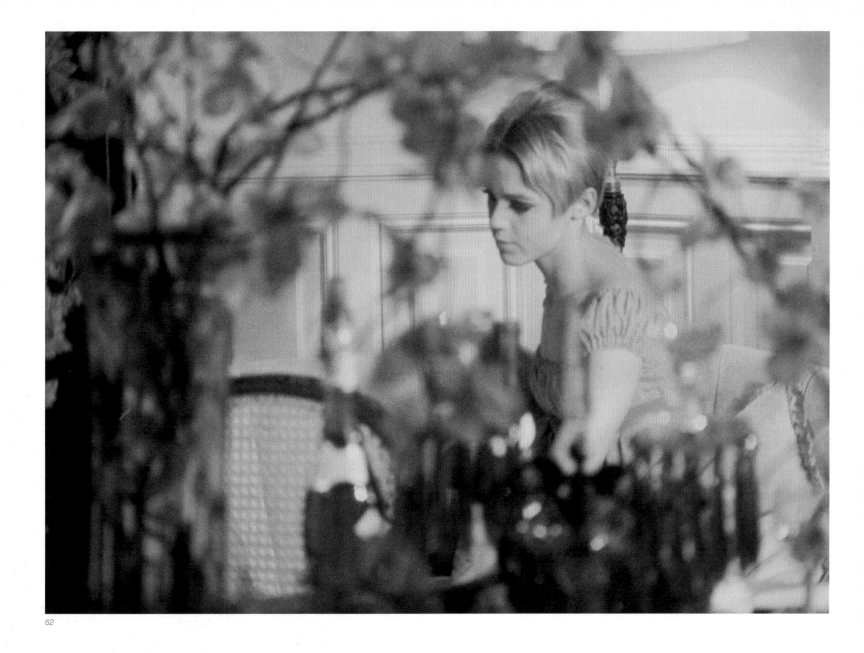

62

TRIED TO USE PEOPLE, THE SAME WAY THAT ANDY DID. SHE HAD MAIDS, PEOPLE
FROM THE FACTORY — SATELLITES OF THE STAR. IT WAS A CASE OF A LITTLE FISH
BEING EATEN BY A BIGGER FISH, BEING EATEN BY A FISH SLIGHTLY BIGGER, BEING
EATEN... CHUCK WEIN WAS SUPPOSED TO BE THE PERSON WHO LANDED EDIE: HER
FRIEND. EDIE TOLD ME DURING ONE OF OUR SESSIONS, 'I'M SUCH A POOR GIRL,
EVERYBODY TAKES ADVANTAGE OF ME.' SHE TOLD ME THAT CHUCK WEIN WAS
PLYING HER WITH ACID AND DIRECTING HER WHILE SHE WAS FUCKING GUYS IN
FRONT OF HIM. BUT THEN AGAIN, EDIE ALWAYS REMINDED ME OF THE JOKE ABOUT
THE FAIRY PRINCESS, LYING NUDE ON A BED HIGH IN A TOWER, SLEEPING FOR A
THOUSAND YEARS. THEN THE RESCUING PRINCE COMES UP AND HE KISSES HER,
SHE WAKES UP AND SAYS, 'EVERYBODY WANTS TO FUCK ME!'

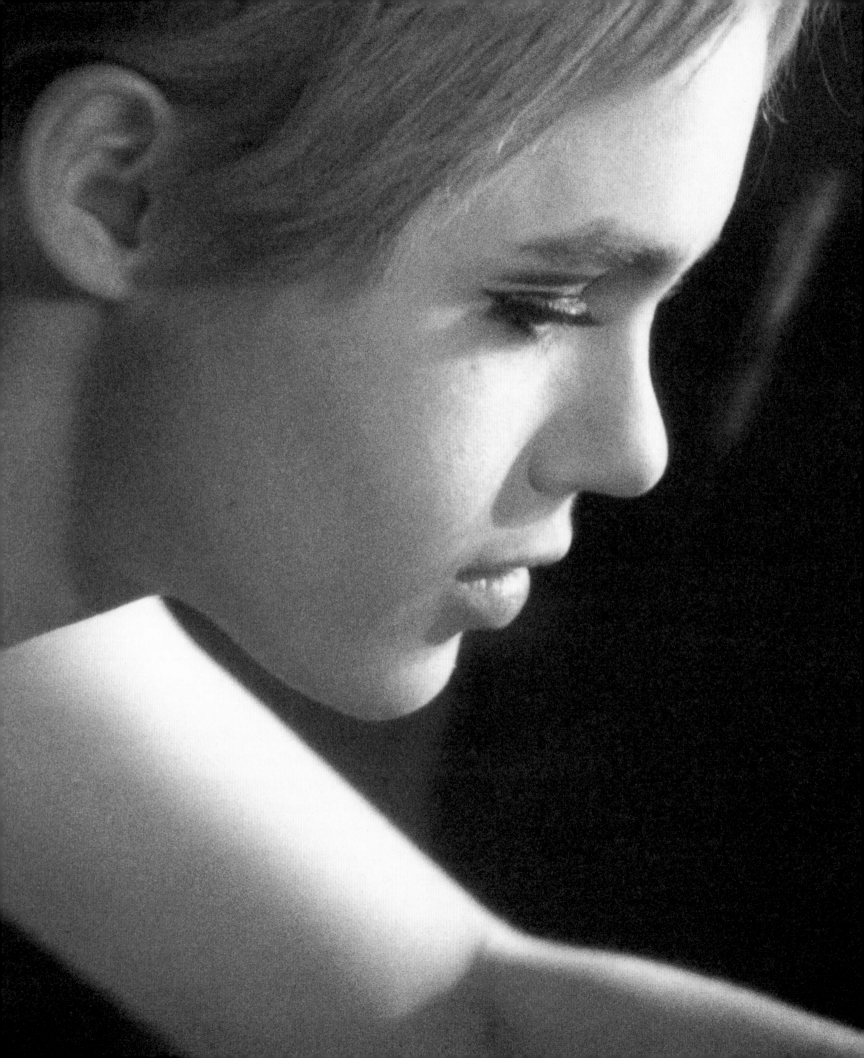

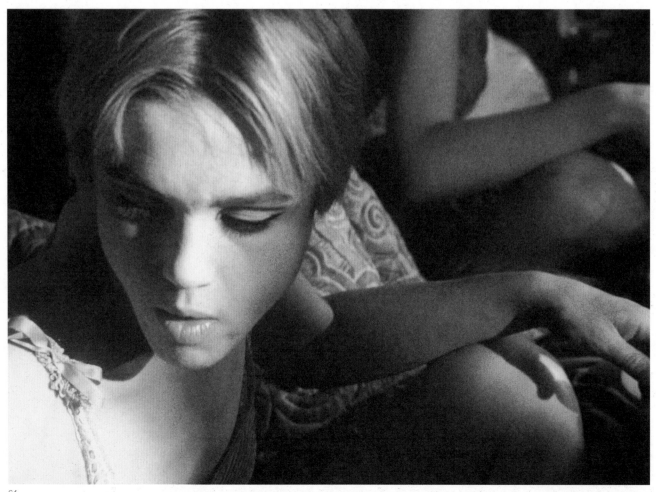

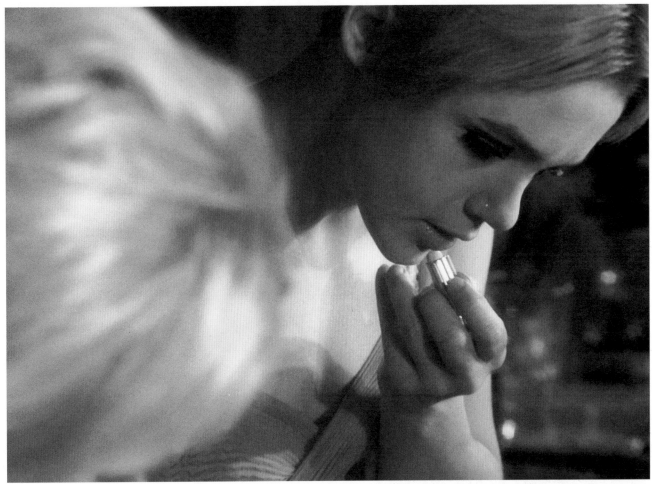

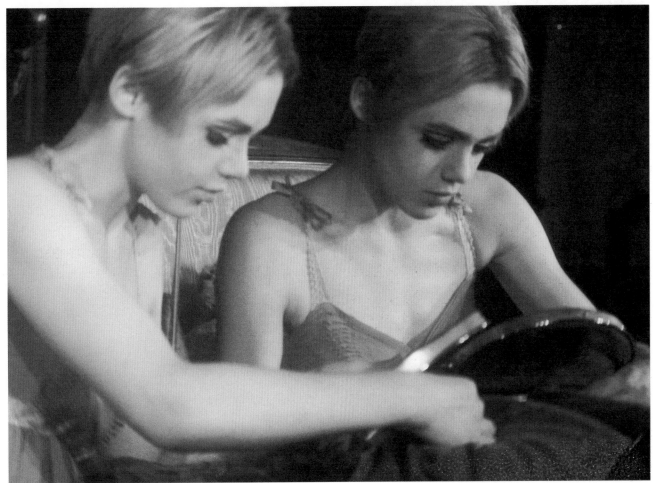

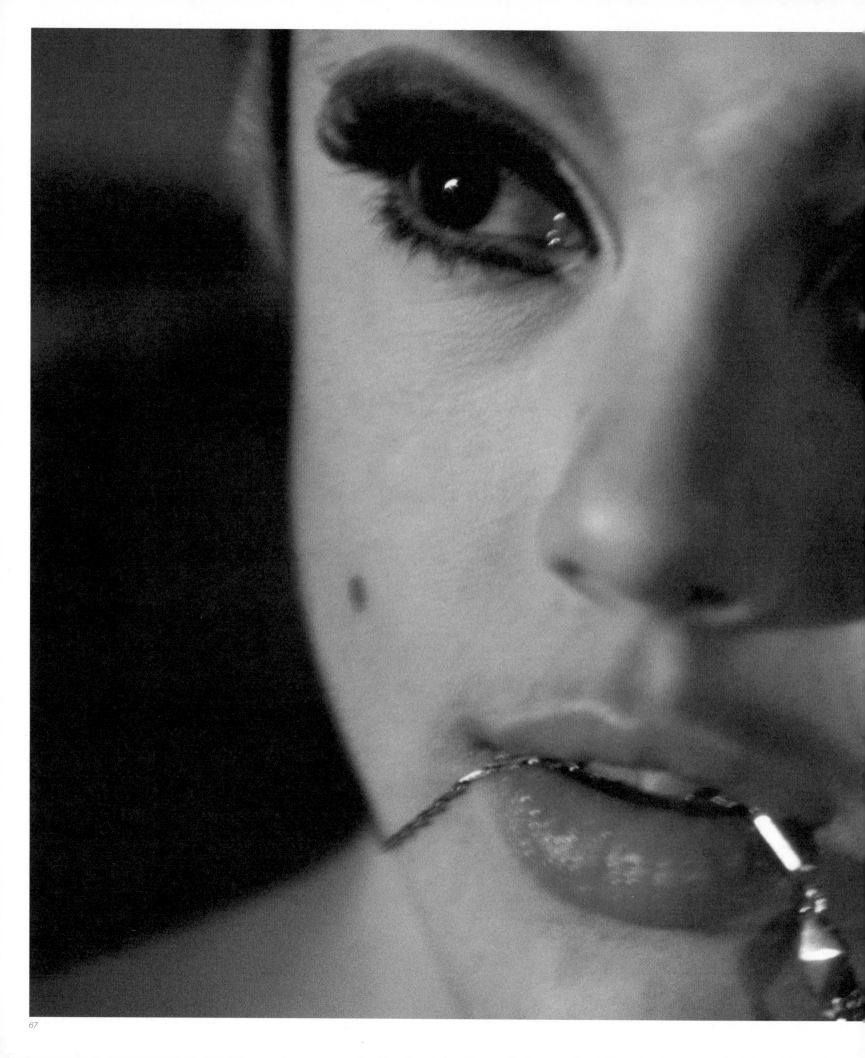

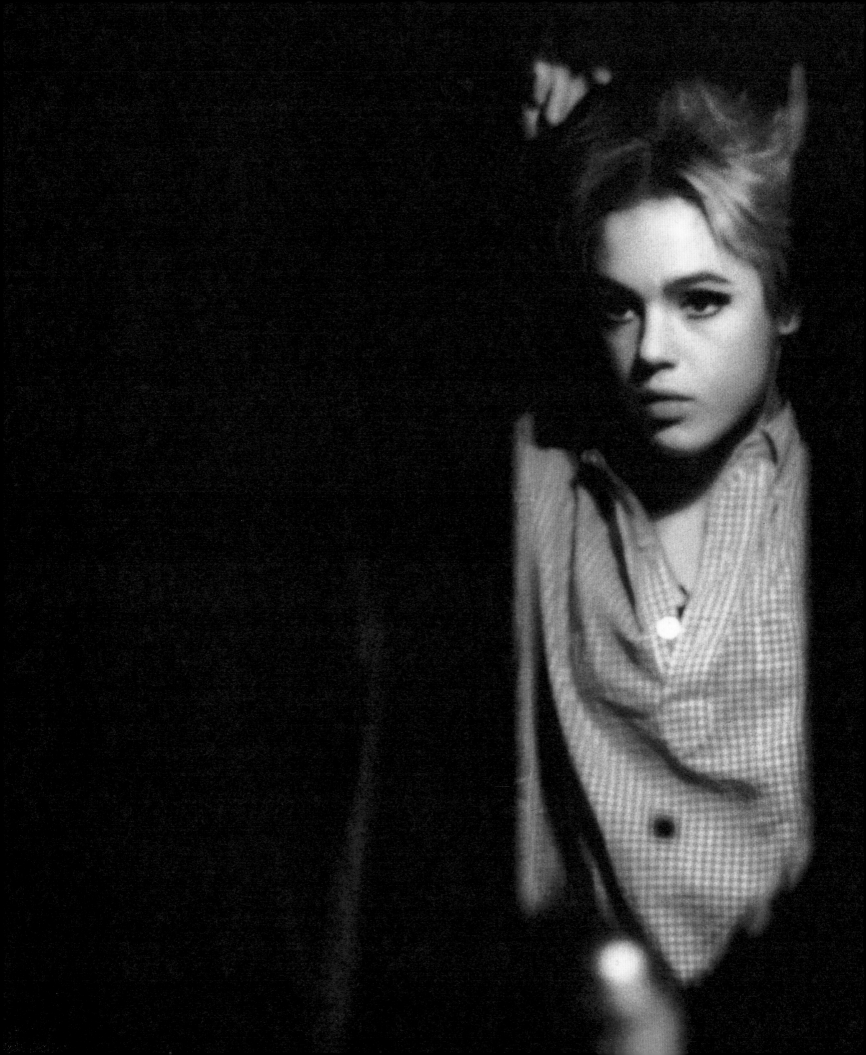

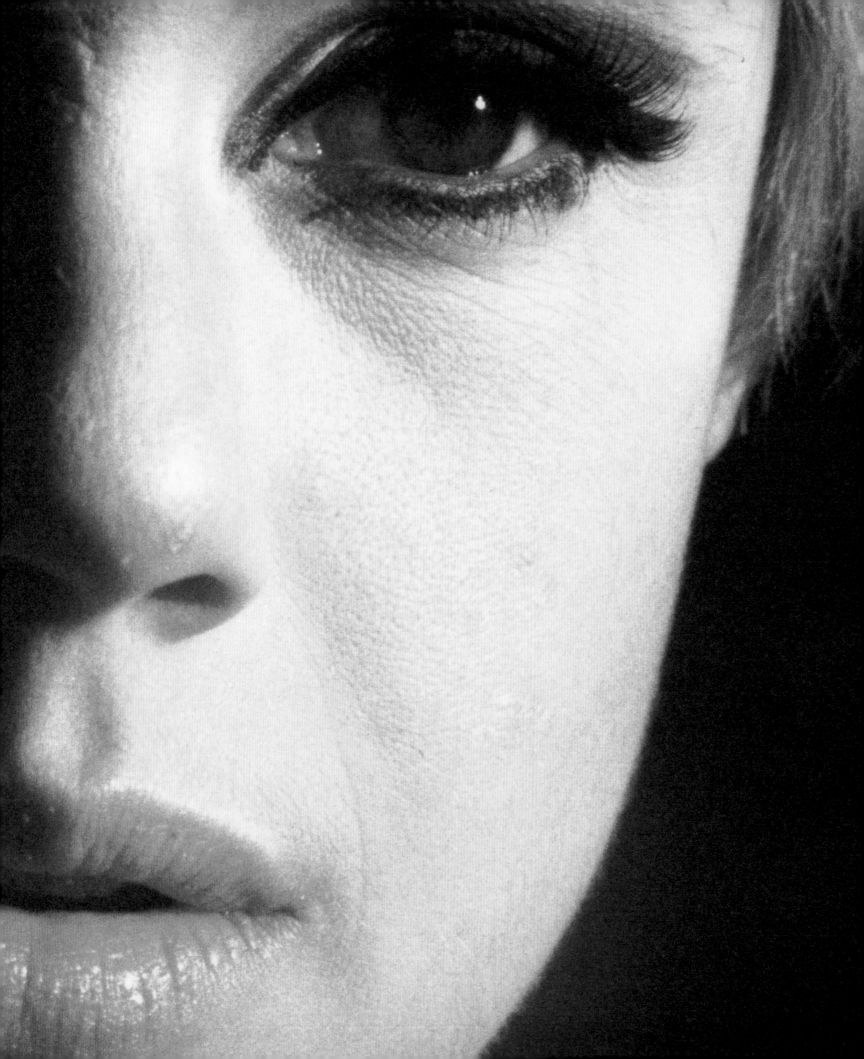

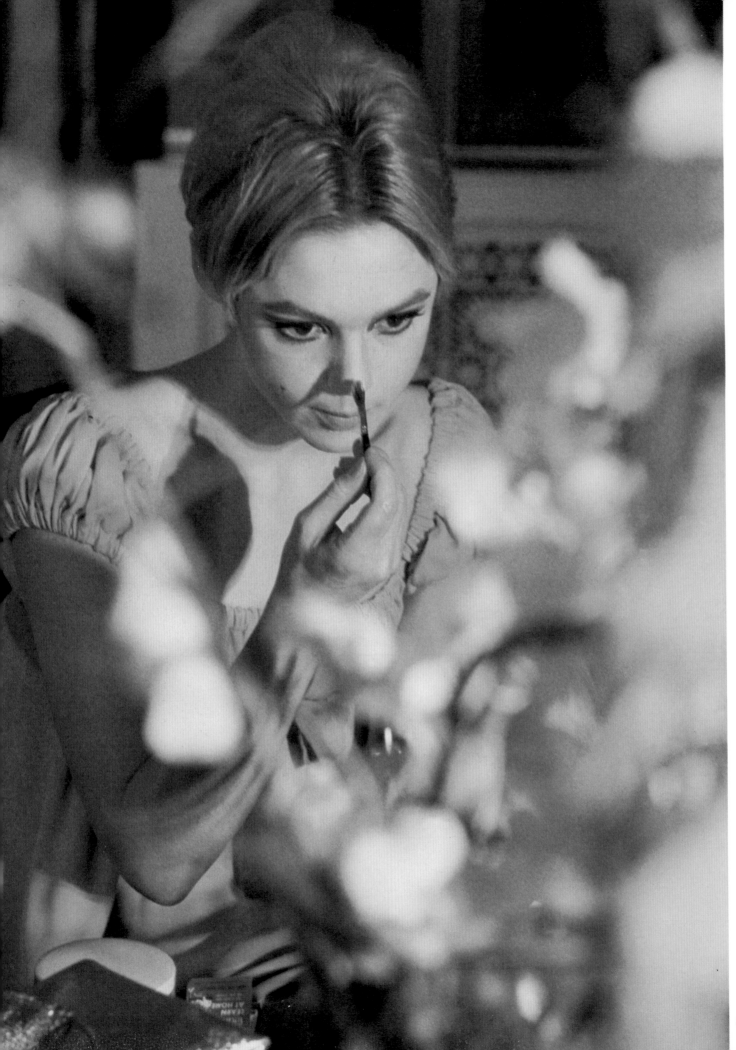

THE LOST COLOR PRINTS

THE G

EDIE, NIC

ET CETER

ANDY WAS A HUNTER-GATHERER. EDIE WAS ONE OF THE THINGS THAT HE COLLECTED. HE TOYED WITH HER, PLAYED WITH HER, JUST LIKE A CHILD PLAYS WITH A WATCH, DESTROYS IT AND THROWS IT ASIDE. EVERYTHING BECAME ANDY'S MATERIAL. ALL THE CASUALTIES THAT HE GATHERED AROUND HIM... NONE OF THESE PEOPLE WERE REALLY IMPORTANT TO HIM. THEY EACH WERE GATHERED FOR SELF-IMPORTANCE, BUT NEVER REALISED THEY WERE ONLY RAW MATERIAL – THAT'S WHAT DESTROYED THEM. FOR THE PEOPLE WHO DID REALISE WHAT THEIR RELATION WITH ANDY WAS BASED ON, IT WAS DIFFERENT. THESE PEOPLE DIDN'T LET THEMSELVES GET SUCKED IN, THEY CAME IN A COLLABORATIVE SENSE AND DID NOT NEED ANDY OR THE GROUP TO DEFINE THEMSELVES.

NICO WAS ONE OF THE PEOPLE THAT CAME INTO ANDY'S SPHERE, HAVING ALREADY ESTABLISHED HERSELF AS A HUMAN BEING. SHE INTERACTED, SHE DEFINED, SHE DID NOT BELONG. SHE MORE THAN SURVIVED: SHE LIVED, SHE LAUGHED. NICO IS A STRONG WOMAN, A LADY. SHE COULD NEVER BE AN INTEGRAL PART OF A WORLD WHERE ONE OF THE MOTIVATIONS IS THE DESTRUCTION OF THE FEMALE. SHE WAS A HUMAN BEING IN A WORLD OF SYMBOLS — INDESTRUCTIBLE. THEY COULD NIBBLE HER ANKLES, THEY COULD BE PETTY ANNOYANCES, THAT'S ALL. SHE WOULD CALL ME AT 3 A.M. AND WITH HER

DEATH'S HEAD VOICE IMPLORE, 'NAT, PLEASE COME. I NEED YOU SO MUCH. HURRY HURRY, PLEASE HURRY.' AND SO, REJOICING TO MYSELF, 'TONIGHT'S THE NIGHT, TONIGHT'S THE NIGHT,' I WOULD JUMP UP, GET OUT OF BED, SLAP A COMB ACROSS MY HEAD, SLAP ON SOME COLOGNE, GRAB A HUNK OF HASH AND FLY OVER TO HER APARTMENT ON JANE STREET, WHERE I WOULD SIT AT THE EDGE OF HER BED WHILE NICO COMPLAINED THAT THE HASH WASN'T SPEED, THAT SHE WAS IN LOVE WITH PETER FONDA AND THAT WOMEN SMELLED BETTER THAN MEN.

INGRID'S ANOTHER CASE. WHEN INGRID ACTED DUMB, SHE WASN'T ACTING. THAT WOMAN ACTUALLY TOOK IT SERIOUSLY, SHE REALLY BELIEVED SHE WAS A SUPERSTAR. SHE WAS ABSOLUTELY BRAINLESS, GRACELESS, SENSELESS. IT WAS RUMOURED SHE HAD BEEN WORKING AS A STREET HOOKER. SHE'S A NASTY JOKE, ANDY'S ANTI-WOMAN JOKE. IF EDIE WAS ANDY'S CONCEPT OF WOMAN, THEN INGRID WAS ANDY'S CONCEPT OF PARODY OF WOMAN. EDIE WAS THE POOR LITTLE RICH GIRL, AND INGRID THE JOKE. EDIE WAS THE TRAGEDY AND INGRID THE COMEDY. THEY WERE ANDY'S TWO EXTREMES IN WOMEN: EDIE AS DOOMED AND INGRID AS LUDICROUS. THAT WAS THE WAY ANDY WAS FUNCTIONING, GOING FROM ONE SIDE TO THE OTHER: THESIS, ANTITHESIS, BUT NO SYNTHESIS...

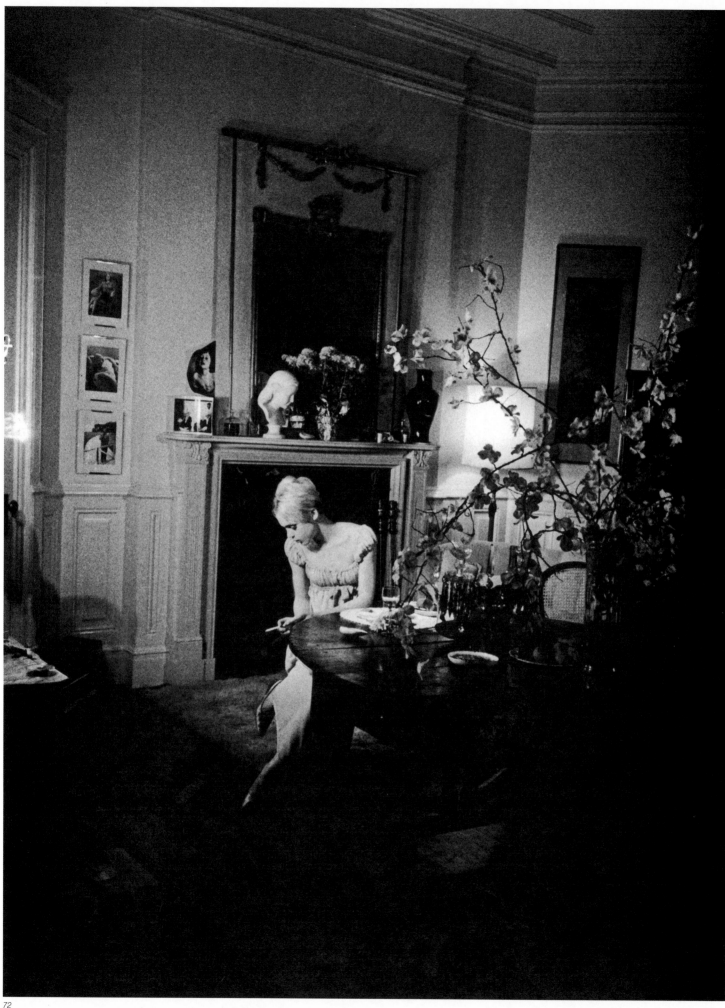

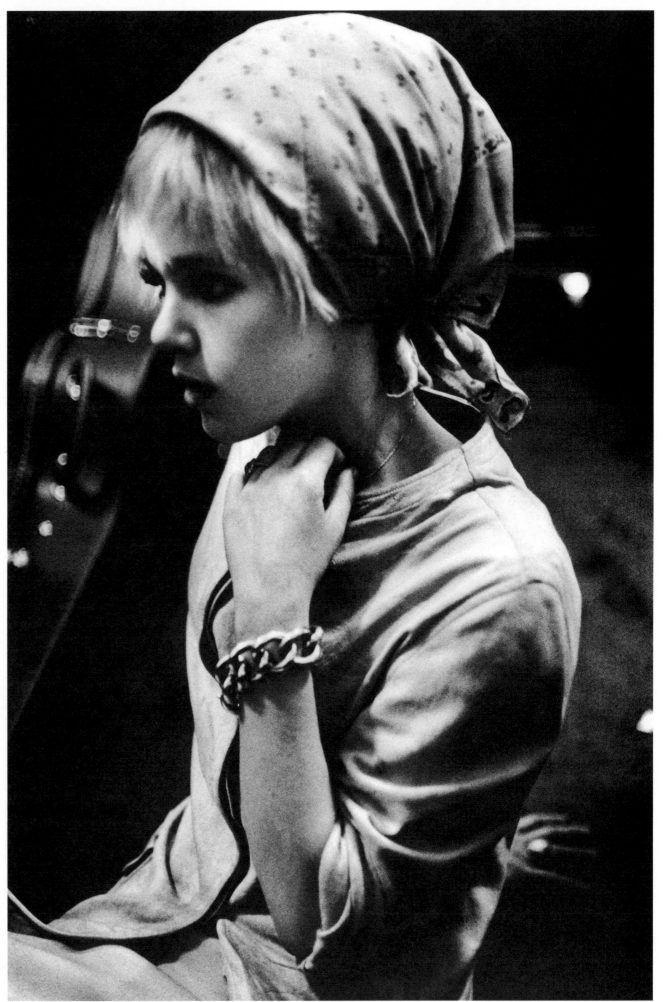

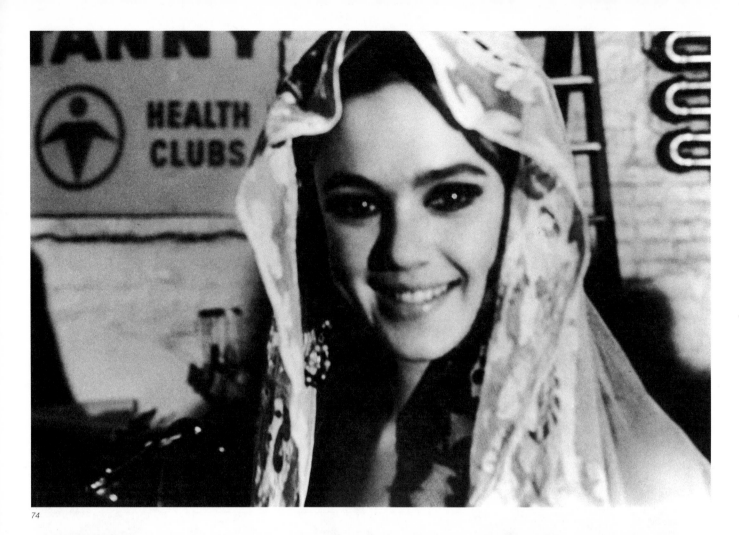

74

75

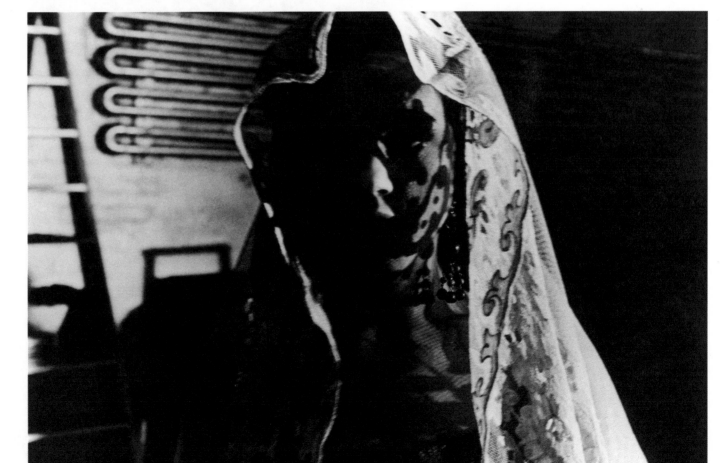

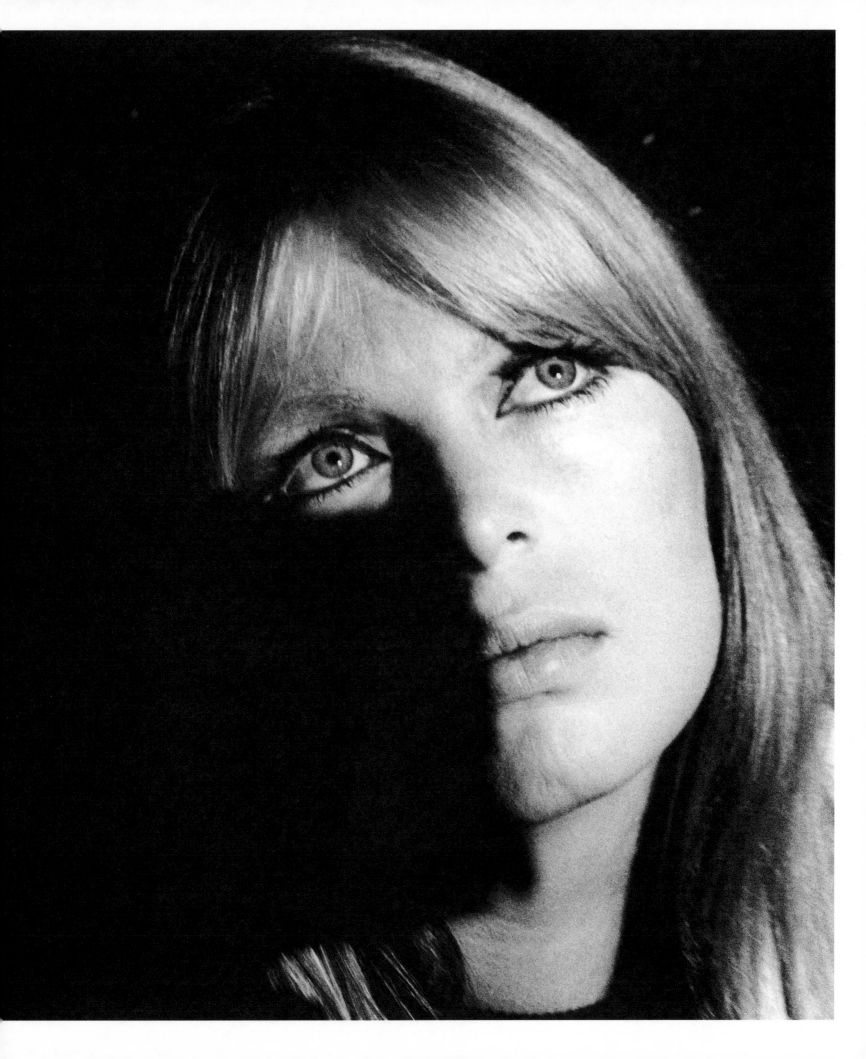

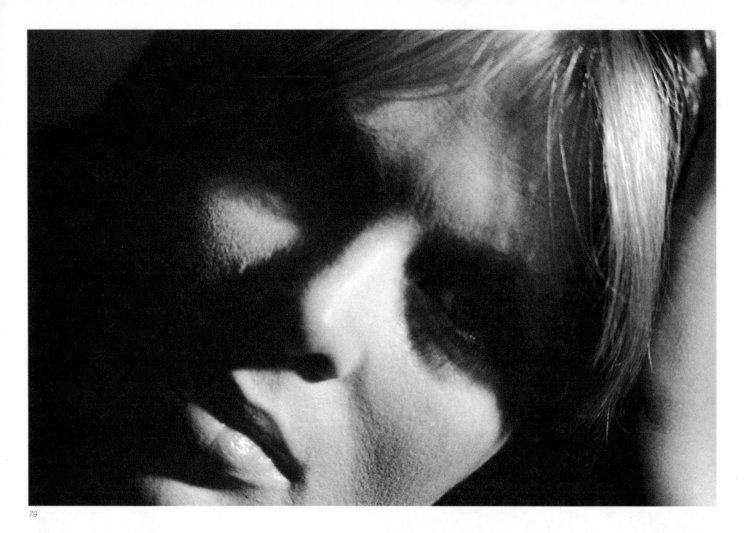

79

80

82

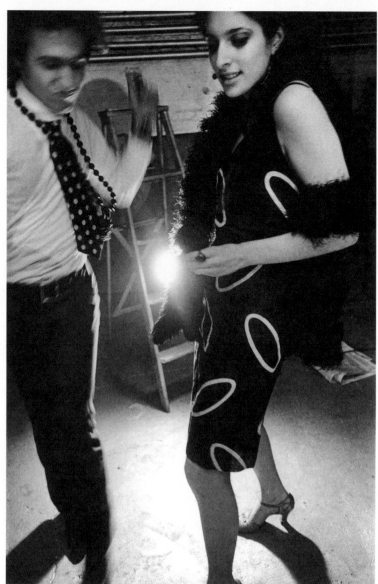
83

PARAPHERNALIA. PILGRIM CLOTHES DECIDED TO GO MOD AND HIRED BETSEY JOHNSON TO DESIGN THEIR LINE. THEIR FLAGSHIP STORE WAS PARAPHERNALIA. BETSEY HIRED ANDY TO MAKE A PARTY. THUS ANDY WARHOL POP ARTIST BECAME ANDY WARHOL DRESS SALESMAN. HE WAS A HIRED GUN, SILVER SPRAYED GEORGE RAFT.

ANDY CAME WITH A BUNCH OF PRE-PACKAGED SUPERSTARS AND THE VELVETS. FRUG, FRUG, FRUG... OUR JOB WAS TO GET AMERICA HOT TO TROT. WE STAGED A PARTY IN A FISHBOWL, A STORE WINDOW ON MADISON AVENUE. CROWDS GATHERED... THE IDEA WAS THAT EVERYBODY WHO SAW THE PARTY WOULD BUY CLOTHES THERE. THE GIRLS SHOWED THE NEW FASHION WHILE THEY WERE DANCING TO THE VELVET'S MUSIC. IT WAS CASH IN TIME AT THE ZOO, 'WE WILL TAKE YOU TO PARADISE, JUST BE WILLING TO PAY THE PRICE'. WE WERE THE SHOW, ANDY'S CIRCUS. THAT WAS THE WAY ANDY WORKED: HE MANUFACTURED HAPPENINGS OUT OF THE PEOPLE AROUND HIM. THEY WERE HIS RAW MATERIAL — GLITTERING CANNON FODDER. HE SOLD US AS COMMERCIAL ART. HE MANUFACTURED CANDY KISSES, WRAPPED IN SILVER... PULL A PIECE OF CELLOPHANE AND OUT POPS THE STAR. THE SUPERSTARS WERE AT PARAPHERNALIA AS MEDIA, AND THE PUBLIC, NOT THE MERCHANDISE, WAS BEHIND GLASS. ANDY'S OWN ATTITUDE TOWARD CLOTHING WAS PRETTY WEIRD. HE ONCE ASKED ME TO GO SHOPPING WITH HIM. WHEN I SUGGESTED THAT WE SHOULD GO TAKE A LOOK AT ONE OF THE UPPER-CLASS SECOND HAND CLOTHING-STORES WHICH WERE THEN GETTING FASHIONABLE, HE SAID: 'OH NO NAT, NEVER BUY USED CLOTHING, IT'S LIKE WEARING SOMEBODY ELSE'S PERSONALITY!' EXCEPT FOR THIS, WHAT HE WORE WAS OF NO IMPORTANCE TO HIM. HIS CONCEPT OF FASHION WAS WHAT HE GOT OTHER PEOPLE TO WEAR. ANDY HAD A BIG THING FOR HERSHEY'S CHOCOLATE KISSES, WRAPPED UP IN A SILVER PACKAGE. SEEING PEOPLE DRESSED UP IN SILVER, LIKE AT THE PARAPHERNALIA SHOW, WAS LIKE HIS FANTASY COME TRUE. PLASTIC WRAPPED BODIES, NON-BIODEGRADABLE, PLASTIC PUSSIES AND MADE TO ORDER SEX.

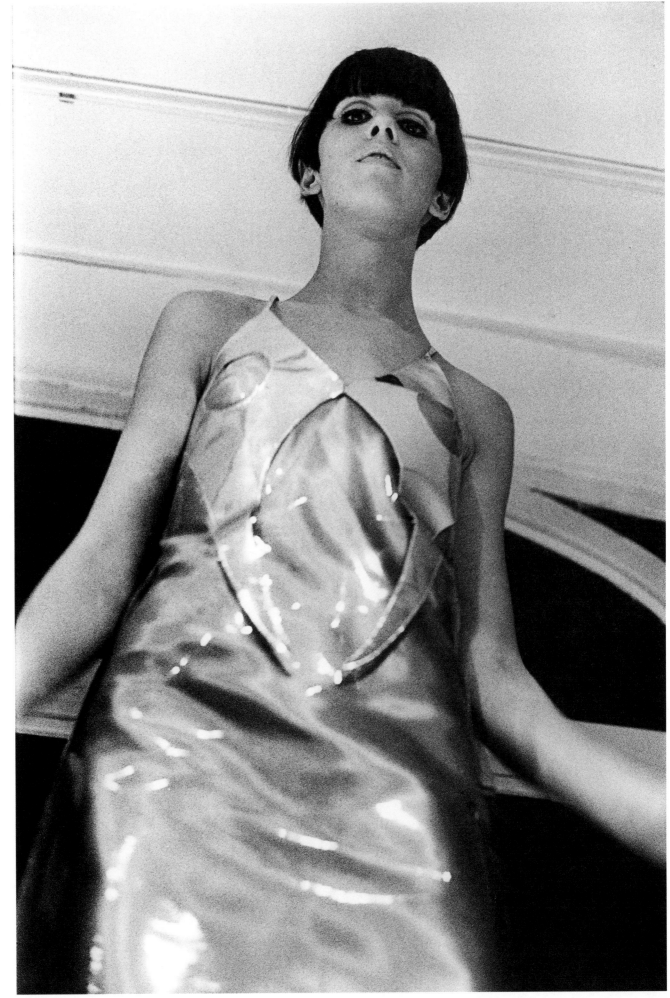

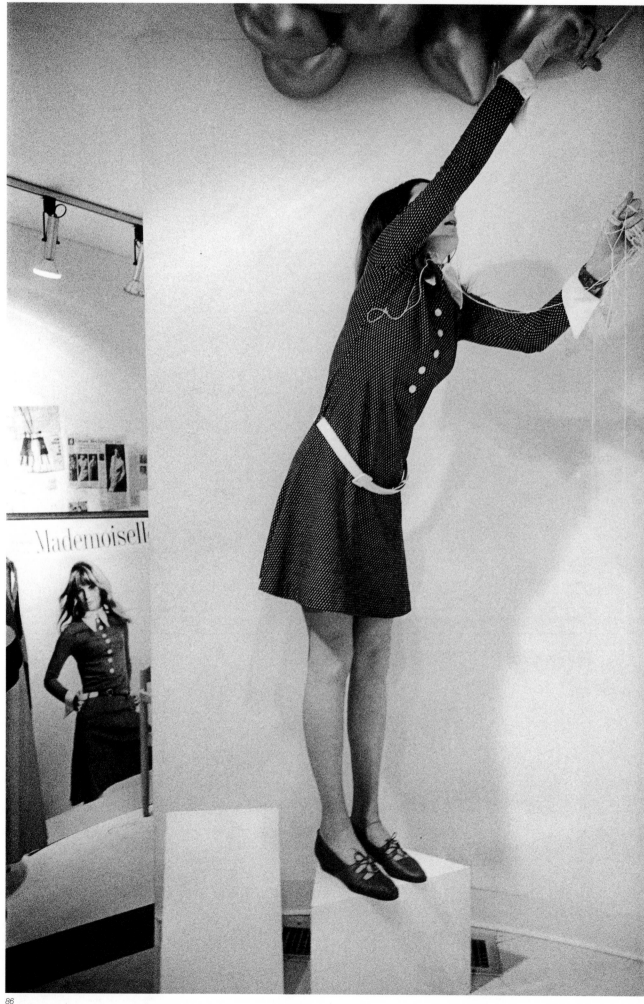

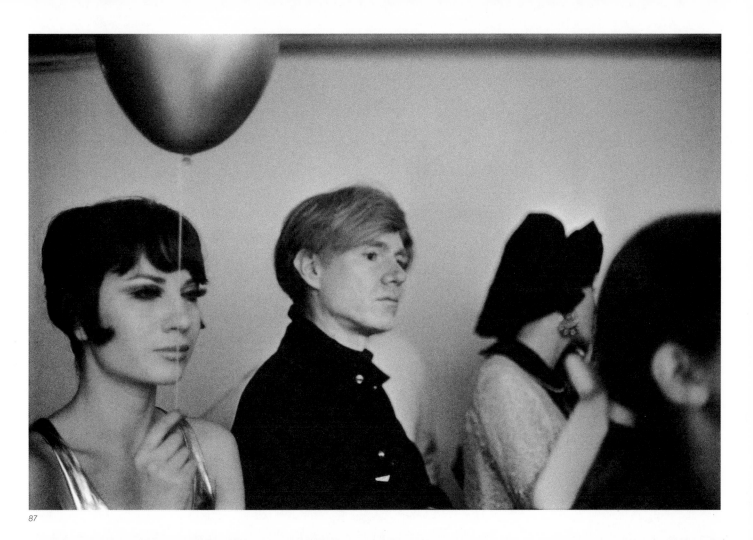

87

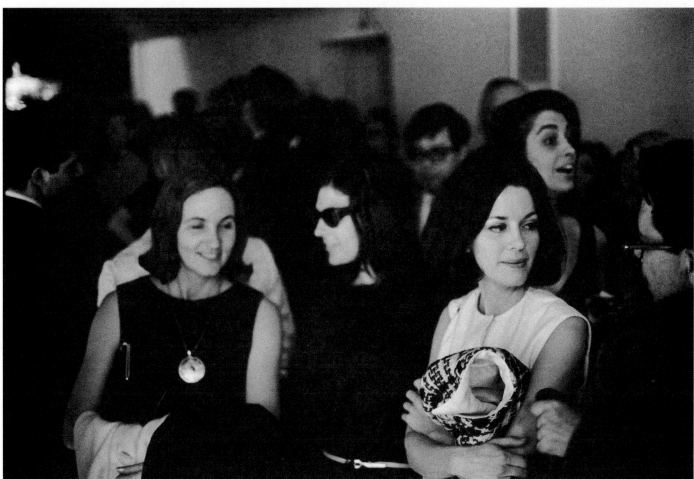

88

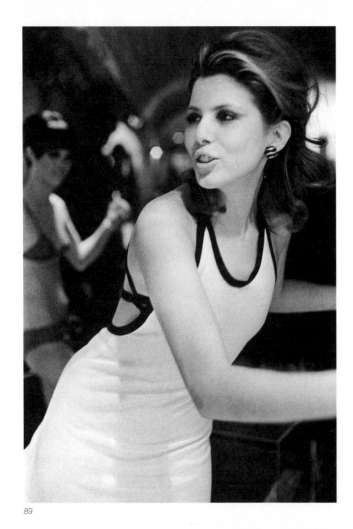

89

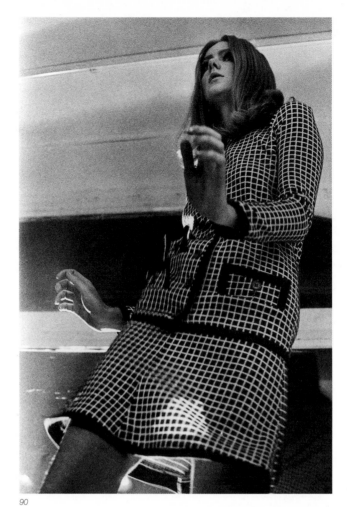

90

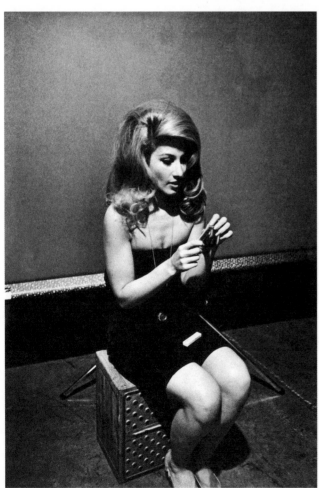

91

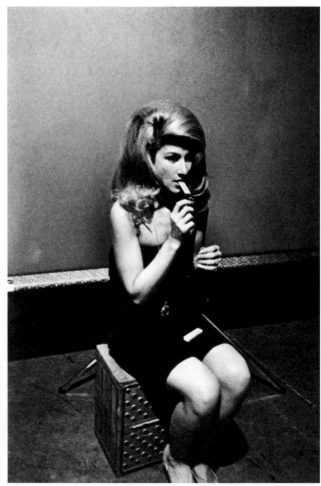

92

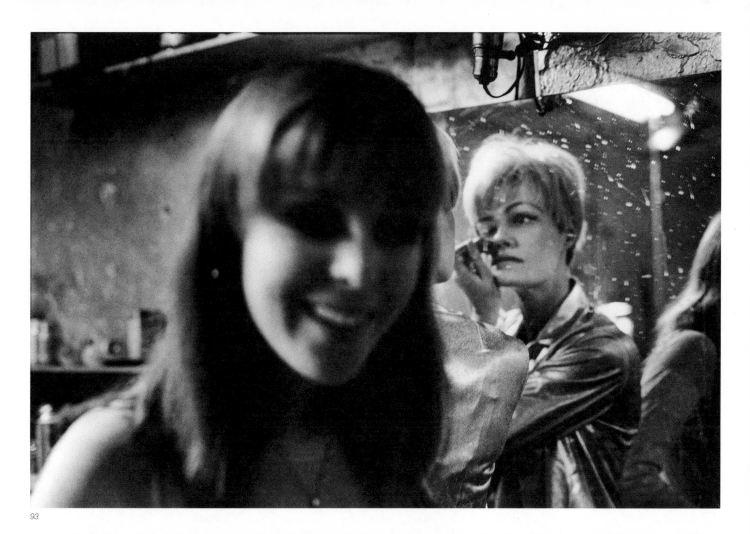

93

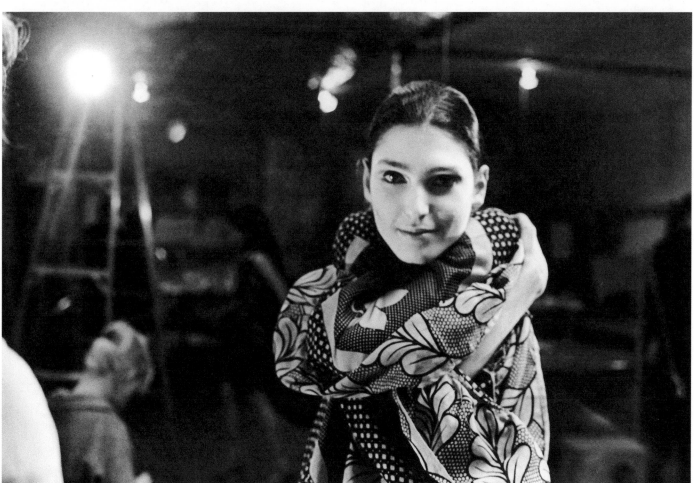

94

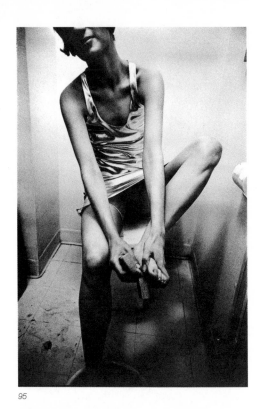

95

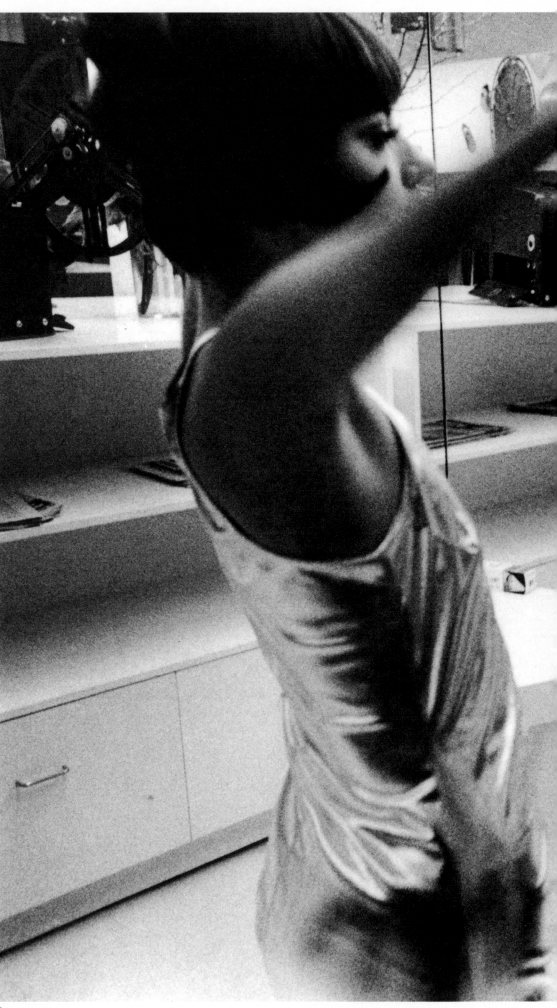

96

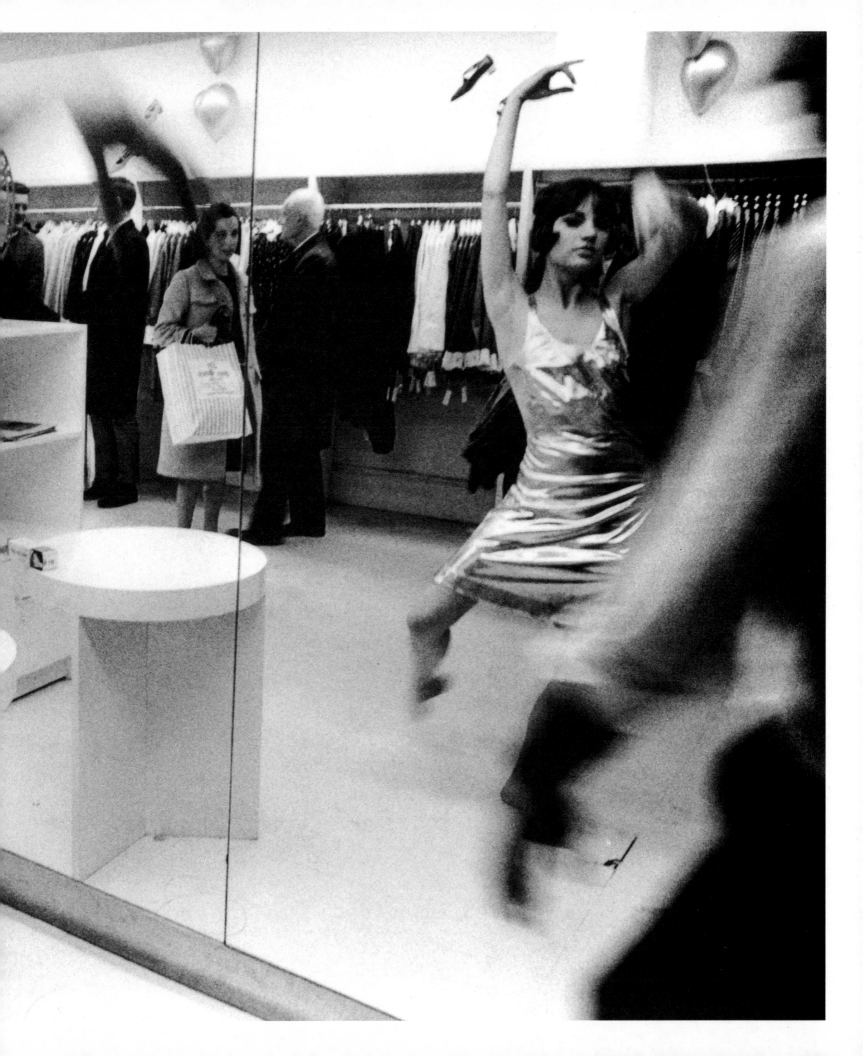

THE GIRLS – EDIE, NICO, INGRID ET CETERA

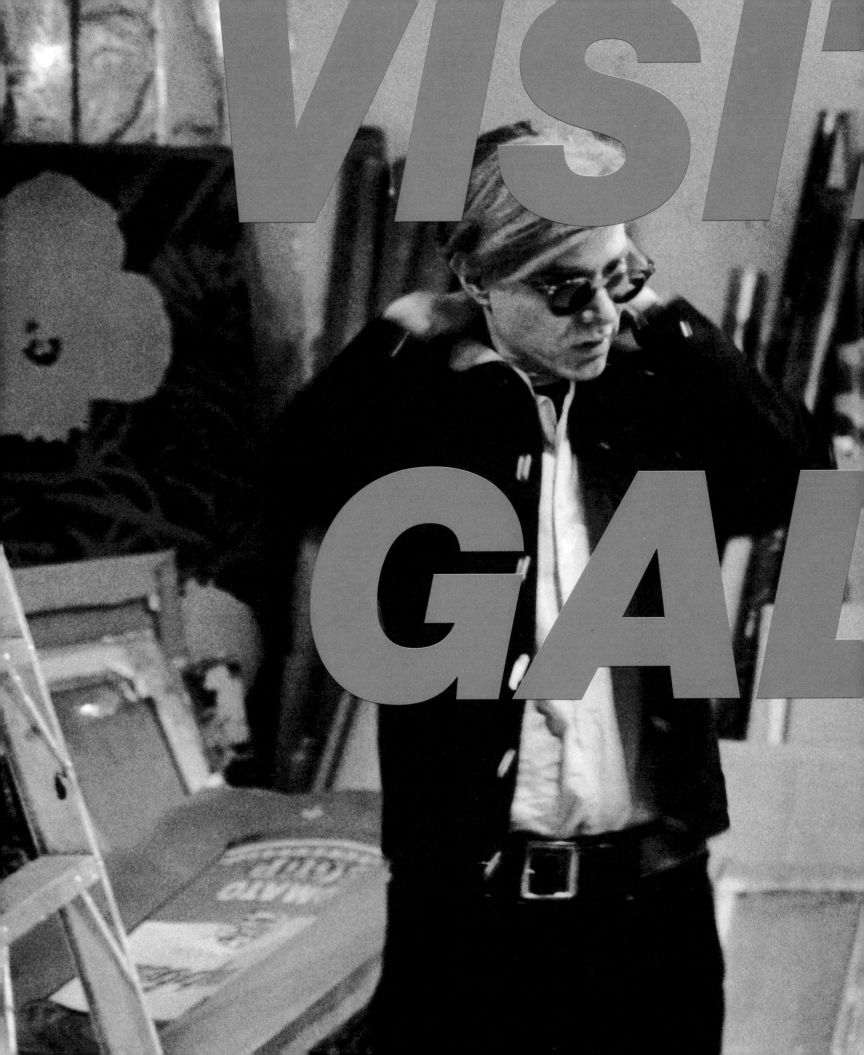

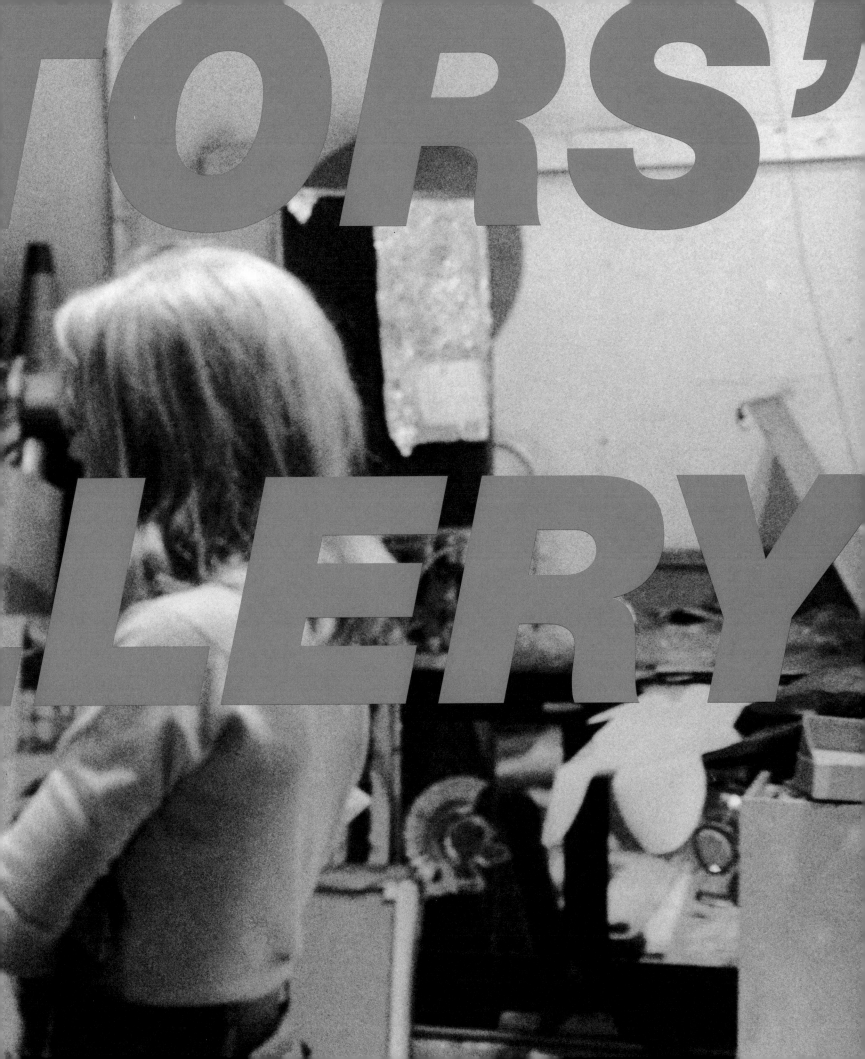

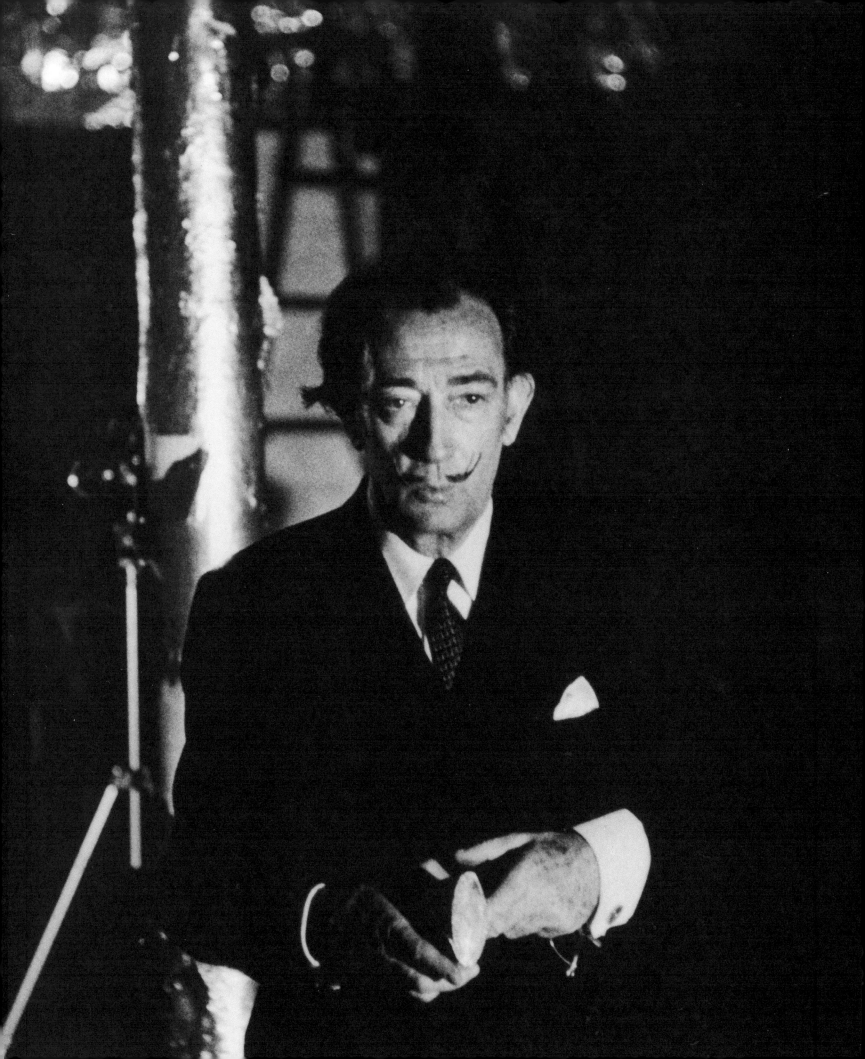

DIN DINS WITH DALI. *HE CAME IN, UNNOTICED, AND LIKE A THREE-CARD-MONTE DEALER MOVED TO THE PERIPHERY, WHERE WITH PICKPOCKET'S FINGERS HE TOYED WITH SMALL OBJECTS SO AS TO DRAW ATTENTION AWAY FROM THE MORE CROWDED COUCH AREA WHERE THE SPOTLIGHT BELONGED... ON DALI. HE THEN STARTED TO PROWL UP AND DOWN THE SIDELINE SEEMINGLY ENGROSSED WITH HIS FINGER DANCING AND OBLIVIOUS TO ALL ELSE. I STEPPED IN FRONT OF HIM AND GRABBED TWO QUICK IMPROMPTUS. HE LOOKED CAREFULLY INTO MY CAMERA BEFORE I EVEN HAD IT TO MY EYE. HE WAS A PRO.*

LATER THAT AFTERNOON, ANDY RELAYED A REQUEST THAT I DRESS FOR DINNER AND MEET HIM AND DALI AT THE SAINT REGIS. WE WAITED AT A TABLE IN THE BAR AND DALI ARRIVED WITH GALA, HIS WIFE. HE WAS PLAYING THE 'GREAT DALI', TALKING IN NODS AND GESTURES, AND GALA SAT DOWN NOT LOOKING BEHIND HER AS IF ASSUMING THAT AS BEFITS ROYALTY THE CHAIR WOULD BE PLACED UNDER HER ASS AS SHE SAT DOWN. IT WAS [WHAT A FILM IF IT WASN'T]. WE ORDERED DRINKS AND ANDY AND DALI PUT THEIR HEADS TOGETHER AND STARTED TO MURMUR. MRS DALI TRIED TO ENGAGE ME WITH A LITTLE SMALL TALK, BUT I KEPT MY EARS PEELED AND CAUGHT SOME OF THE SCAM... ANOTHER FREEBIE. ANDY TURNED TO ME, AND TOLD ME THAT DALI WAS SEARCHING FOR A PHOTOGRAPHER WHO WAS BOLD AND BRAVE. STUPID AND FREE, THOUGHT I. WOULD I BE INTERESTED IN DONNING A PARACHUTE AND TAKING SOME SNAPS OF A LIVING DESIGN WHILE I WAS FLOATING DOWN? I ANSWERED THAT I WAS A PROFESSIONAL PHOTOGRAPHER, THAT I HAD NO FALL-BACK INCOME IF I WAS INJURED. I WOULD CHARGE HIM; JUMPING FROM A PLANE WOULD BE EXPENSIVE BUT I WOULD CONSULT MY AGENT AND LET HIM KNOW. HE PUFFED HIMSELF UP: I COULD VISUALIZE TEARS IN HIS EYES. I SAT UP. 'I AM DALI,' HE SAID. MRS DALI SAID, 'THIS IS DALI.' I SAID 'I'M A PROFESSIONAL PHOTOGRAPHER; I WORK FOR PAY.' SHE AVERTED HER EYES. HE STARTED TALKING TO ANDY. I WAS PRESENTED THE BILL. THEY NEVER UTTERED ANOTHER WORD ASIDE FROM 'ADIEU'. I NEVER GOT MY DINNER.

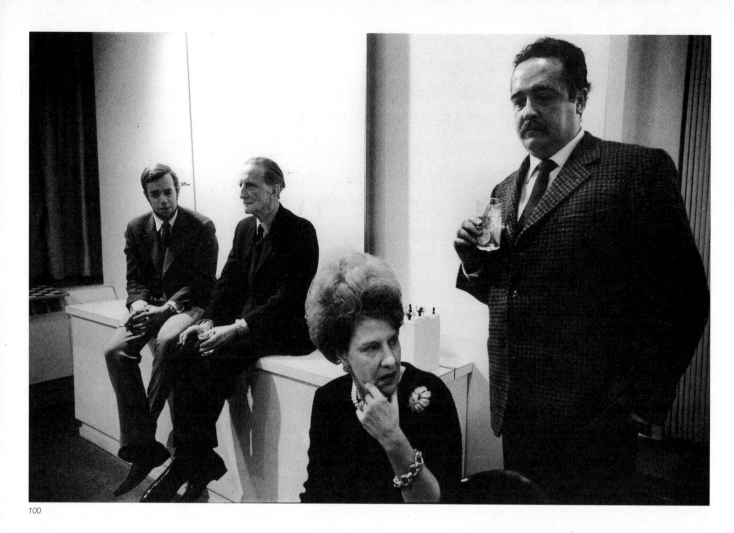

100

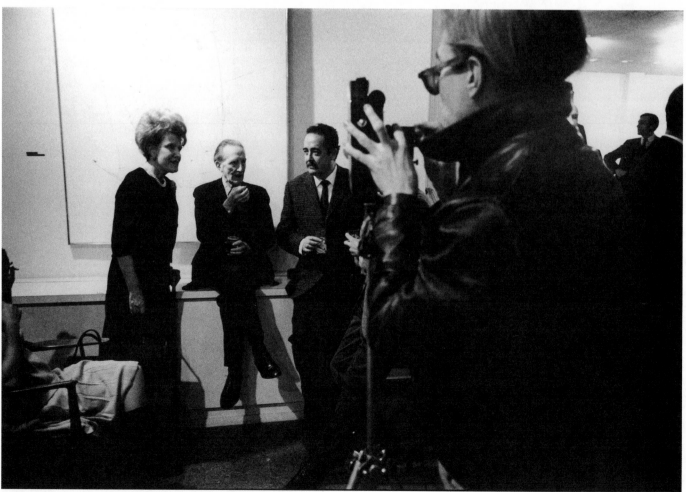

101

DUCHAMP. MY ENTRY INTO THE WORLD OF THE PAPAS AND MAMAS OF THE KIDS THAT HUNG AROUND THE FACTORY WAS ALWAYS THROUGH THE SERVANTS' ENTRANCE. I WORKED AS A DELIVERY-BOY FOR AN APPLIANCE HOUSE IN MANHATTAN, I DELIVERED FLOWERS FOR AN UPTOWN FLORIST. I WOULD BRING, FOR EXAMPLE, THREE DOZEN LONG STEMMED ROSES TO HEDY LAMAR: I WOULD GO TO THE SERVANTS' ENTRANCE, RING THE SERVICE BELL AND MAKE MY DELIVERIES THROUGH THE REAR, ASSHOLE DEMOCRACY! SO THE ONLY WAY THAT I COULD EVER COME INTO CONTACT WITH MY BETTERS WAS AS A SERVANT. 'GALLING!!!' AS A DELIVERY BOY I WOULD RUN DOWN MADISON AVENUE, AND STAND IN FRONT OF BROOKS BROTHERS AND SAKS. THESE STORES WERE BUILT TO LOOK LIKE FORTRESSES. THERE IS A REASON FOR THAT, IT'S TO INTIMIDATE THE POOR. THESE WERE THEIR CASTLES, THEIR STOREROOMS... I WAS HUNGRY AND THEY OWNED THE TOYS.

WHEN ANDY CALLED ME UP AND TOLD ME HE WANTED ME TO TAKE PHOTOGRAPHS OF THIS DUCHAMP-THING, I SAW MYSELF AS A REPRESENTATIVE OF WHERE I CAME FROM, BREACHING THE CITADEL. I FELT GOOD: 'AIN'T NOBODY THROWING ME THROUGH NO SERVANTS' ENTRANCE.' AND THERE I WAS. VERY FIXED IN MY MIND WAS: 'HEY BASTARDS, A LONG TIME AFTER YOU'RE DEAD, PEOPLE ARE GOING TO KNOW YOU ONLY THROUGH ME. WHEN ALL IS SAID AND DONE, WHEN EVERYTHING IS GONE, THE PHOTOGRAPH IS WHAT'S GOING TO REMAIN. THE PHOTOGRAPHER IS THE PRODUCER OF HISTORY.' I FELT VERY STRONG. THE PEOPLE AT THE DUCHAMP SHOW WERE THE REAL MOVERS AND SHAKERS. THEY LOOKED POWERFUL. IT WAS NOT A SHOW OF ART, IT WAS A DISPLAY OF POWER. THIS WAS AMERICAN ARROGANCE, OLD WEALTH INHABITING THEIR PREPAID WORLD.

IT WAS INTERESTING THAT THEY ACCEPTED US... THE WAY WE WERE DRESSED, JEANS AND LEATHER JACKETS. WE HAD A VERY CONSCIOUS IDEA THAT WE WERE THE BARBARIANS AT THE DOOR, THE BOGEY-MEN, WE WERE WHAT YOU WERE WARNING YOUR KIDS ABOUT. BARBARA RUBIN'S MODUS WAS: THROUGH SHOCK, PUBLICITY... THROUGH PUBLICITY, MONEY. AND MINE WAS: GO WITH THE FLOW, I'M ENJOYING THIS. I KNEW THAT IF IT WASN'T FOR MY CAMERA AND BLACK STAR, THESE PEOPLE WOULD HAVE ME AT THE SERVANTS' ENTRANCE: BACK TO THE BACK DOOR. SO THERE I WAS, WALKING THROUGH THE FRONT...

ANDY'S COMING TO THIS ARTSHOW WAS LIKE A GUERILLA ATTACK. THAT'S WHAT MADE HIM. AS A MATTER OF FACT THAT'S WHAT MADE ALL OF US, A FEELING LIKE: 'FUCK YOU MAN, WE'LL KICK OUR WAY IN HERE.' DUCHAMP WAS SURROUNDED BY HIS PHALANX OF DEFENDERS. ANDY WAS ATTACKING — WE WERE HIS POINT MEN. THESE PEOPLE WHO WERE SURROUNDING DUCHAMP AND THE NEWLY EMERGING POP ARTISTS WERE THE SAME BREED OF PEOPLE WHO MIGHT COMMISSION A HANDLER TO IMPORT AND SHOW A POODLE, TO BEST IN SHOW AT THE WESTMINSTER KENNEL CLUB, ARRIVISTES. YOU SEE PRETTY MUCH THE SAME TYPE GOING TO A HIGH-CLASS DOGSHOW AS TO A HIGH-CLASS ART SHOW: COMMISSIONERS, NOT COLLECTORS. THE PROCESS OF CANONIZATION INVOLVES STERILIZING THE BITCHES AND CASTRATING THE MALES, AS A MEANS TO CONTROL THE BREEDING EVEN BETTER. BASICALLY WHAT THEY DID WAS TO TAKE THE SELECTED BY THE LEASH, LEAD THEM AROUND IN A CIRCLE AND THE JUDGES [LEO CASTELLI, IVAN KARP, HENRY GELDZAHLER] WOULD POINT OUT: 'YEAH, WE'LL TAKE THIS ONE,' AND THAT'S WHO SOCIETY WOULD BUY. THE ENTOURAGE, ANDY'S CARAPACE, MIGHT BE ANNOYANCES, BUT AT THE VERY WORST THEY LEFT A PUDDLE ON THE FLOOR... THE MAID COULD COME IN WITH A KLEENEX AND WIPE IT UP. WHEN WE CAME IN TO THE DUCHAMP SHOW, THEY EXPECTED US TO BE... ER, AH, AHUM... DIFFERENT. THEY EXPECTED US TO BE OUTRAGEOUS, THIS WAS OUR JOB. WE WERE SUPPOSED TO CHEW SLIPPERS AND BURY BONES IN THE SOFA. THEIR MAIN CONCERN WAS THAT WE DIDN'T PISS ON THE AUBUSSON. SO THESE PEOPLE WHO WERE WITH DUCHAMP ACTED AS DEFENDERS, WHO MADE SURE THAT NONE OF US WOULD RUN OVER AND BITE HIM IN THE ANKLE, BUT THEY WEREN'T DEFENDING DUCHAMP... THEY WERE PROTECTING THEIR INVESTMENT. MEANWHILE THE OLD MAN LET ANDY POSE HIM HERE AND PUSH HIM THERE WITH A BENIGN SMILE — WHY NOT, AFTER ALL HE HAD ALREADY MADE HIS.

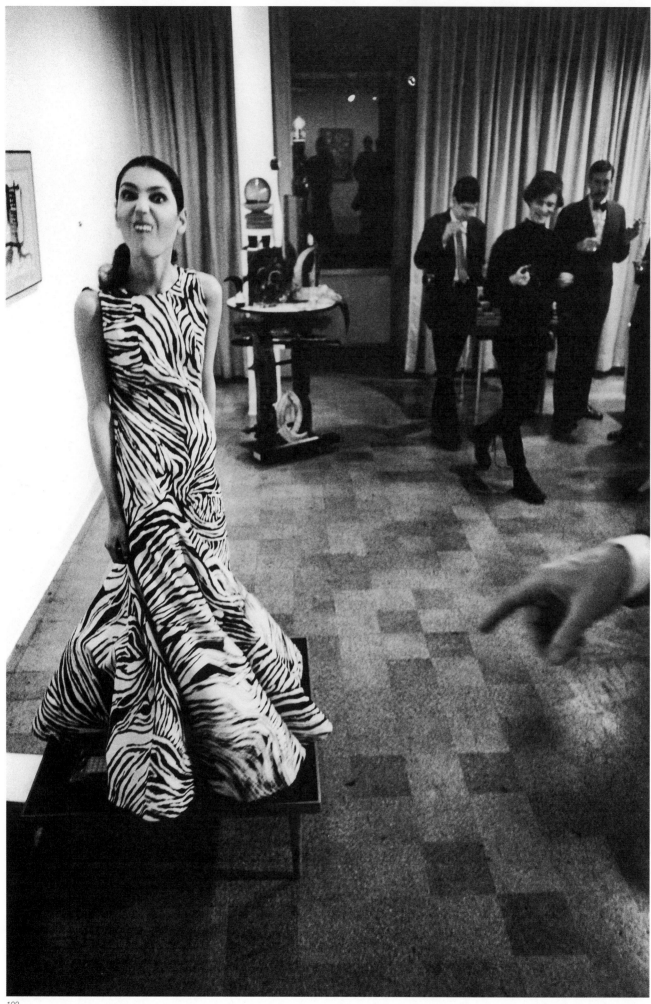

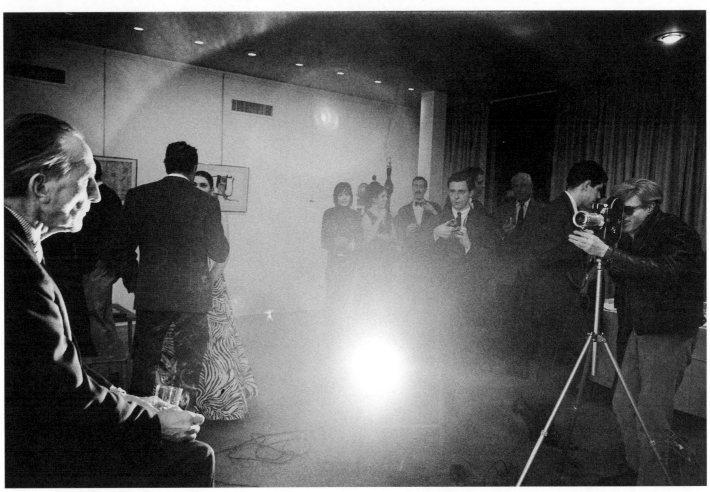

103

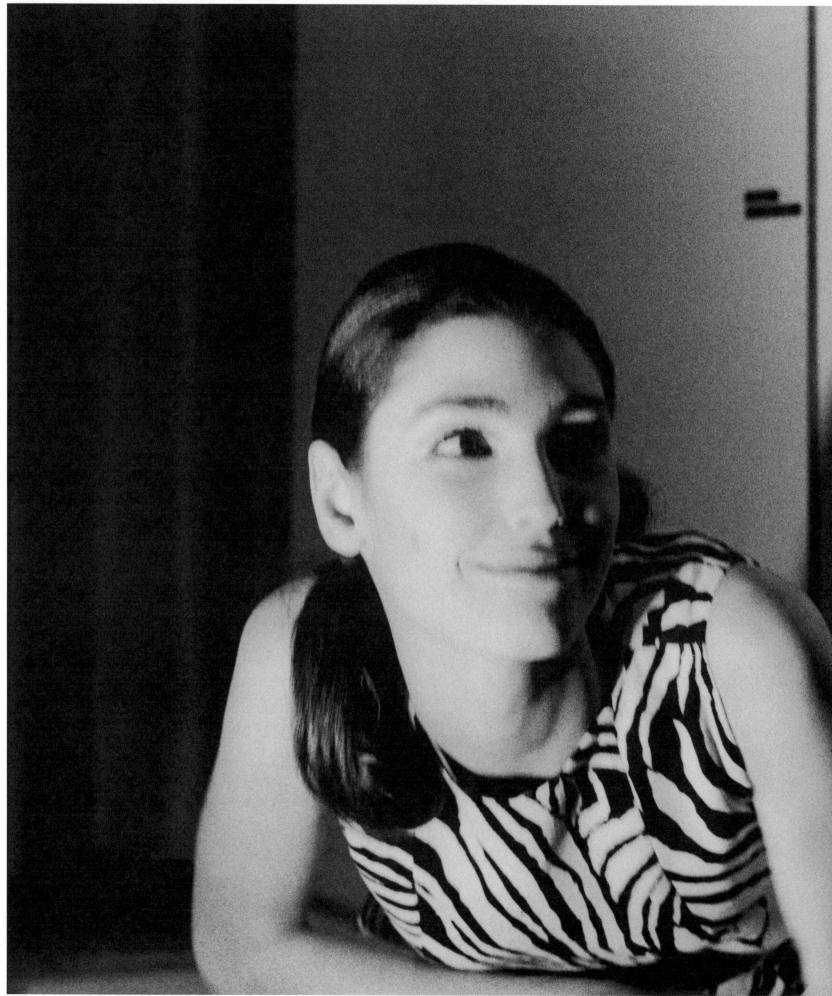

ENTER BOBBY THE WAIF, EXIT ROBERT THE TRIUMPHANT. **THE JOINT WAS ATWITTER, THE DENIZENS AGOG, 'BOBBY'S COMING, BOBBY'S COMING'. BARBARA ROBIN, GROUPIE, WAS PACING UP AND BACK LOOKING LIKE IT WAS HER ELDEST'S BAR MITZVAH AND THE DERMA WAS LATE. THIS WAS BARBARA'S PARTY, AND HER EGO IF NOT HER HEAD, WOULD ROLL IF THINGS DIDN'T GO SMOOTHLY AND SHE WAS ON VERY THIN ICE HERE. PAUL MORRISSEY, THE FACTORY NEGATIVITY, WAS AGAINST IT (AS HE WAS AGAINST EVERYTHING HE COULDN'T CLAIM CREDIT FOR). POSSIBLY HE WAS WORRIED THAT PEOPLE MIGHT ENJOY THEMSELVES. THE SOUND OF LAUGHTER WAS TO PAUL AS THE SMELL OF GARLIC WAS TO COUNT DRACULA. BUSY BUSY, THE FACTORY HUMMED 'BOBBY'S COMING, BOBBY'S COMING.' ANDY WAS IN THE PAINTING STORAGE SECTION MAKING A SELECTION. STEVEN SHORE WAS SWEEPING THE FLOOR AND GERARD MALANGA WAS IN THE BATHROOM SEARCHING FOR THE PERFECT POSE. THE MOST OBVIOUSLY BLATANT OF THE WEIRDOS WERE BANNED FOR THE EVENT. ALL ALONG THE FIRE ESCAPES GROUPIES KEPT THE VIEW: ALL PRESENT SEEMED TO BE TAKING THE ATTITUDE THAT IF BOBBY WERE DROPPED IN THE SNOW IT WOULD STEAM. BARBARA'S PACE SPED UP AS THE FIFTEEN-MINUTE MARK PASSED. MORRISSEY WAS NOWHERE TO BE SEEN. I IMAGINED HIM IN THE BASEMENT, PRAYING TO THE CELTIC GOD OF ENNUI FOR A NO SHOW. THERE WAS NO PLACE FOR LIFE-NEGATING PAUL AMONGST THE FREEWHEELING, HEAVY-PARTYING WET-FINGERED DYLAN MOB. ONE SNIDE PIECE OF SARCASM OUT OF PEON PAUL'S THIN LIPS AND AL ARONOWITZ WOULD HAVE BON MOTED HIM INTO OBLIVION — BESIDES, WHO NEEDS A DOORMAN WHEN THE WALLS HAVE BEEN BREACHED? THIS WAS BARBARA'S MAKE OR BREAK DAY. THE DYLANS AND THE WARHOLS WERE THE GUELPHS AND THE GHIBELLINES OF THE NEW YORK UNDERGROUND SCENE ENGAGED IN A FRATERNAL RUMBLE DEEP IN THAT INSULATED NEW YORK CULTURE WOMB. A BATTLE WAGED NOT FOR PORRIDGE AND BLESSINGS OR CONVERTS AND TERRITORY, BUT FOR PHOTOGENIC CAMP-FOLLOWERS AND MEDIA SPACE.**

I SAW THE DALAI LAMA AND THE POPE IN A HOLIER THAN THOU CONTEST. I COULD SMELL IT COMING, BUT BARBARA'S BRAIN WAS TRANSFIXED WITH THE GRANDIOSE IDEA THAT SHE WAS GOING TO BRING THESE TWO TITANS TOGETHER AND SOMEHOW, SOMEWAY, THE WORLD WOULD BE A BETTER PLACE FOR IT. 'I THINK I SEE HIS CAR,' CALLED A LOOKOUT, AND BARBARA MADE IT TO THE WINDOW IN .02 OF A SECOND. BARBARA'S BEHIND TWITCHED IN FROM OUT OF THE WINDOW AND SHE MURMURED LIKE THE WOODSTOCK PINES, 'HE'S COMING, HE'S COMING.'

DOWN IN THE BASEMENT A PHANTOM BAGPIPE WAILED A DIRGE, AND PAUL STARTED BAYING AT THE MOON AND HANGING GARLIC. 'HE'S HERE, HE'S HERE,' CRIED THE GROUPIES ON THE WATCHTOWER AND A HORDE OF LITTLE GLITTERBOPPERS DETACHED THEMSELVES FROM ANDY AND RAN TO THE WINDOWS TO HANG OUT LIKE TEENIE MOLLY GOLDBERGS WHILE ANDY MADE A MOUE AND GERARD HAD AN ERECTION. AFTER A WHILE THE ELEVATOR MADE RETCHING SOUNDS TO SIGNAL ITS ASCENT AND THE DOORS PARTED AND THE MULTITUDES CAME FORTH. FIRST CAME THIS BROAD BACK, LEANING FORWARD LIKE IT WAS

ABOUT TO GENUFLECT, OR MAYBE... ROLL OUT A RED CARPET!... BUT, NO, IT WAS ONLY A CAMERAMAN WITH THE UBIQUITOUS AIRESFLEX. NEXT CAME TWO LEVITES CARRYING SUNGUNS, A PAUSE, AND THEN THE HORDES DEBOUCHED LIKE OUT OF GROUCHO MARX'S STATE-ROOM IN A NIGHT AT THE OPERA. LEACOCKPENNYBAKERALARONOWITZJONSEYTERRYSIMONNEURWIRTHBETTY, MYRMIDIONS OF DYLANITESCAMPFOLLOWERS, SCRIPTPEOPLECAMERAMEN AND GROUPIES. THEY REMINDED ME OF A VISIGOTH ARMY: THE MEN BIG AND HAIRY, THE WOMEN SMALL AND PLAIN, ARRANGED SO AS TO SET OFF BOBBY LIKE A DIAMOND IN THE ARSEHOLE OF A MULE. THE CIRCUS HAD COME TO TOWN, IT WAS HERETO DAY AT THE ZOO — CAREFULLY CONTRIVED AND WELL ORCHESTRATED. UP IN WOODSTOCK ALBERT GROSSMAN STARTED COUNTING SHEKELS AND EATING HONEY, WHILE IN THE BASEMENT PAUL MORRISSEY ENTERED A COFFIN FILLED WITH SOIL FROM HIS NATIVE SCOTLAND AND SLOWLY SLOWLY CLOSED THE LID, CONTENT IN THE KNOWLEDGE THAT SOMETHING WOULD GO WRONG.

I PROWLED THE SIDELINES, HERE A CLICK, THERE A CLICK, WHILE THE DYLAN PENNYBAKER CREW DID THEIR SHOOT. I DUTIFULLY DOCUMENTED A DISCUSSION INVOLVING DYLAN, WARHOL, JOHN BROCKMAN AND HIS CASH REGISTER (HOW MANY SIXTY PERCENTS MAKE A HUNDRED?) THEN BARBARA ASKED EVERYBODY TO MOVE INTO THE FILMING AREA SO THAT SHE COULD STICK HER LITTLE BOLEX IN. I BOPPED AROUND TRYING TO FIGURE OUT WHAT WAS WHAT UNTIL BARBARA FINISHED HER SHOOT AND THEN I FLASHED THAT THESE PEOPLE WERE THERE ONLY FOR MY CAMERA. THEY WERE SITTING TOGETHER, BUT THEIR EXISTENCE WAS PREDICATED ON BEING RECORDED. THEY WERE CHILDREN OF DARKNESS VIVIFIED BY MY LIGHTS. I SEIZED MY MOMENT. I PUT THE SPOTS DIRECTLY ON THEM, OBLITERATING ALL SHADES AND BACKGROUND (INCIDENTALLY SHUTTING OUT THE MOVIE PEOPLE). IT WAS MY STAGE. DID THESE PEOPLE WANT EXPOSURE, BOY WOULD I GIVE THEM EXPOSURE. ALL THE EXPOSURE THE FLOODS WOULD ALLOW. I TOLD ANDY AND BOBBY TO PUT ON SHADES AND LOOK DIRECTLY INTO THE CAMERA... I TOLD GERARD TO LOOK TO THE SIDE. GERARD TRIED TO UPSTAGE EVERYBODY WITH A HEADBACK PROFILE POSE WHICH LEFT HIM LOOKING LIKE HE HAD WHIPLASH FROM GIVING TOO MUCH HEAD THE PREVIOUS EVENING. NONE RELATED TO THE OTHER. THE SCENE REMINDED ME OF THREE MERCHANT PRINCESSES DONE BY SOME FLEMISH PAINTER, AND I SHOT THEM THAT WAY.

A JEWISH POTLATCH COMMENCED. ANDY GAVE BOBBY A GREAT DOUBLE IMAGE OF ELVIS. BOBBY GAVE ANDY SHORT SHRIFT. SHOOTING AND PLUNDERING FINISHED, THE DYLAN GANG HEADED FOR THE DOOR, ME AND MY NIKON AT THEIR HEELS. THEY LEFT AS THEY HAD ENTERED; ACTING AS IF THE JEWS LEFT THEIR DOORS OPEN FOR BOBBY ON THE PASSOVER. BOBBY THE WAIF HAD EMERGED AS ROBERT THE TRIUMPHANT. THEY DEPARTED HAVING TIED THE ELVIS IMAGE TO THE TOP OF A WOODSTOCK STATION WAGON, LIKE A DEER POACHED OUT OF SEASON. MUCH LATER, BOBBY TOLD ME HE'D TRADED THE ELVIS FOR ALBERT GROSSMAN'S COUCH.

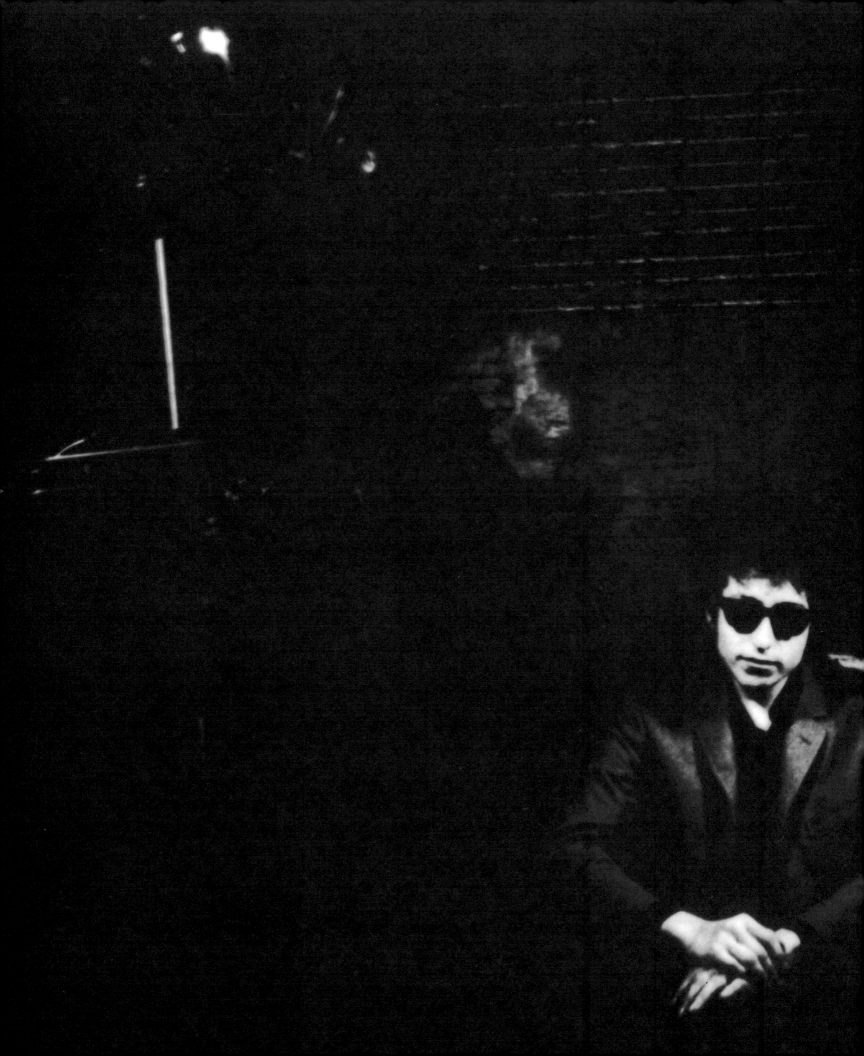

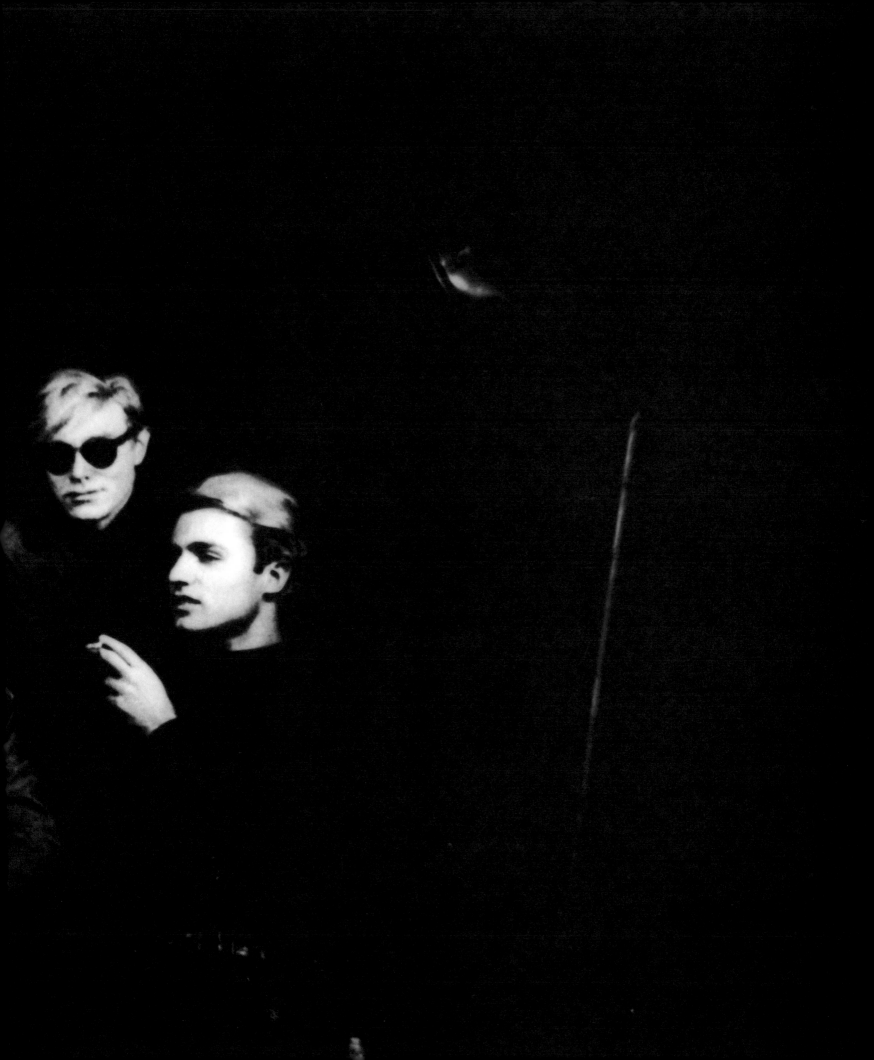

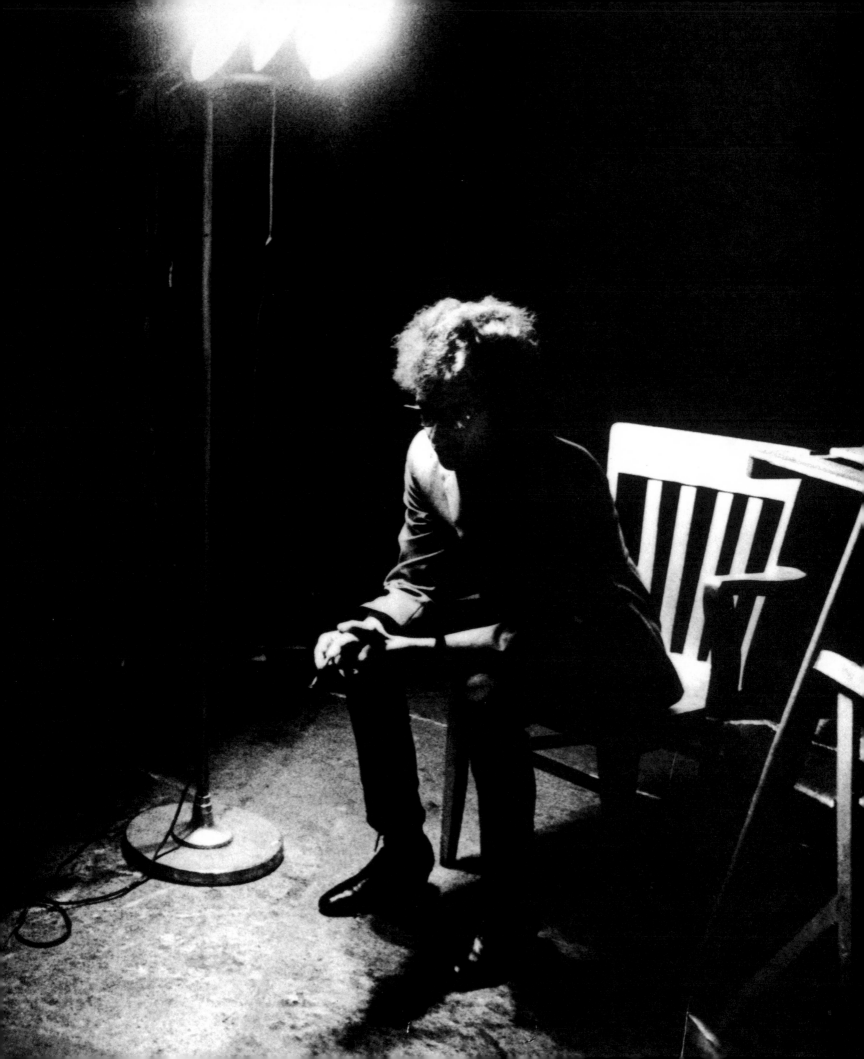

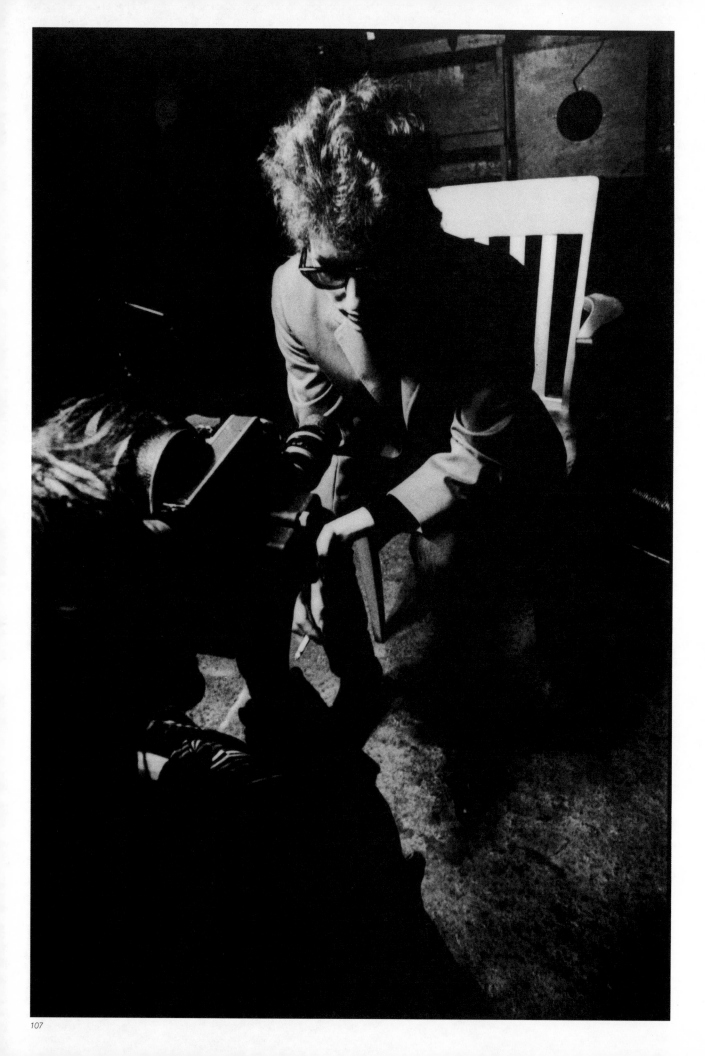

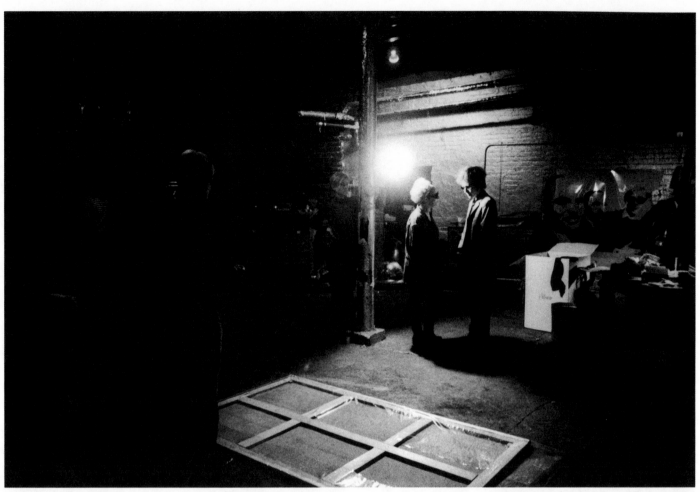

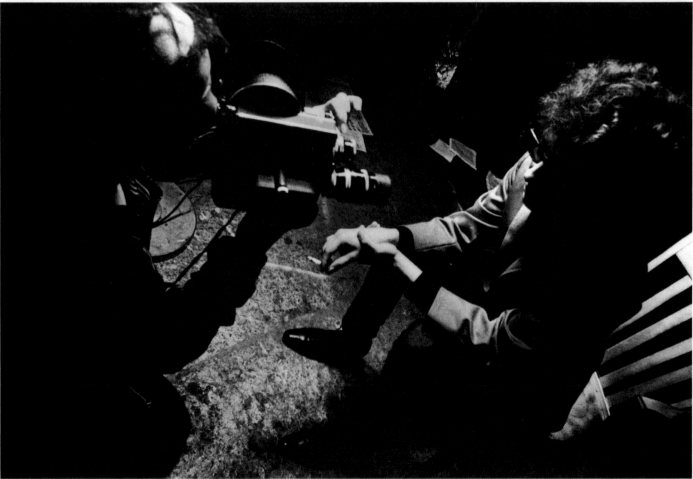

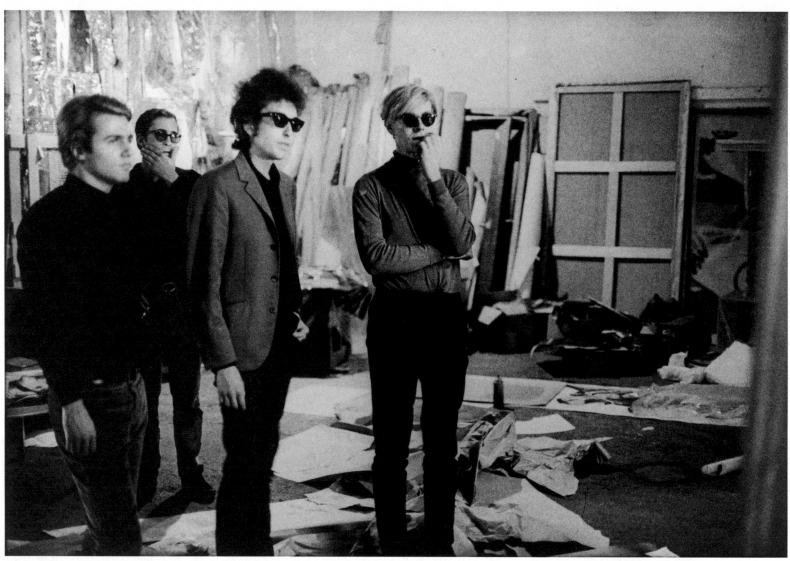

110

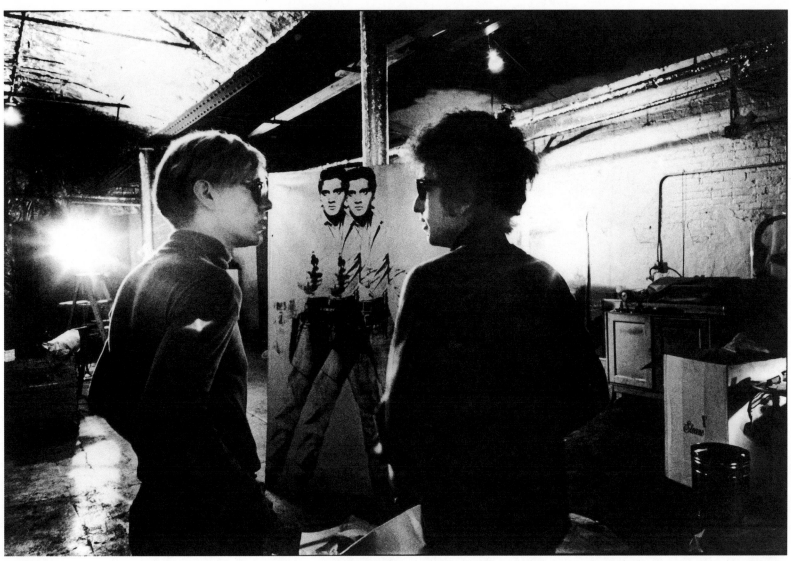

111

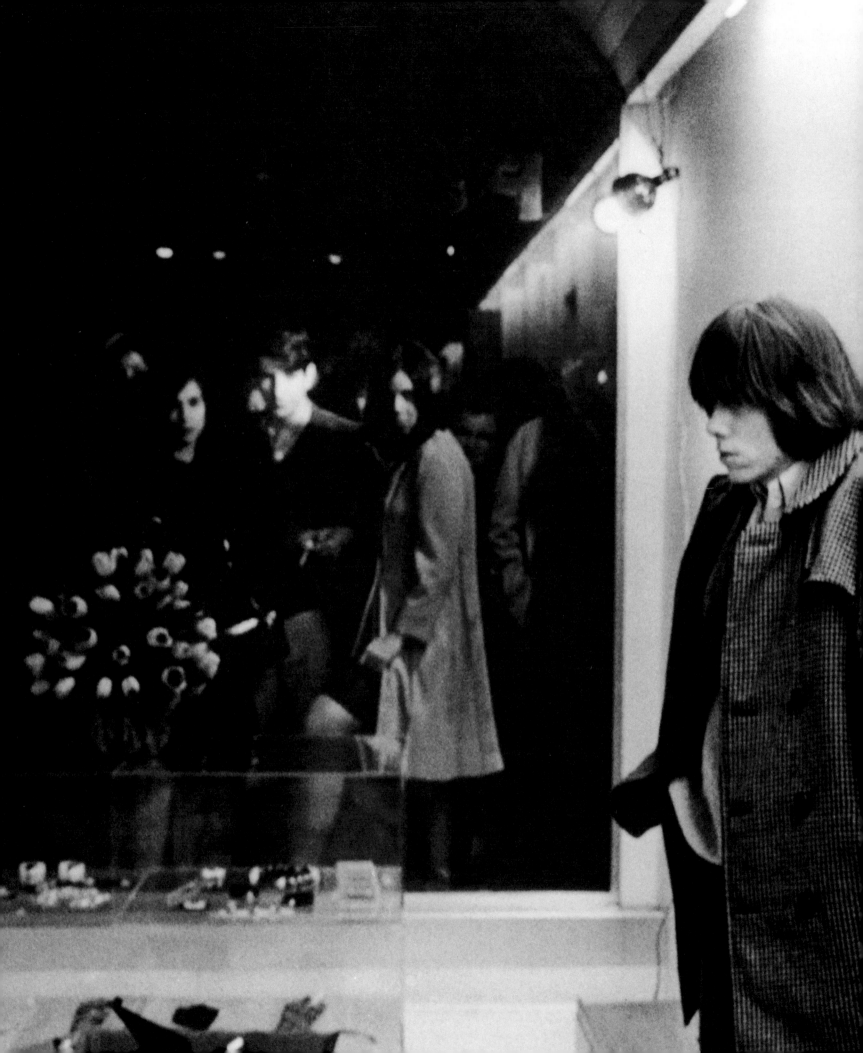

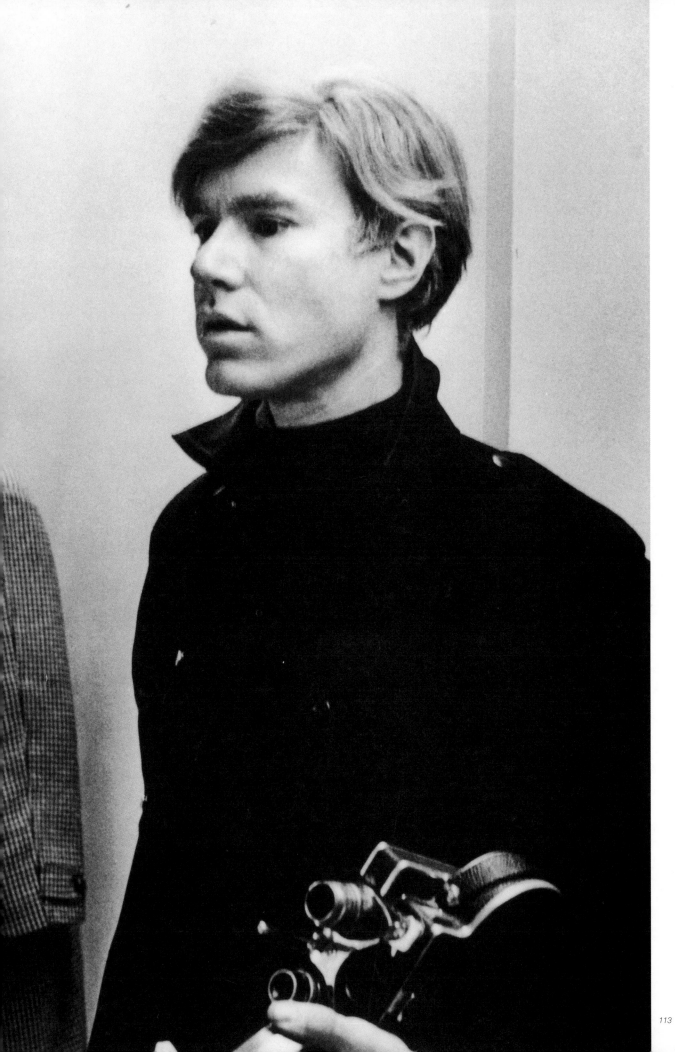

113

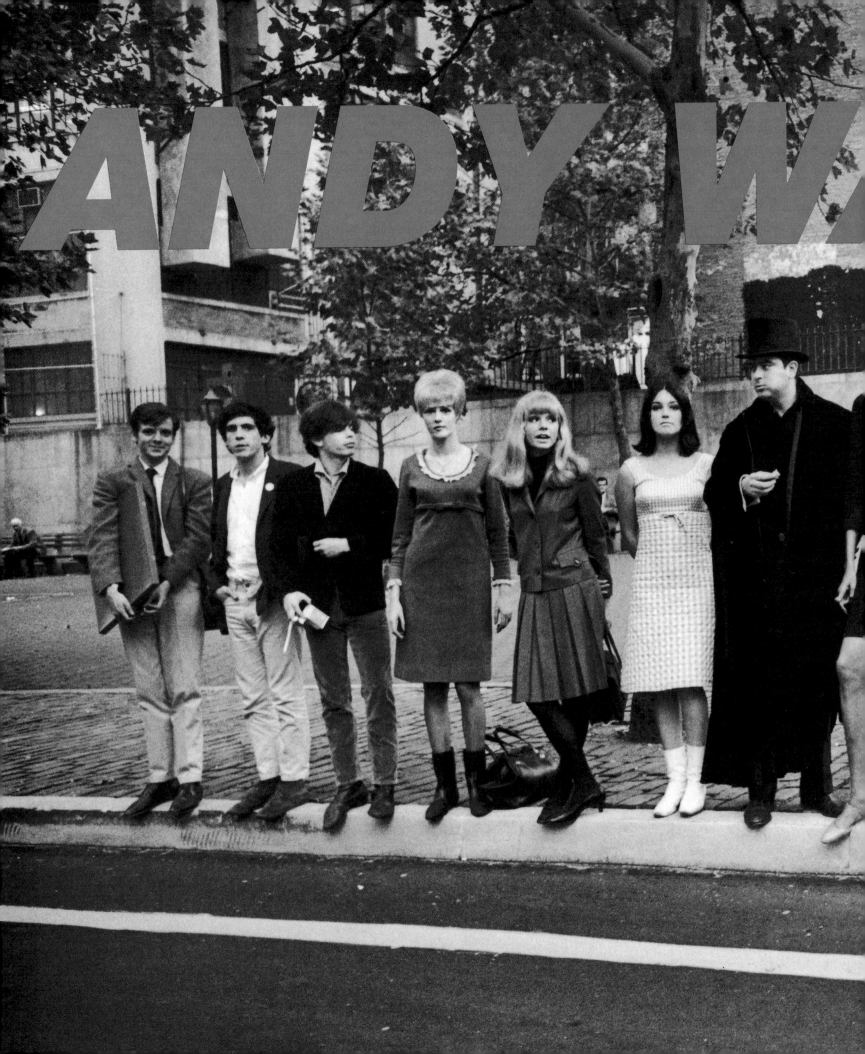

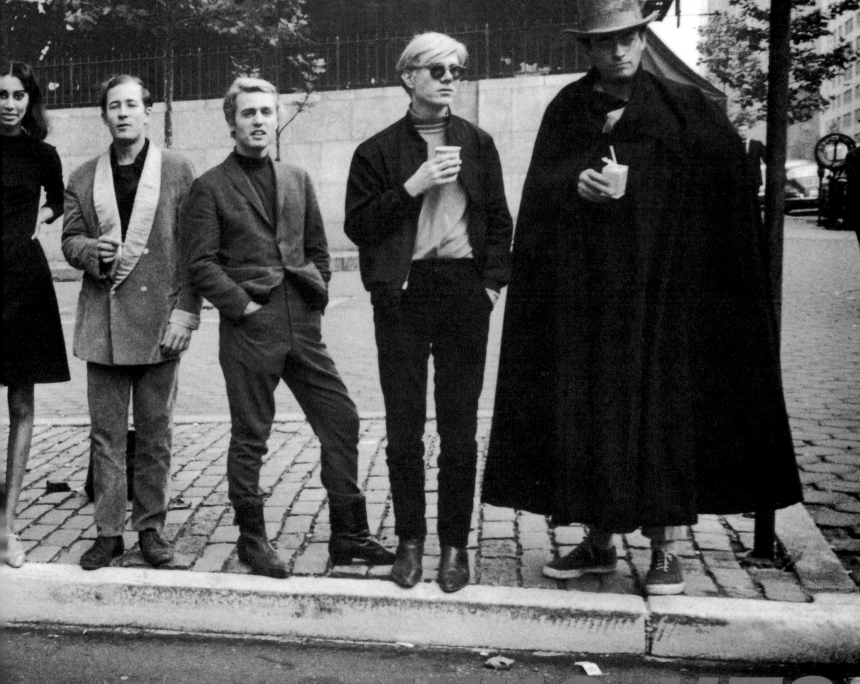

ARHOL

WHO HE?

ANDY WAS LIKE A GREEK GOD; A TITAN. HE ATE HIS CHILDREN. HE GOT THE KIDS INTO HIS CLAWS BY HAVING OTHER PEOPLE AROUND THINKING THEY WERE CELEBRITIES. IF YOU ARE SLIGHTLY BENEATH A SUPERSTAR, WHAT ARE YOU? A STAR, RIGHT! MAYBE THE BREAK-UP OF THE AMERICAN NUCLEAR FAMILY HAD SOMETHING TO DO WITH IT. MAMA AND PAPA WERE TOO BUSY MAKING THEIR FORTUNES, SO THESE PEOPLE, UPPER MIDDLE CLASS LATCHKEY CHILDREN LIKE CONTEMPORARY ENGLISH SOCCER THUGS BANDED INTO ANDY'S TRIBE AND WENT TRASHING. THEY WERE OUTCASTS AND ANDY WAS LIKE THE NANNY. IN ANDY'S KINDERGARTEN ANYTHING WAS ACCEPTABLE, YOU DID WHATEVER YOU WANTED TO DO, SOMEONE WOULD CLEAN UP THE MESS LATER. DURING SCHOOL EXCURSIONS THE BOYS MAY HAVE WALKED DOWN THE STREETS, BUT THEY WERE NEVER ON THE STREETS. I WENT OUT CRUISING WITH THEM A COUPLE OF TIMES. THE BOYS WOULD PUT ON THEIR LEATHER JACKETS AND MARCH UP AND DOWN SIXTH AVENUE, AROUND SHERIDAN SQUARE. ANDY WOULD GIGGLE AND SAY: 'WELL, WE'RE CRUISING, WE'RE CRUISING!' IT WAS LIKE A CHILDREN'S GAME OF 'FOLLOW MY LEADER', AND THEN TO AN ALL-NIGHT ICE CREAM PARLOR...

AT THE FACTORY THERE WERE A LOT OF DABBLERS IN DRUGS, BUT ANDY WAS AFRAID OF DRUGS. THEY WEREN'T EXPLORERS, THEY WERE EXPERIMENTERS. BIG DIFFERENCE: AN EXPLORER CAN FALL OFF THE EDGE OF THE WORLD, AN EXPERIMENTER CAN ALWAYS BACK AWAY FROM THE TEST-TUBE. THE POWER ELITE, ANDY AND PAUL, DIDN'T USE DRUGS. THEY WERE AFRAID TO LOSE CONTROL, AND CONTROL WAS THE NAME OF THEIR GAME. ANDY CONVERTED HIMSELF FROM BEING ANDY WARHOLA OF PITTSBURGH, PENNSYLVANIA, SON OF A COALMINER, INTO BEING A MAJOR FORCE BEHIND AMERICAN COMMERCIAL SOCIETY AND THE ARTS. WHEN YOU MOVE FROM BEING A SQUIB IN THE VILLAGE VOICE TO THE POINT WHERE YOU OWN YOUR OWN MAGAZINE, YOU'RE NO LONGER A MEDIA-OBJECT, BUT THE MEDIA BELONG TO YOU. HE USURPED THEIR POWER. BUT HE NEVER GOT THROUGH TO THE REAL PEOPLE. I SPENT AN AFTERNOON WALKING THROUGH HARLEM, STOPPING KIDS AND SAYING: 'HEY, WHY DON'T YOU TELL ME ABOUT ANDY WARHOL.' ALMOST 100 PERCENT OF THE

REACTIONS WERE: 'WHO HE?'. THEY FINALLY GOT TO KNOW HIM WHEN HE DID THAT TELEVISION COMMERCIAL. IT HAD ANDY ON CAMERA HOLDING A PUG DOG IN HIS ARMS. OFF CAMERA-VOICE: 'WHAT IS THE MOST EXCITING THING THAT HAPPENED TO YOU TODAY?', AND ANDY LOOKS WITH A BLANK LOOK AND THEN THE PUG YAWNS. WHEN THAT COMMERCIAL WAS RUNNING AND I WAS ASKING THESE BLACK KIDS ABOUT ANDY WARHOL, THERE WERE TWO LITTLE GIRLS IN THE SUBWAY; I STUCK MY TAPE RECORDER UNDER THEIR NOSES AND SAID: 'HEY KIDS WHAT DO YOU THINK ABOUT ANDY WARHOL?' ONE OF THE GIRLS LOOKED UP AND SAID: 'WHO HE?' THE OTHER GIRL SAID: 'OH, HE THE FAGGOT ON TELEVISION WITH THE DOG!'

SO ANDY WAS LIKE A ROCK THROWN INTO A POOL, CAUSING INFINITE SURFACE RIPPLES, BUT NO PROFOUND EFFECT. AT THE END HIS BIGGEST LEGACY SEEMED TO BE SEVERAL PLASTIC WATCHES, WHICH SOLD FOR TOO MUCH MONEY TO A GROUP OF PEOPLE MAKING FOOLS OF THEMSELVES. MY LEGACY TO ANDY WAS VALERIE SOLANIS. I WAS THE PERSON WHO INTRODUCED HER TO ANDY... VALERIE SOLANIS, A TERRIBLE SHOT. SHE ACTUALLY PROVED MASCULINE SUPERIORITY — I DON'T KNOW TOO MANY MEN WHO COULD STAND LIKE ABOUT 2.5 FEET AWAY FROM TARGET WITH A .38, AND BLOW IT. BRIDGET POLK'S SISTER GAVE VALERIE MY TELEPHONE NUMBER. I WAS SUPPOSED TO BE LOOKING AT THIS PLAY THAT VALERIE WAS WRITING: UP YOUR ASS. I SAID TO MYSELF: 'GOD, WHAT A BORE, I'LL GIVE THIS TO ANDY.' SO I SENT HER UP TO THE FACTORY. ANDY HAD ALL THESE PEOPLE AROUND HIM TO PROTECT HIM, BUT SUDDENLY IT WAS LIKE ALL HIS WORST FEARS WERE REALISED — SOMETHING DID COME THROUGH: VALERIE SOLANIS. IT WENT BANG BANG BANG. MAYBE THAT'S WHY ANDY TURNED COMPLETELY AFTER THE SHOOTING. HE REALISED THERE WERE NO DEFENSES. THE ONLY DEFENSE WAS RETREAT. AFTER VALERIE FUCKED UP, WHAT YOU HAD WAS ANDY II. HE LOOKED THE REAL THING IN THE EYE. HE GOT SMACKED DOWN TO REALITY... INTIMIDATIONS OF MORALITY. THERE IS NOTHING LIKE GETTING SHOT TO KILL A PARTY. ANDY BECAME A CORPORATION, AND THAT WAS THE END OF THE FACTORY BEING THE PLACE WHERE ANYTHING COULD HAPPEN, INCLUDING TAKING POT-SHOTS AT THE HOST.

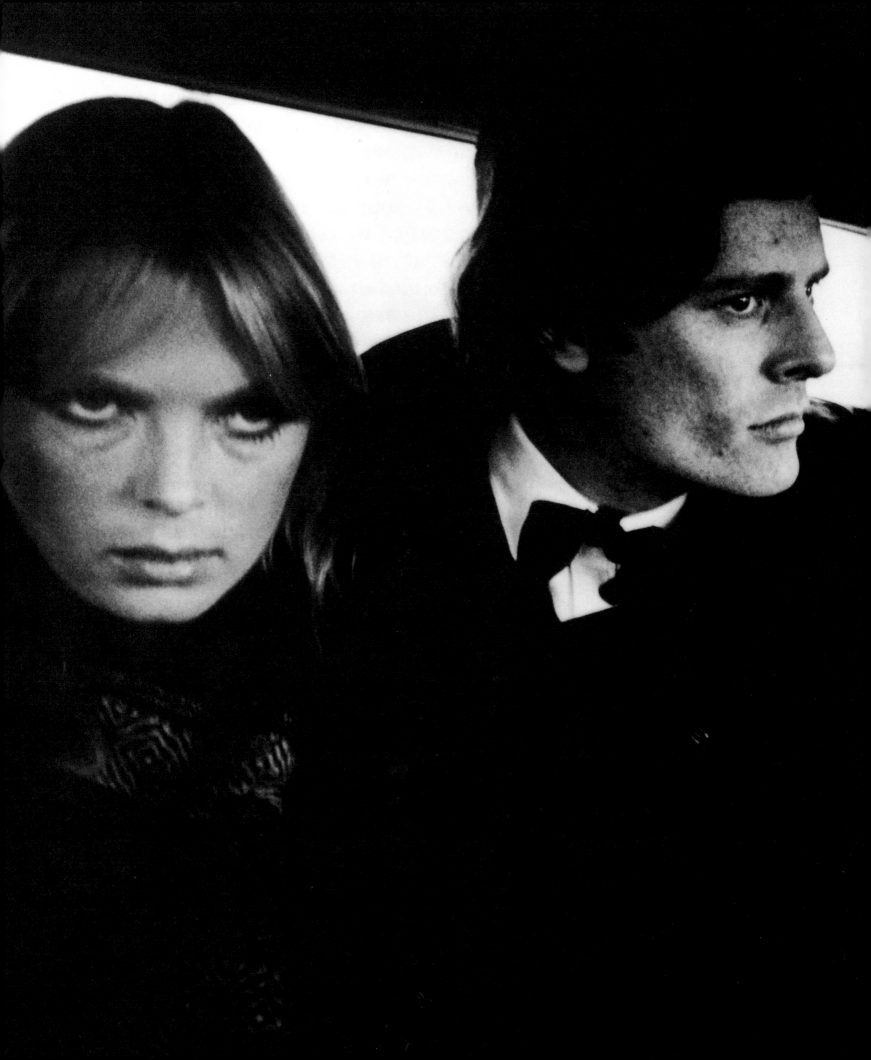

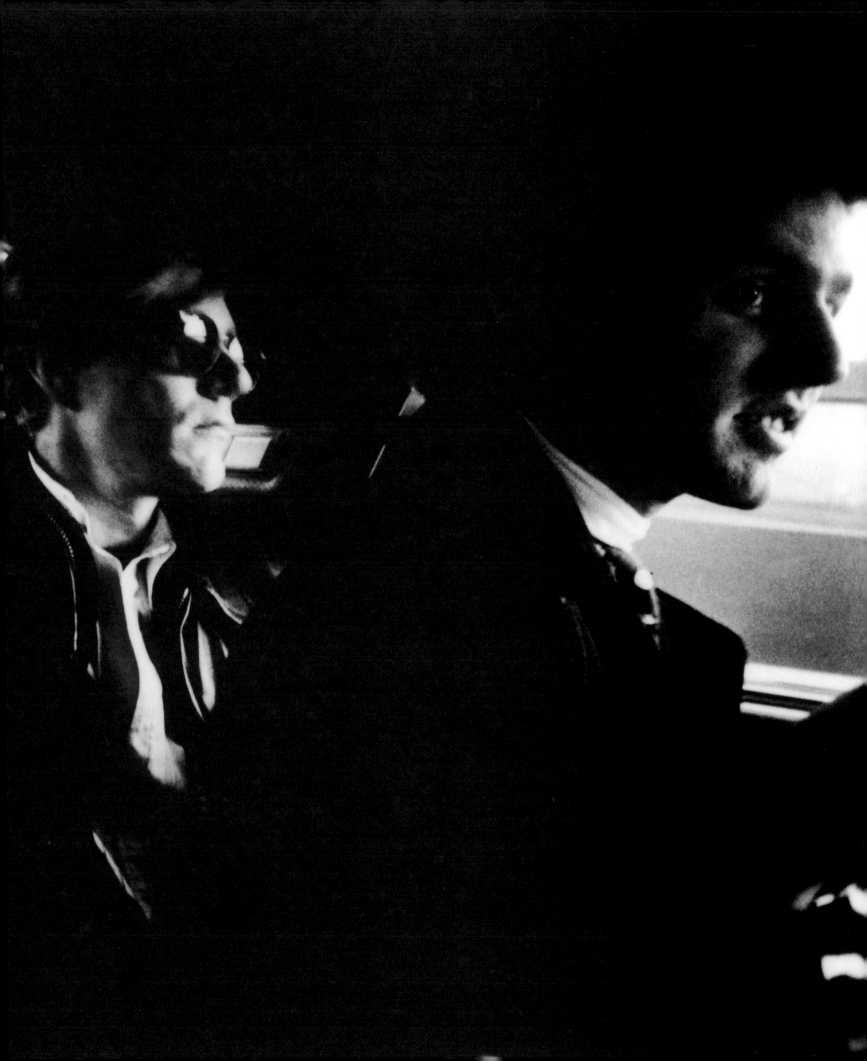

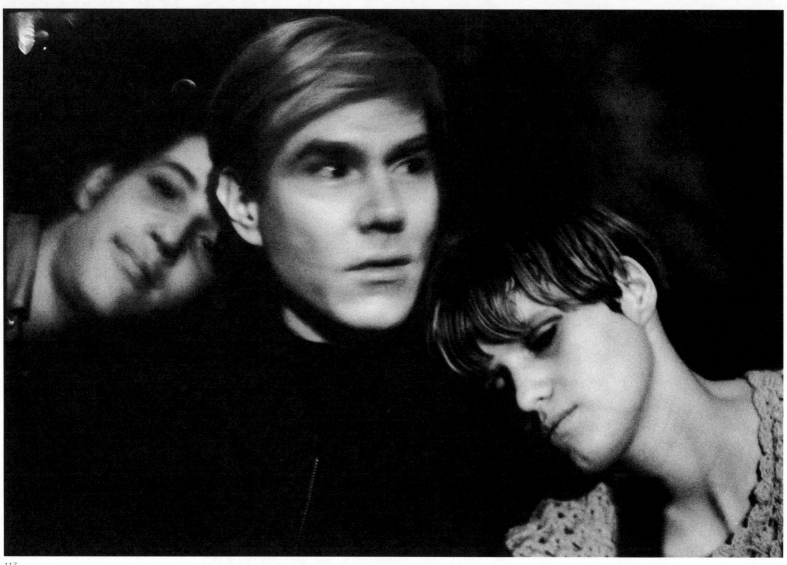

117

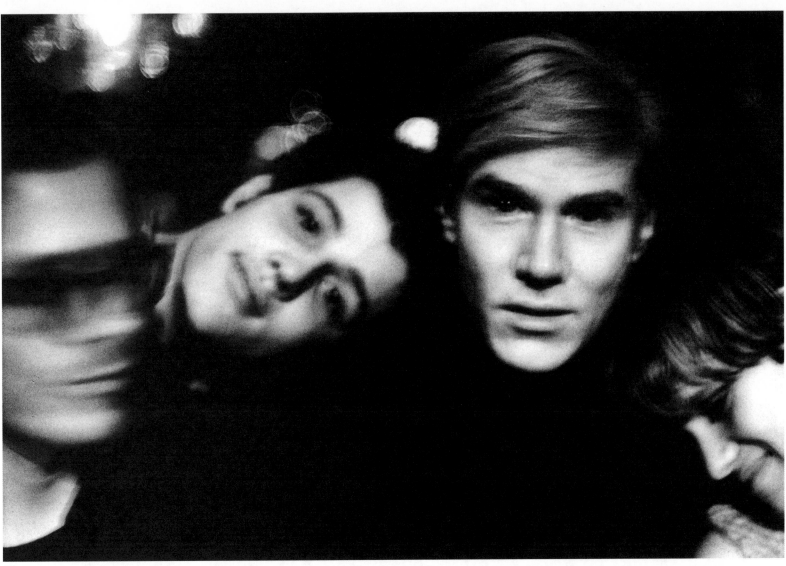

118

ANDY IN THE SLUMS. AFTER HANGING AROUND THE FACTORY FOR A WHILE I LEARNED A LITTLE BIT ABOUT SOME OF THE TRICKS AND TECHNIQUES... UP-TIGHT, YOU KNOW. THAT WAS THE SITUATION: EVERYBODY WAS UP-TIGHT, STRESS PSYCHOLOGY. SO I SAID TO MYSELF: 'WELL ANDY, WE'RE GONNA MAKE YOU A BIT UP-TIGHT AND SEE HOW YOU REACT.' I BROUGHT HIM DOWN TO AN ENVIRONMENT WHICH WAS THE ONE I KNEW HE WAS TRYING TO AVOID, THEN I SAID: 'HERE, LET'S SEE WHAT YOU DO IN THE SUNLIGHT.'

A FELLOW PHOTO-JOURNALIST, LARRY FINK, CAME DOWN TO THE FACTORY ON SOME SORT OF ASSIGNMENT. I TRIED TO USE LARRY AS A COVER TO MANIPULATE ANDY A LITTLE BIT. OUR SET-UP WAS THAT LARRY WAS GOING TO TAKE ANDY DOWN INTO THE LOWER EASTSIDE AND THE FAR WESTSIDE OF GREENWICH VILLAGE AND PHOTOGRAPH HIM AND I WAS GOING TO PHOTOGRAPH ANDY BEING PHOTOGRAPHED. WE DRAGGED ANDY OUT INTO THE REAL WORLD. ANDY WOULD DO ANYTHING FOR PUBLICITY, PISS OFF THE EMPIRE STATE, EAT DANONE YOGHURT, FUCK KING KONG... IF IT PAID, ANDY PLAYED. BUT ONCE HE WAS WALKING AROUND IN THE SLUMS, ANDY GOT UPSET. HE JUST WANTED TO GET IN AND OUT AS QUICKLY AS POSSIBLE. SOME KIDS CAME UP TO LOOK AT THE STRANGE ANIMALS, BUT ANDY COULDN'T RELATE TO THEM, HE WAS JUST TOO FRIGHTENED. MAYBE HE THOUGHT THE BLACK WOULD COME OFF, ON HIM. THE THING IS THAT, ANDY GROWING UP WHERE HE GREW UP, YOU WOULD HAVE EXPECTED HIM TO FEEL MORE AT EASE WITH THE POOR KIDS. THINKING OF THE HOURS AND HOURS HE WOULD SPEND TALKING TO ALL THE UNIVERSITY KIDS THAT CAME TO INTERVIEW HIM ... WITH THE EGG-HEADS IT WAS FEEL ME, TOUCH ME, WITH THE SLUM KIDS IT WAS YOU'RE BLACK, STAY BACK!

AS THESE 'SMELLY-PUSHY-UGLY' KIDS CAME CLOSE, ANDY FREAKED OUT, HE SAW HIS LIFE PASS IN FRONT OF HIM. 'NICE KID, NICE KID. HERE, LET ME PLAY A GAME FOR YOU, SONG AND DANCE — SURE, WHY NOT... GET ME OUT OF HERE!!!' THEN HE BECAME A SHOWMAN. HE STARTED CLOWNING AROUND, RUNNING UP AND DOWN THE STREET. HE MADE BELIEVE HE WAS RUNNING AWAY FROM THE KIDS AND CLIMBED INTO THIS BARREL, HIS HIDE-OUT, POSING. HE USED INGRID AND GERARD AS HIS FOILS TO MAKE SURE THAT NOBODY COULD COME TOO CLOSE TO HIM, OR MAYBE EVEN TOUCH HIM, UGH! IN THE MEANWHILE WE WERE TAKING PHOTOGRAPHS. THE CAMERA WAS ALL-IMPORTANT. FOR THE FACTORY-CROWD ITS PRESENCE ALWAYS SEEMED TO CHANGE EVERYTHING INTO A MAGIC SESSION. THEY STARTED TO DO THINGS. BUT FOR THE 'REAL' PEOPLE IN THE SLUMS IT DIDN'T WORK THAT WAY. THE KIDS JUST GOT BORED AND LEFT. AND THIS BIG, BROAD BUTCHER THAT HAD BEEN STANDING LOOKING FROM A DOORWAY SLOWLY APPROACHED, LOOKED AT THE WEIRDOS, WAS PHOTOGRAPHED AND MOVED AWAY. HE COULDN'T CARE LESS, HE PROBABLY HAD MORE IMPORTANT THINGS TO DO... LIKE CUT MEAT.

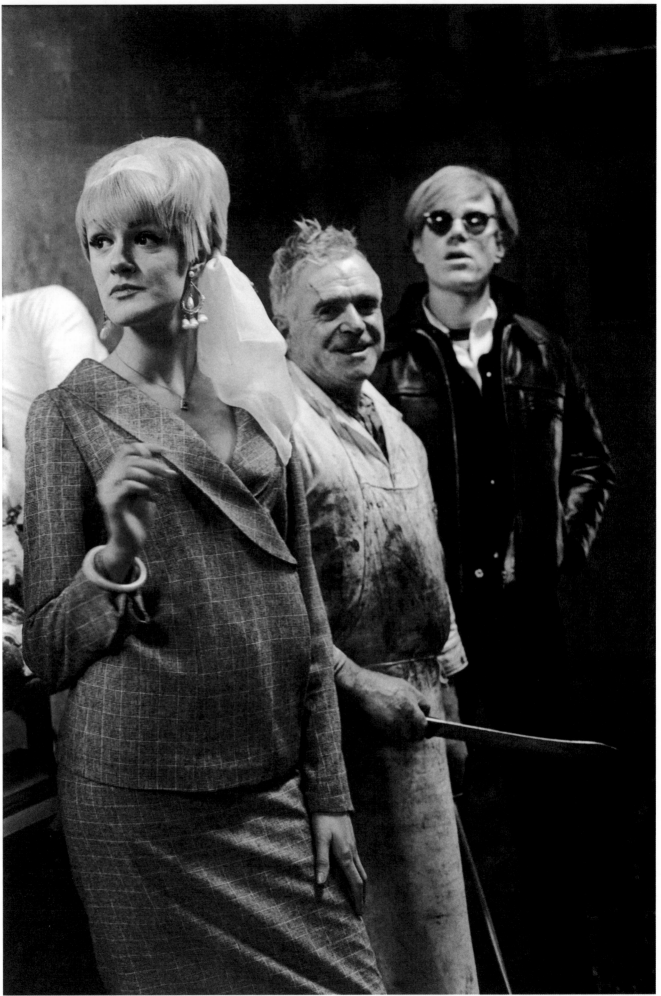

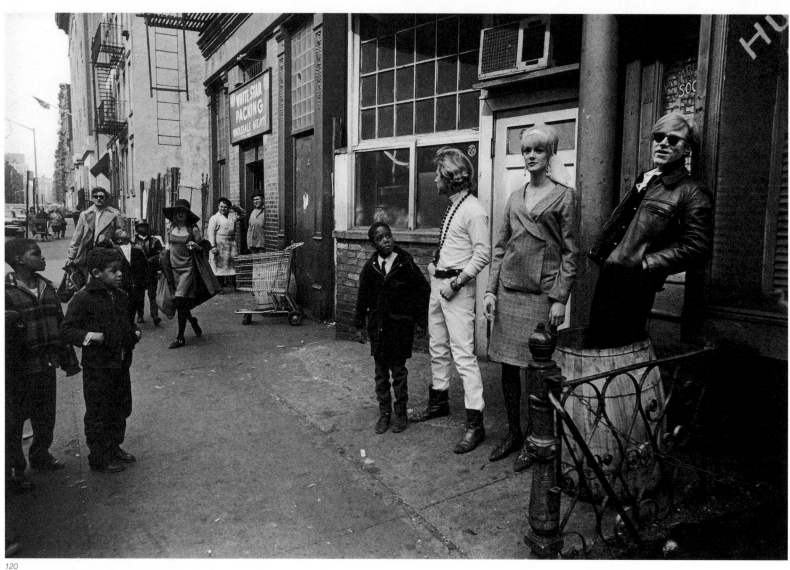

120

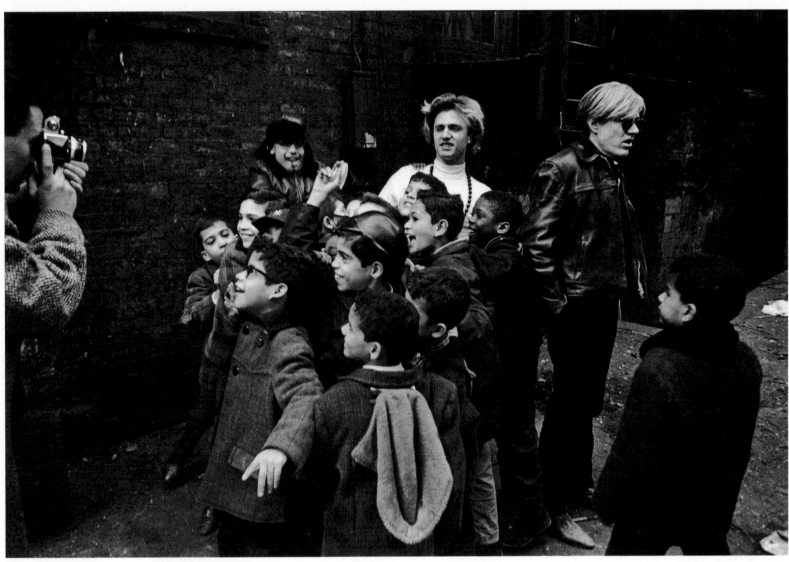

121

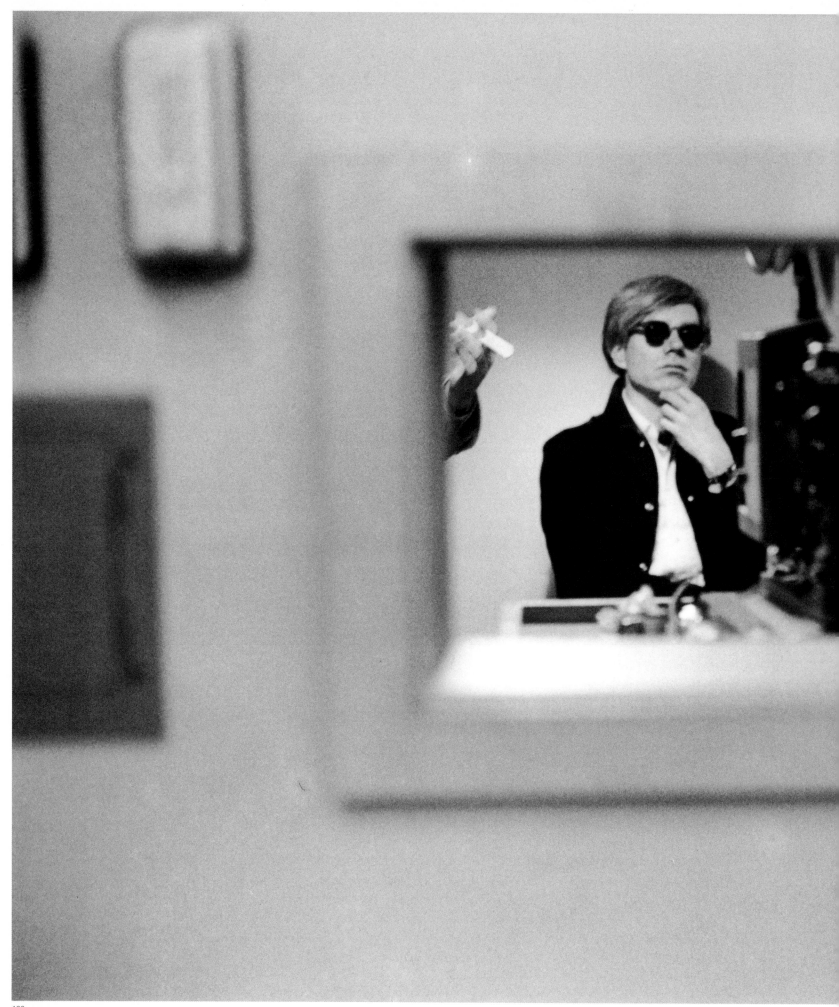

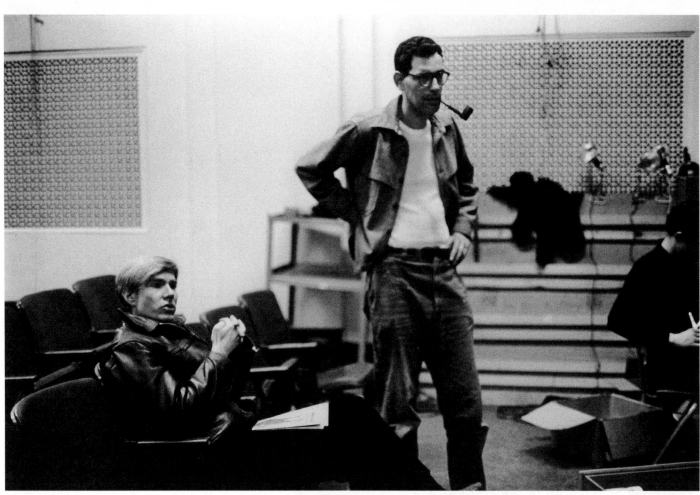

123

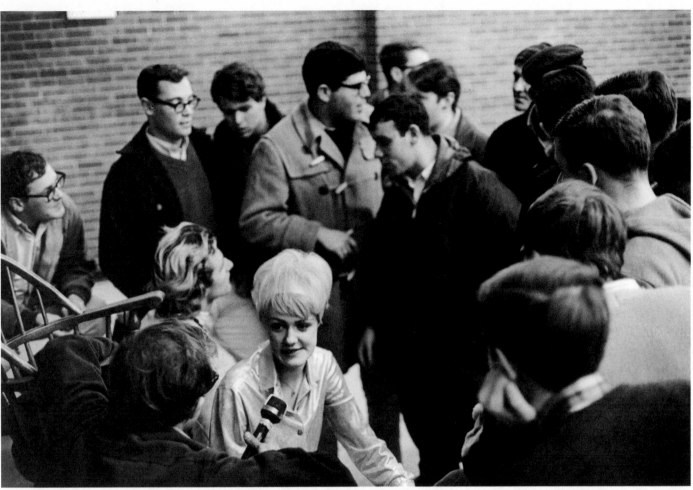

124

125

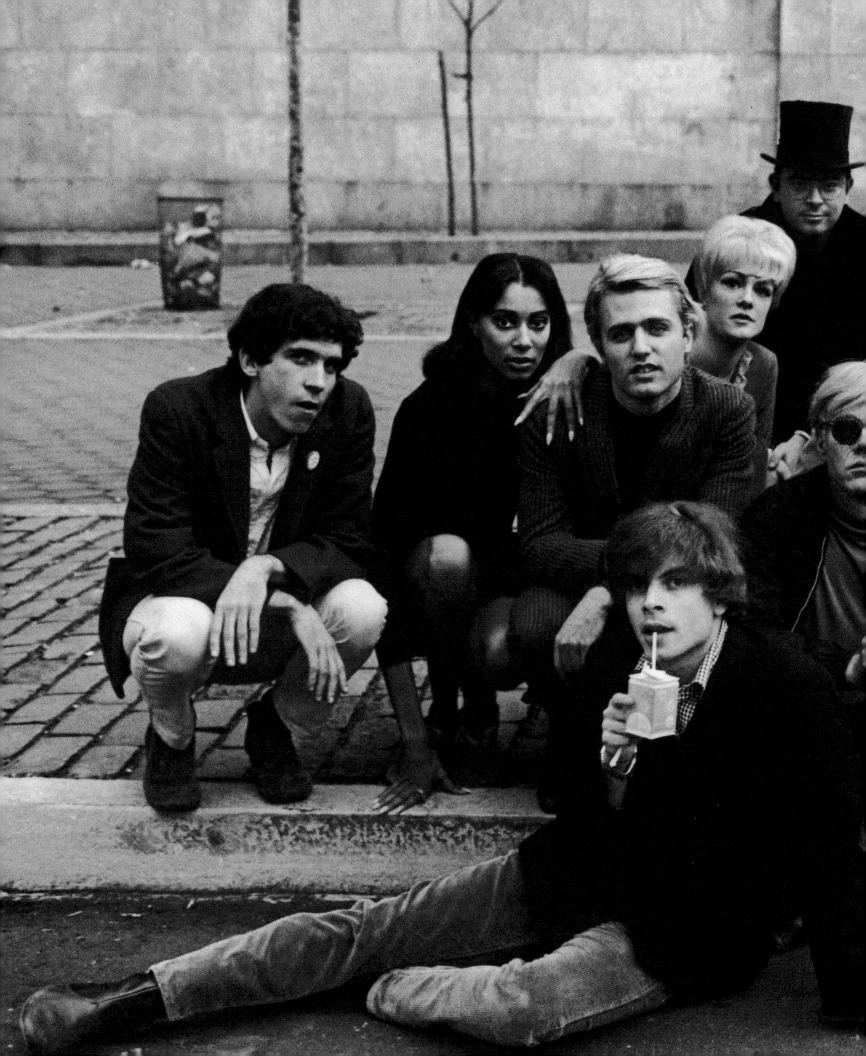

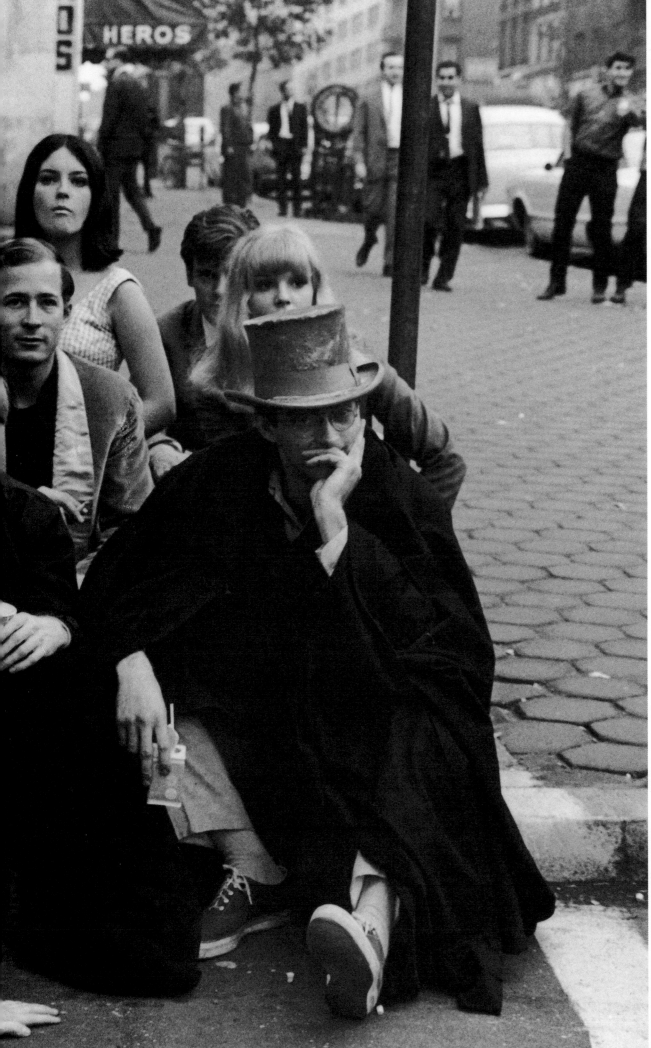

126

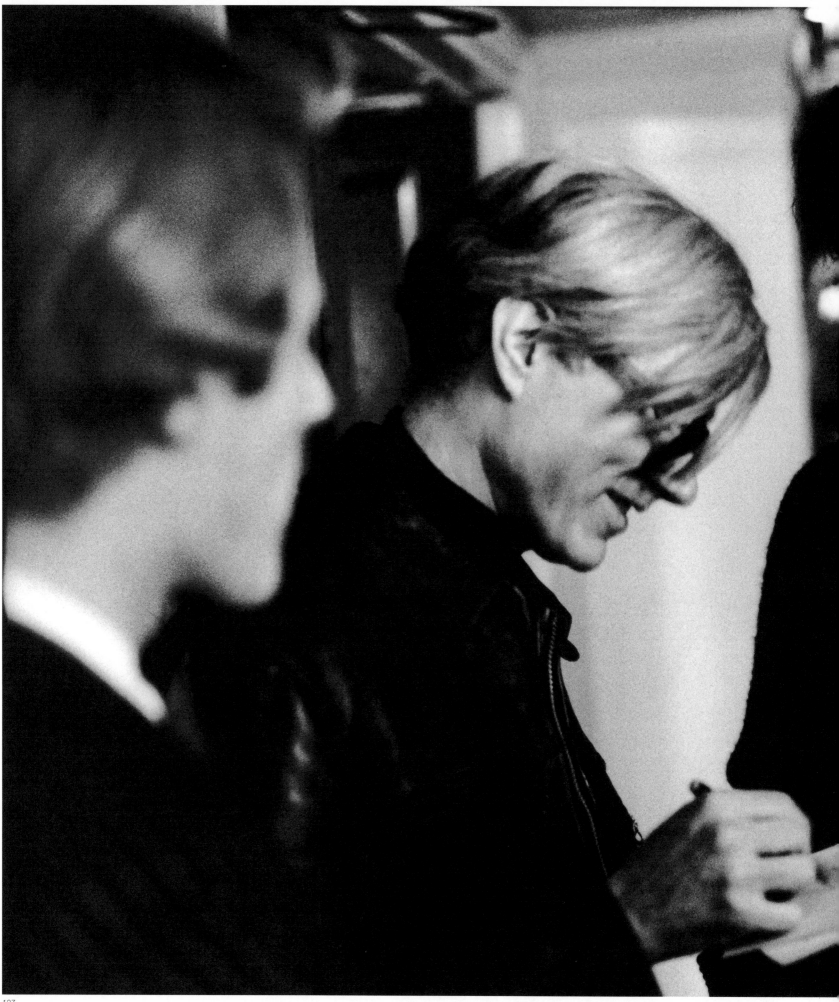

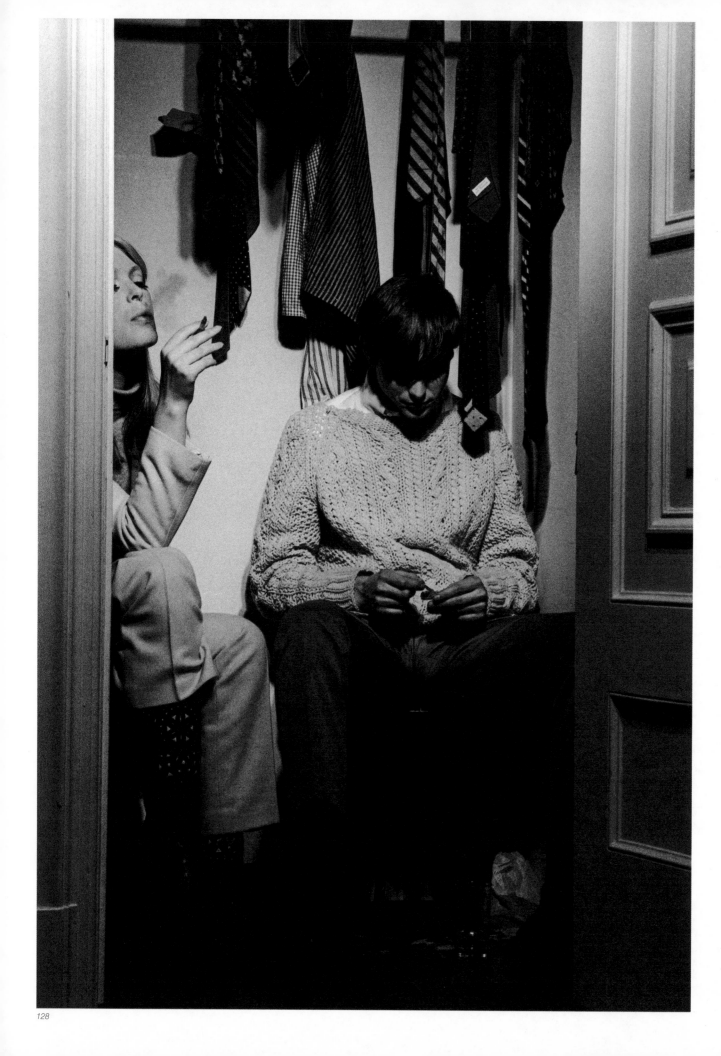

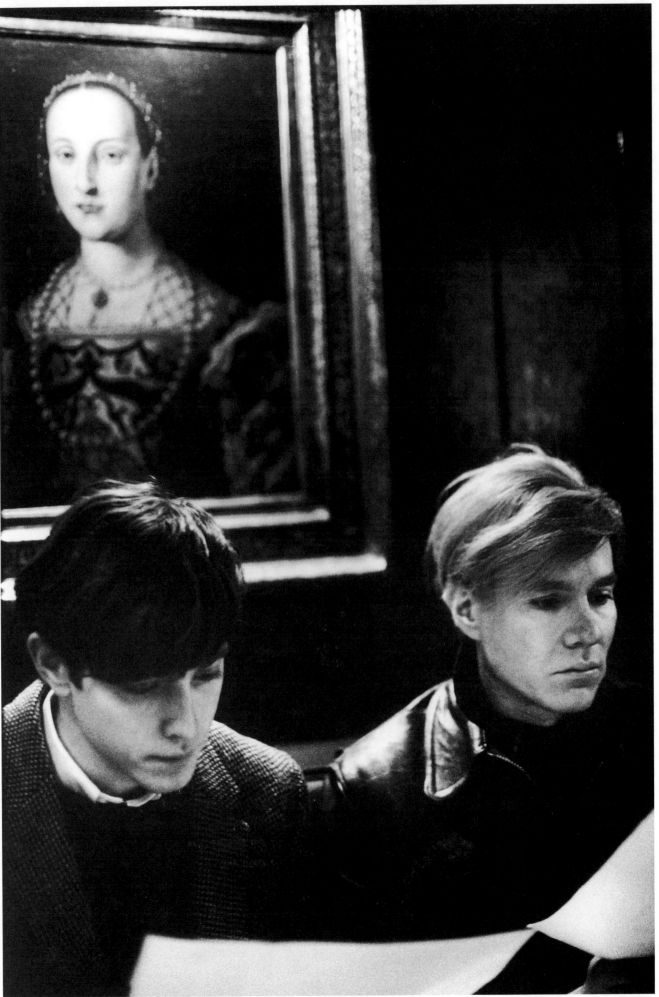

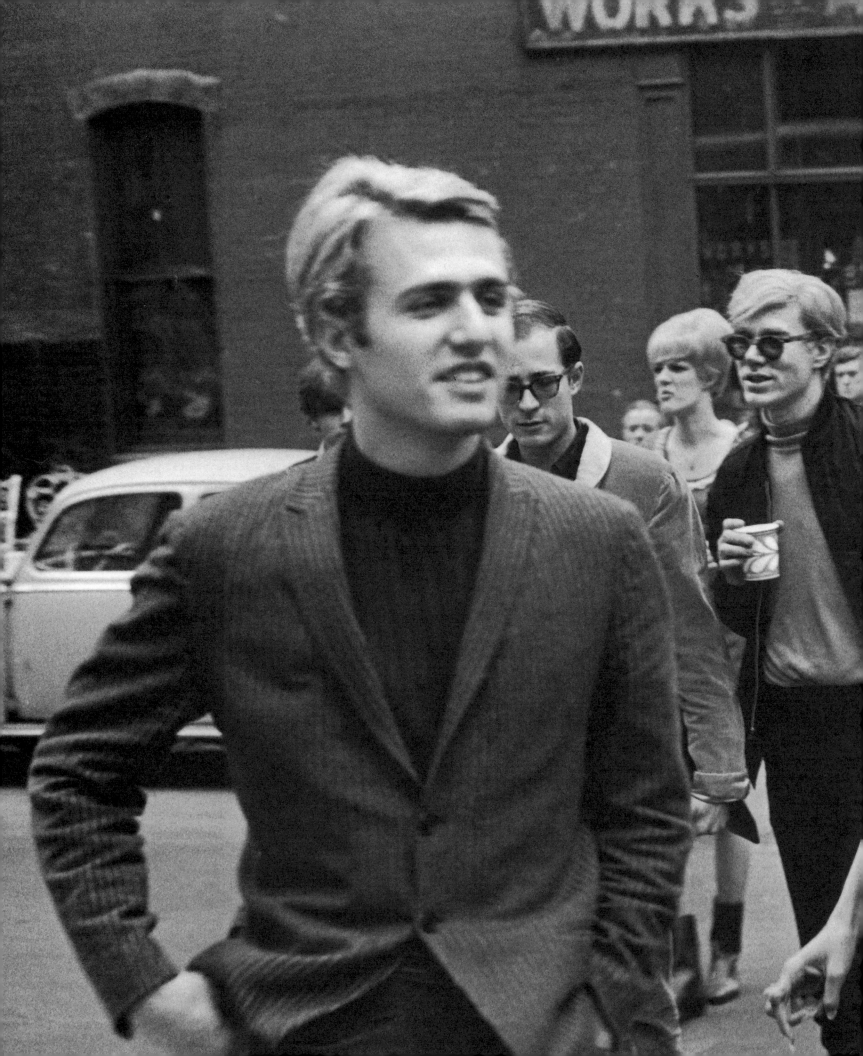

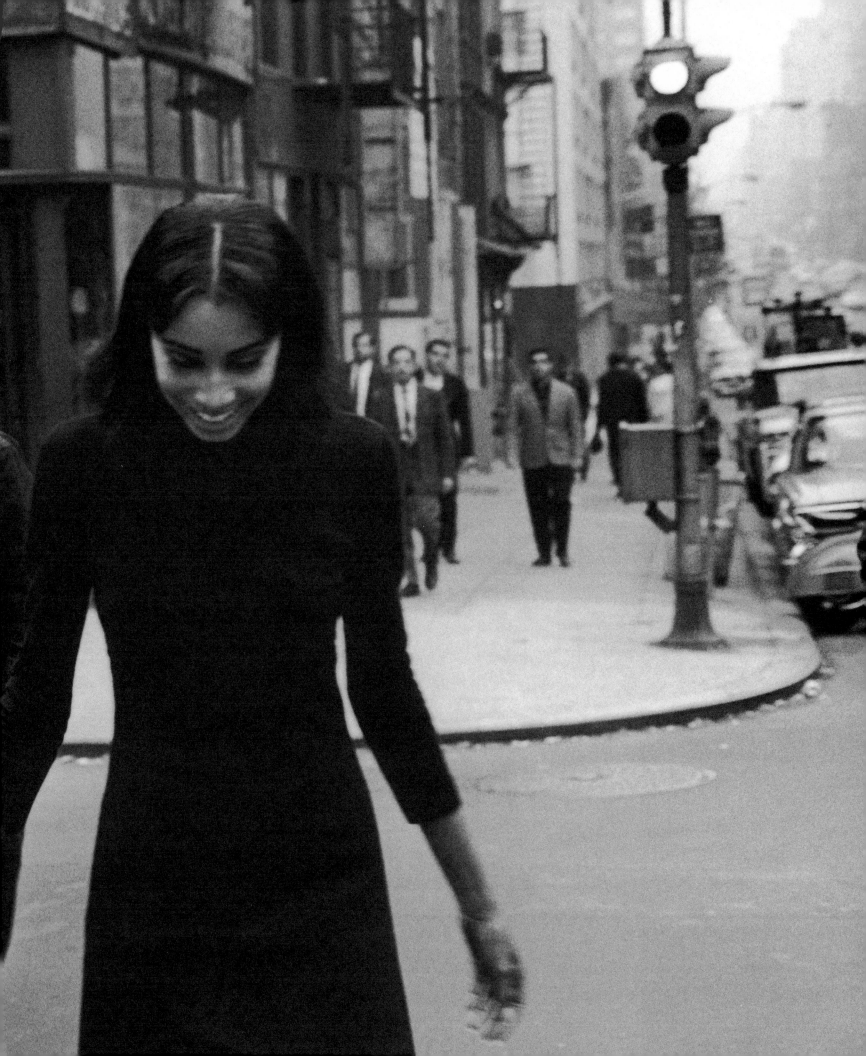

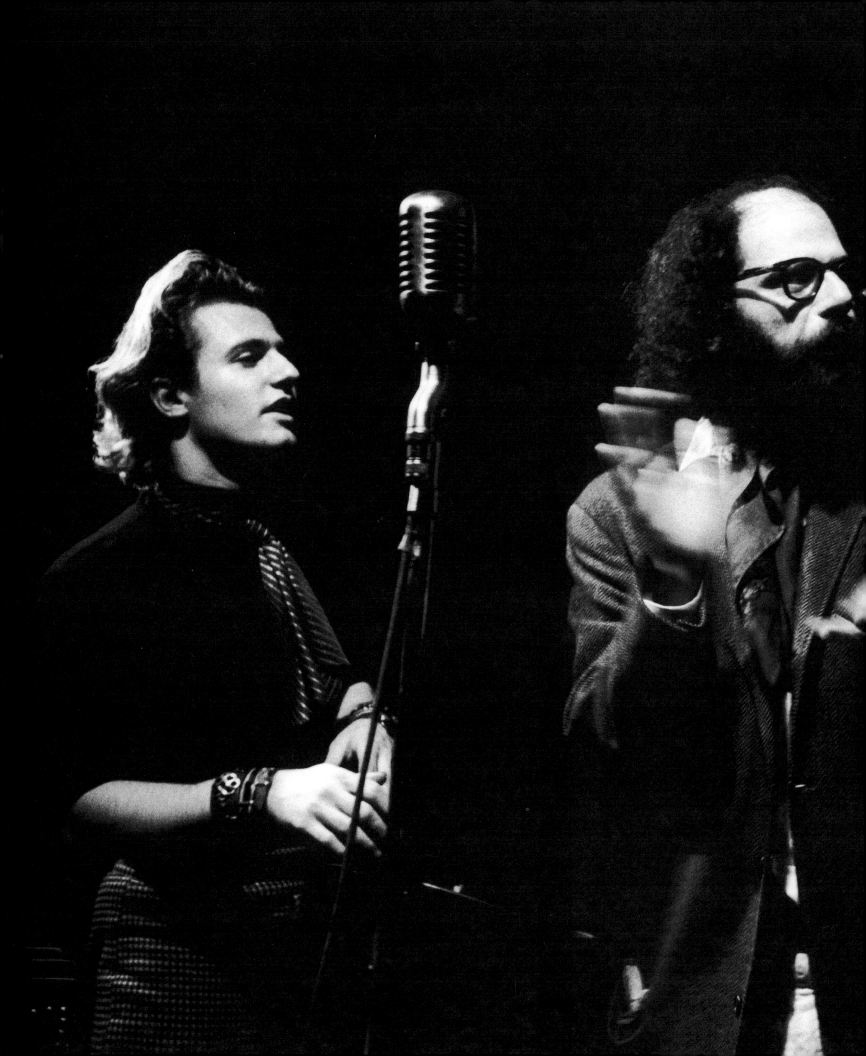

EPITA

AND EPIP

IT WAS A GREAT PARTY; A SPEED FREAK'S DREAM. THE GREAT AMERICAN FANTASIA FULL OF FUN, FROLIC AND FORGET-ME-NOTS. SOME OF THE GUESTS LEFT IN LIMOUSINES, SOME IN AMBULANCES, OTHERS NEVER FOUND THE DOOR. IT WAS PLAIN OLD-FASHIONED HETEROSEXUAL YOU-GIRL-ME-BOY-LET'S-FUCK SEX THAT GOT ME THERE.

I WAS FALLING ASLEEP AT A TOM WOLFE PREPUBLICATION PARTY WHEN I SPIED JEANNE K. AND WE LOOKED AT EACH OTHER AND SAID, 'YES...' AND JEANNE SAID, 'LETS GO TO THE FACTORY. THERE'S A PARTY TONIGHT AND NOBODY WILL EVEN NOTICE US.' SO WE MADE IT TO 47TH STREET AND SUBMERGED OURSELVES IN EACH OTHER AND A COUCH. WHEN WE EMERGED WE FOUND THAT SOMEBODY HAD STOLEN JEANNE'S PURSE WHILE WE WERE MAKING LOVE. I WAS INTRIGUED — THE WALLS WERE SILVERED, THERE WAS A MAN CALLED BILLY NAME LIVING IN THE TOILET AND PEOPLE WERE DOING ALL SORTS OF WEIRD THINGS ALL OVER THE WEIRD PLACE. NOBODY HAD NOTICED US EXCEPT A PURSE-SNATCHER. THE ART WAS INCREDIBLE, THE MUSIC GREAT AND THE NATIVES WERE KINKY. THIS WAS THE ERA OF THE PHOTOGRAPHER AS ANTHROPOLOGIST — ERNST HAAS'S PHOTOS OF BALINESE FERTILITY DANCES, INGE MORATH'S PHOTOS AND ESSAYS ON HEAD-HUNTERS IN NEW GUINEA — AND SUDDENLY I FOUND MYSELF IN THE FACTORY ON EAST 47TH STREET WITH SOME OF THE FREAKIEST PEOPLE OF EARTH. AFTER I FUCKED JEANNE K. ON THE COUCH I LOOKED UP AND SAID TO MYSELF, WHO NEEDS NEW GUINEA?

AND SO I HUSTLE MYSELF A COUPLE OF ASSIGNMENTS ON ANDY FOR SOME MAGAZINES AND DECIDED THAT ANDY WARHOL WAS A SUPERFICIAL GENIUS FOR SUPERFICIAL PEOPLE, AND THAT THE DENIZENS OF THE FACTORY WERE A PIRANHA PACK WAITING TO STRIP THE FLESH OFF YOUR BONES AT THE FIRST SIGN OF BLOOD. I STAYED AT THE FACTORY FOR CLOSE TO TWO YEARS. I WATCHED POP DIE, I SAW PUNK BEING BORN. I PARTICIPATED IN A CULTURAL REVOLUTION THAT SHOOK THE SUPERSTRUCTURE OF OUR SOCIETY. I CAME I SAW I OBSERVED I ENJOYED. I ALLOWED MYSELF TO SEE THINGS THAT I HAD ONLY FELT BEFORE AND I BECAME FREER BECAUSE OF ANDY AND THE FREEDOM HE ACCORDED TO AND CONFERRED UPON THE PEOPLE AROUND HIM — THE FREEDOM TO FUCK UP — THE FREEDOM TO TRY AND DIE. I CAN'T REALLY SAY WHAT HE DID TO/FOR THE REST OF SOCIETY, BUT HE WAS MY ARTISTIC MESSIAH. HE SAID DO OR DIE. I DID, OTHERS DIED... SO IT GOES. IN RETROSPECT AND AFTER A WHOLE LOT OF LIVING, I LOOK UPON THE FACTORY SCENE LIKE A PERPETUAL CARNIVAL IN RIO DE JANEIRO, BEAUTIFUL GIRLS, PRETTY BOYS, MUSIC IN THE AIR AND FUCKING IN THE STREETS, AND EVERY ONCE IN A WHILE SOMEBODY RUNS IN AND KILLS ONE OF THE GUESTS.

NOW ANDY BESTRIDES HIS WORLD LIKE A BLEACHED BLOND COLOSSUS, A SILVER SPRAY-PAINTED BLACK WIDOW SPIDER; FUCKING 'EM OVER, SUCKING THEM DRY AND SPITTING THEM OUT. I WITNESSED THE BIRTH OF HIS MONSTER, ME A KID FROM A BROOKLYN SLUM WHO READ THE AUTOBIOGRAPHY OF BENVENUTO CELLINI IN A FOUR-ROOM APARTMENT OFF ROGERS AVENUE, WHOSE CAB-DRIVER FATHER WAS CRIPPLED WHILE EARNING FIVE BUCKS UNLOADING A COAL TRUCK IN CONEY ISLAND. THEY PARADED FOR MY

CAMERA IF NOT FOR ME, THIS AMERICAN ROYALTY CALLED SUPERSTARS, BECAUSE I WAS A WORKING PHOTOJOURNALIST — A PROFESSION CELEBRATED AND MYTHOLOGIZED IN BLOW UP AND REAR WINDOW — REGULARLY PUBLISHED AND UNDER CONTRACT TO A MAJOR AGENCY. CELEBRITIES ARE LIKE ACADEMICS, THEY MUST BE PUBLISHED TO JUSTIFY THEIR EXISTENCE. YOU SEE THEREFORE THEY ARE. THEY MAY NOT HAVE WANTED ME OR LIKED ME, BUT THEY SURE DID NEED ME. WHO EVER HEARD OF A CELEBRITY THAT NOBODY EVER HEARD OF? BUT THERE WAS STILL THE PROBLEM OF HOW TO STRIP THE FACADE. THESE WERE THE GREAT DISSEMBLERS, PROFESSIONAL IMAGE PROJECTORS. CULTURAL ECDYSIASTS SHOWING ONLY AS MUCH AS THEY WERE PAID TO REVEAL — G-STRINGS AND PASTIES AND NOTHING MORE. DON'T SHOW FEAR OR THEY WILL CLIMB ALL OVER YOU. INFILTRATE, ASSIMILATE, BECOME ONE OF THEM BUT NOT PART OF THEM, SOFTLEE SOFTLEE CATCHEE MONKEE. AND SO I BECAME AS MUCH OF A SPY AS A JOURNALIST. THE FIRST OF THE RED HOT GONZOS: SPOOKING ABOUT LIKE SIR RICHARD BURTON IN MECCA, MIXING WITH THE FAITHFUL BUT KNOWING THAT A SLIP OF THE VEIL WOULD REVEAL A FIVE O'CLOCK SHADOW. I BECAME A VISIBLE PRESENCE, THE YANG PIMPLE OF A SMOOTH YING CHEEK. DEFINITE VISIBILITY: A LIPSTICK-STAINED CIGARETTE LEFT SMOULDERING BY THE KA'BAH... MUDDY FOOTPRINTS NEAR THE ARK... A CRUMPLED KLEENEX DROPPED BY THE WAILING WALL... `HI FOLKS... I'M HERE... IT'S ME, NAT... WATCH THE BIRDIE... LOOK DIRECTLY IN THE CAMERA...' SOMETIMES A PART OF THE SCENE AND SOMETIMES THE SCENE ITSELF. I WOULD JUMP ON THE STAGE AND DANCE AS I SNAPPED. I WOULD JUMP ON STAGE AND TAKE PICTURES OF THE AUDIENCE. I WOULD JUMP INTO THE AUDIENCE AND TAKE PICTURES OF THE STAGE. I WOULD JUMP INTO CONVERSATIONS AND DIRECT POSES AT THE SAME TIME... ONE TIME I MADE LOVE IN A MOVIE HOUSE AND SNAPPED A COUPLE WITH MY PANTS DOWN... I SLUGGED A SECURITY COP AND TOOK PICTURES OF THE ENSUING MINI-RIOT... HIGH VISIBILITY AND THIS AT A TIME WHEN PHOTOJOURNALISTS WERE BARELY SEEN AND BARELY HEARD. SOFTLEE SOFTLEE CATCHEE MONKEE AND SLOWLEE SURELEE `WHAT'S HE DOING HERE?' CHANGED TO `WHERE THE HELL IS HE?' CHANGED TO `SOMEBODY CALL NAT.'

EXCITING THINGS HAPPENED: MY NAME ON THE FLYERS, MY OWN GROUPIES... AND A ONE-MAN SHOW OF MY ENLARGED CONTACTS AT ANDY'S EDIE RETROSPECTIVE AT THE CINEMATIQUE: PHOTOS BY NAT FINKELSTEIN. OPERATING THE LIGHTS AT THE EXPLODING PLASTIC INEVITABLE SHOWS. THE VELVET UNDERGROUND BANANA ALBUM: PHOTOS BY NAT FINKELSTEIN. MOBBED BY TEENIES AT THE ROLLING STONES RKO CONCERT. STILLIE AT THE BETSEY JOHNSON SHOW. STILLIE FOR THE WARHOL – DYLAN MEETING. UNTIL FINALLY I COMMITTED THE CARDINAL SIN: I THREATENED PARITY WITH ANDY ON A JOINT VENTURE: THE ANDY WARHOL INDEX. IT DIED A DEATH OR WAS EXECUTED, HOW EVER YOU WANT TO LOOK AT IT. I COMMITTED THE CARDINAL SIN — I WANTED TO GET PAID, AND THE TRADITIONAL CANTONESE GREETING FA TSAI (MAKE MONEY) WAS NOT IN ANDY'S LEXICON. SOFTLEE SOFTLEE CATCHEE MONKEE WAS ANDY'S APHORISM AS WELL AS MINE BECAUSE UNDERNEATH IT ALL ANN DEE WARHOL NEVER STOPPED BEING ANDREW WARHOLA, CHILD OF A MCKEEVERSPORT, PENN. IMMIGRANT FAMILY SCRAMBLING AROUND THE MINES SCRATCHING OUT THE YANKEE DOLLAR.

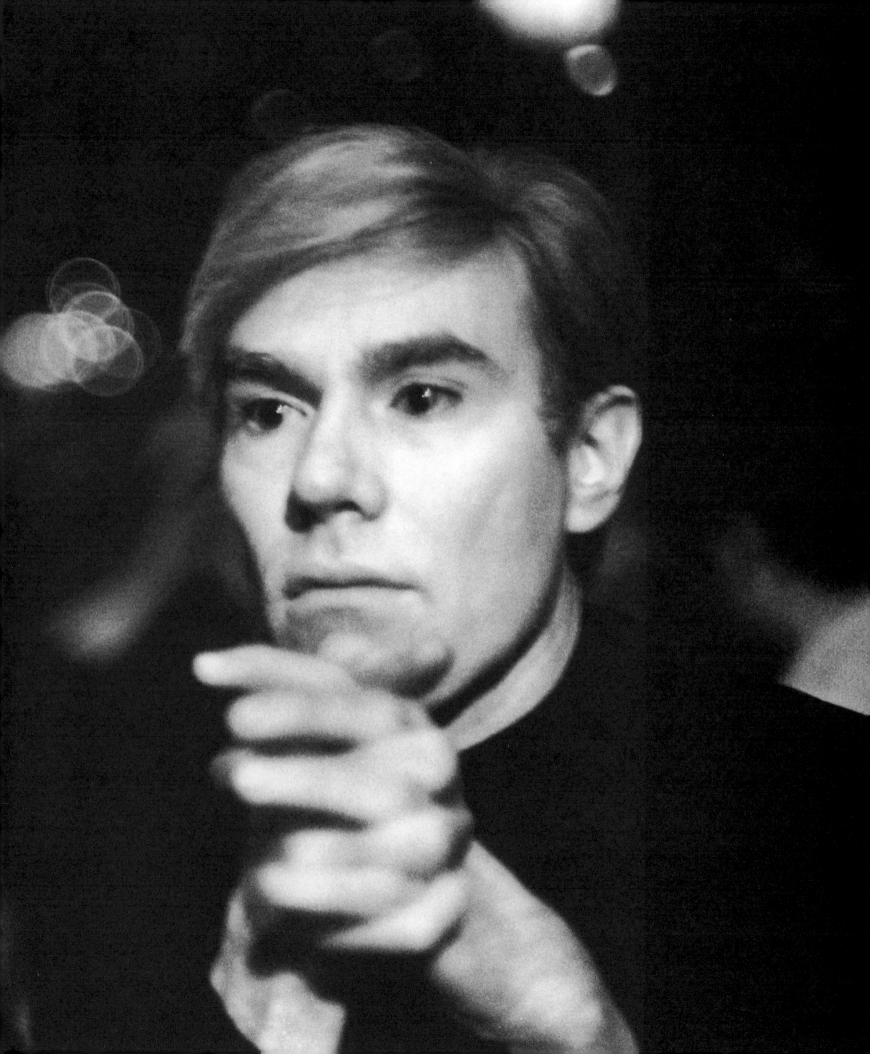

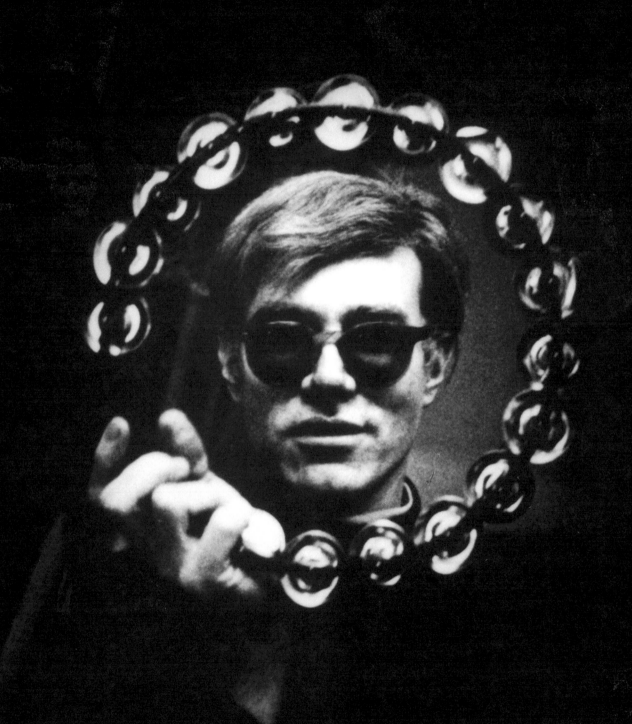

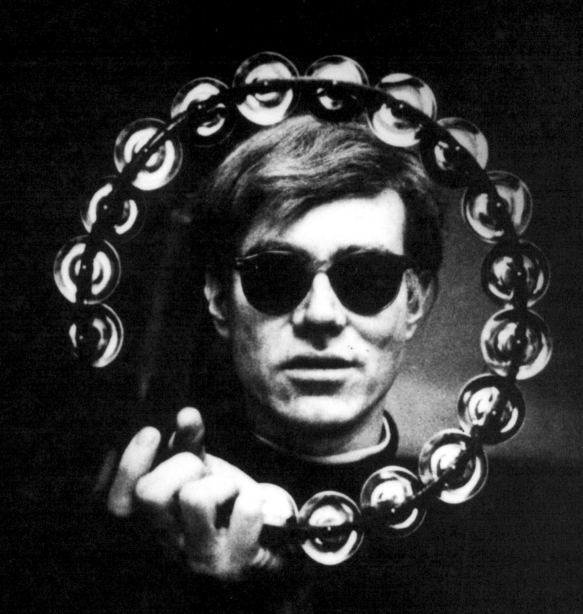

THE WARHOLIAN APPROACH TO POLITICS. **IT WAS THE DAYS OF BIRMINGHAM, WATTS, NEWARK AND HANOI. IT WAS THE TIME OF VIETNAM, CIVIL RIGHTS AND PEACE AND FREEDOM. SOON TO COME WOULD BE THE TEAR-GAS BURSTS AND THE RED GLARE OF ANGER. THE MOVEMENT WAS FORMING, THE YOUTH REBELLION BREWING. THERE WERE SIGNS OF RIOT AND REVOLUTION IN THE AIR AND STREET-FIGHTING PEOPLE WERE GIRDING THEIR LOINS. THE ALPHABETIC STAGE OF THE REBELLION WAS IN PLACE: SNCC, YAWF, SCLC, SDS AND YIPPIE LINED UP AGAINST FBI, CIA, BNDD AND ALL THE PDS ACROSS THE NATION. WE SHALL OVERCOME, FEED THE PEOPLE, LET THE CHILDREN PLAY, MAKE LOVE NOT WAR VERSUS AMERICA LOVE HER OR LEAVE HER, KILL THE GOOKS, DEFOLIATE AND DESTROY: THE TIMES THEY WERE A — CHANGING. I WAS TIRED OF THE FACTORY, ITS MASTER MANIPULATOR AND HIS SATELLITES: SEEKERS OF REFLECTED GLORY. I WAS GETTING READY TO GO BACK INTO WHAT I CONSIDERED TO BE THE REAL WORLD, MARCHING WITH, FIGHTING FOR AND REPORTING ON THE FOLK WHO WERE OUT THERE IN THE STREETS TRYING TO BUILD A BETTER WORLD FOR ALL AND NOT NEWSPAPER SPACE FOR THEMSELVES. TO ME, ANDY AND THE ENTOURAGE, STEVEN SHORE, BARBARA RUBIN, EDIE SEDGEWICK ET AL WERE THE SPOILED SPAWN OF THE ESTABLISHMENT, PLAYING AT ART AND TITILLATION BY NIGHT AND RETREATING TO GRANPA'S TRUST FUND BY DAY. 'LOOK AT ME, LOOK AT ME' — SYMPTOMS OF ANOMIE; PERFECT PEACHES PRAYING FOR A BRUISE. TOYS AND TEASE, SHOCK AND BOTHER, UV LIGHT AND TWO PERCENT HEROIN AS DANGEROUS AS A CONEY ISLAND ROLLER-COASTER RIDE AND THEN, STOCKINGS AT THEIR ANKLES, BRA STRAPS ON THEIR ARMS, SNEAKING BACK TO DADDY WARBUCK'S CONDO BY DAWN. AND OUT ON THE STREETS THEIR PARENTS' AGENTS WERE GOING 'BANG, BANG YOU'RE DEAD' WITH REAL BULLETS AND REAL CLUBS SHEDDING THE BLOOD AND LIVES OF REAL PEOPLE ... BLACK, YELLOW, AND WHITE ... NOT PINK AND MAUVE, THEIR POP ART FANTASY. AS A JOURNALIST, I HAD DONE A LOUSY JOB AT THE FACTORY: I WENT IN WITH THE IDEA THAT I WOULD SHOW AMERICA THE DECADENCE LURKING BENEATH THE SURFACE OF THE NEW POP CULTURE BUT THE MEDIA, FOR WHOM I WORKED, CONVERTED THE ROIL OF DECAY INTO A SAFETY VALVE AND A JOKE. ANDY WARHOL, ALLEN GINSBERG AND TIMOTHY LEARY — OPPORTUNISTIC PRETENDERS — WERE TIMELIFE ANOINTED AS LEADERS OF THE CHILDREN'S CRUSADE, WHICH WE CALLED THE MOVEMENT. IN RETROSPECT I SUPPOSE THAT I SHOULD HAVE ASKED MYSELF, 'WHO OWNS THE PRESSES? WHO CONTROLS THE MEDIA? WHO PRINTS THE NEWS? WHO DEFINES THEIR OWN ENEMY?'. BUT I WAS IDEALISTIC AND NAÏVE AND THOUGHT THAT I COULD CHANGE THE WORLD 35 MILLIMETERS AT A TIME. I WAS RUNNING DOWN WEST 4TH STREET... SATURDAY NIGHT... HIGH ON ACID AND SELF-ESTEEM, KALEIDOSCOPE CITY, BLURS AND BLURBS, COLOURS AND LIGHTS, MUSICAL PROTEST EVERYWHERE. I WAS GOING TO MEET ANDY AND SOME SATELLITES AT THE CAFÉ SOCIETY DOWNTOWN, THE NEWEST IN-SPOT. ANDY HAD CALLED ('OH NAT, COME DOWN, IT'S IMPORTANT AND FUN') AND I HAD SOMETHING WHICH I WANTED TO SHOW HIM. I WAS CARRYING A COPY OF THE NEW YORK TIMES SUNDAY MAGAZINE UNDER MY ARM. THEY WERE SITTING AROUND A LARGE ROUND TABLE... VIP... ANDY, BARBARA RUBIN, GERARD MALANGA AND STEVEN SHORE... THEIR SUTTON PLACE FLUNKY WITH TWO BLACK GUYS. FIVE WHITE FRIENDS AND TWO STRANGERS.**

'ANDY, LOOK AT THIS.' AND I TOSSED THE MAGAZINE ON THE TABLE... CENTRE SPREAD: 'POLICE RIOT IN WASHINGTON... FOUR PAGES BY NAT FINKELSTEIN'. POLICE BEATING PRO-PEACE/CIVIL RIGHTS DEMONSTRATORS, COPS CLUBBING KIDS, AMERICAN NAZI PARTY MEMBERS IN UNIFORM SPLATTERING CIVIL RIGHTS MARCHERS WITH RED PAINT WHILE THE POLICE LOOKED ON. IT WAS A MAJOR STORY IN THE MAINSTREAM PRESS DOCUMENTING THE SPLITTING OF SKULLS OF INNOCENT PEOPLE WHO WERE EXERCISING THEIR CONSTITUTIONAL RIGHTS, BY THE FORCES OF LAW AND ORDER. THE FIRST TIME THAT MIDDLE AMERICA COULD SEE THEIR CHILDREN WITH BLOOD FLOWING DOWN THEIR CHEEKS. 'ANDY, ANDY, LOOK AT THIS.' ANDY LOOKED UP AND SAID, 'NAT, I'D LIKE YOU TO MEET THE CHAMBERS BROTHERS.'